Soviet Emigré Artists

Soviet Emigré Artists
Life and Work
in the USSR and the United States

Marilyn Rueschemeyer Igor Golomshtok Janet Kennedy

M. E. Sharpe, Inc. Armonk, New York and London

Available in the United Kingdom and Europe from M. E. Sharpe
Publishers, 3 Henrietta Street, London WC2E 8LU.

Published simultaneously as Vol. XV, No. 1-2 of *International Journal
of Sociology.*

Library of Congress Cataloging in Publication Data

Rueschemeyer, Marilyn, 1938-
 Soviet emigre artists.

 Bibliography: p.
 1. Artists, Expatriate—United States—Interviews. 2. Artists—
Soviet Union—Interviews. 3. Artists, Jewish—United States—Inter-
views. 4. Artists—Social conditions—United States. 5. Artists—
Economic aspects—United States. 6. Art and Society—United States.
I. Golomshtok, Igor. II. Kennedy, Janet, 1948- . III. Title.
N6536.R8 1985 704'.03924073 84-23558
ISBN 0-87332-296-7

Design by Sophie Schiller.

Printed in the United States of America

*This book is dedicated to Dietrich and Nina,
to Nikita A.,
and to the memory of Bella and Julius*

Contents

List of Illustrations

Acknowledgments

This book could not have been written without the interest and generosity of the Soviet emigré artists, art historians, and critics who agreed to be interviewed. With warmth and courteousness, they spent hours answering questions, assessing their experiences in the Soviet Union and recalling the chaos, tribulations, and excitement of their first years in the United States. Among the artists who contributed so much to this project are Katerina Arnold, Vagrich Bakhchanyan, Paul Bunin, Mikhail Chemiakin, Rimma and Valery Gerlovin, Vladimir Grigorovitch, Henry Khudyakov, Marc Klionsky, Vitaly Komar, Alexander Kosolapov, Alexander Melamid, Lev Meshberg, Ernst Neizvestny, Alexander Ney, Gregory Perkel, Alexander Prostakov, Vladimir Ryklin, Sophie Schiller, Zarina Sheglov, Ilya Shenker, and Igor Tulipanov. We are grateful to John Bowlt, Norton Dodge, Larissa Haskell, and Alison Hilton for their help and inspiration and to Alexander Glezer, Margarita Tupitsyn, Eduard Nakhamkin, Ronald Feldman, Rowman Kaplan, and the staffs of the Galerie St. Etienne and the Lefebre Gallery for their cooperation and advice. We thank Robert Thornton of the Rhode Island School of Design Museum for his help in reproducing one of the artist's prints, and Sue Carroll for her excellent typing of part of the manuscript and for her reactions as an American artist. Our editor, Patricia Kolb, offered her enthusiasm, helpful criticism,

and patience from the very beginning of our work together at M. E. Sharpe, for which we are most appreciative.

Igor Golomshtok and I are enormously grateful to both our families—to Nina and Dietrich, Benjamin, Julia, and Simone—for their toleration of long conversations and meetings over the years, for their participation in gatherings with emigré artists, and for partaking in the spirit of this project, in which we all became so intensely involved.

Finally, it seems important to mention that the authors of this book grew up in very different social and political milieux and were informed by different professional traditions. Through intense discussion, correspondence, and joint meetings with some of the respondents, we brought our varying perspectives together to help us gain a deeper understanding of the lives of Soviet artists. We sought to integrate our observations and analyses, but we also gave each other the space, and respect, for individual assessment.

<div style="text-align: right">

MARILYN SCHATTNER RUESCHEMEYER
Providence, Rhode Island

</div>

Introduction: Emigrating from the Soviet Union

Marilyn Rueschemeyer

Since 1970 approximately one hundred thousand citizens of the Soviet Union have emigrated to the United States. Among them are as many as a hundred painters and sculptors who came to New York with great hopes and expectations for their lives and careers as artists in American society.[1] This book is a record of their experiences. It is based on the reflections of the artists themselves as well as on the impressions of gallery owners and managers, art historians and critics who are familiar with the system of art in the Soviet Union and have known artists there or worked with them after emigration.[2]

Exploring the lives and the work of these artists, as they make the transition from the social and cultural world of the Soviet Union to our own very different one, can tell us much about these two societies as seen from the particular perspectives of our respondents. It also reveals important aspects of art itself—its rooting in human experience and its relation to the social, political, and cultural milieux in which it is created. The act of emigration, because of its radically disruptive character, throws a strong and peculiar light on the culture and society these artists left behind, on their new host country, and on the ways in which art is grounded in a social setting.

These are the major themes we will address in this book. They are embedded in individual stories about mundane issues such as where to live, how to exhibit, and what financial risks to take. At the same time they are often the subject of conscious reflection and discussion, for concern with the underlying questions of one's existence is the lot of the uprooted. Some experience this as a burden, others as a gift.

First, however, we need more information on who these artists are and how they fit into the over-all emigration from the Soviet Union in the 1970s.

Who Are the Emigrés?

Of the roughly 300,000 people who have emigrated from the Soviet Union since 1970, most are Jewish—about 248,000. Among the others who have been allowed to leave are about 50,000 Germans and 8,000 Armenians,[3] as well as selected members of the intelligentsia of every ethnic background. Of the artists who are the subject of this book, some call themselves "half Jewish" and some are drawn to Christian beliefs. Still, the typical pattern is that at least one member of the emigré family is identifiable as a Jew, because such identification was generally necessary for obtaining permission from the Soviet authorities to emigrate to Israel, the official destination of most Soviet emigrants and the one originally fought for by Soviet citizens who wanted to pursue and deepen their Jewish commitments.

Large-scale emigration of Jews from the Soviet Union began in the second half of 1971. By the end of 1978 more than 170,000 Jews—almost 8 percent of the Jewish population of 2,150,000 recorded in the 1970 census—had left the Soviet Union.[4] It is difficult to determine why this emigration was permitted. Analysts have discussed the importance of the fact that internal pressure by minority ethnic groups occurred at a time when the Soviet government wished to improve relations with the West, especially the United States. Developments in the Arab-Israeli conflict may also have influenced Soviet policy, if it can be speculated that the Soviet government reconciled itself to the fact that many Jews went to the

United States rather than Israel since this deflected Arab criticism. Undoubtedly Soviet authorities also saw emigration as a way to rid themselves of Jewish activists and some non-Jewish "trouble-makers" as well. A steep decrease in the number of Jews allowed to leave the Soviet Union—only 21,000 left in 1980, less than 10,000 in 1981, and less than 2,000 in 1982[5]—has paralleled increasing tensions with the United States and complaints by the Soviets that emigrants were not in fact proceeding to Israel, their official destination. In recent years many Jews have been refused permission to leave and others have been hesitant to apply, knowing that their chances are now poor.

It is of course difficult to estimate who or how many would leave the Soviet Union if given the choice, but it seems quite likely that a majority of Jews, like others, would remain; in general, most people prefer to live within a familiar milieu, even if with great difficulty, rather than venture into the unknown. To obtain permission to emigrate, a Jewish citizen of the Soviet Union must receive an invitation in the form of an officially certified petition from relatives in Israel for the uniting of a family. These invitations are almost always requested by the relatives in the Soviet Union when they make serious plans to emigrate. The decisive step, of course, is not requesting an invitation but filing an official application to leave the country, for a person who applies for emigration is seen as rejecting the Soviet system. Taking this step creates tremendous tensions and difficulties; it is all but irrevocable, yet the outcome is uncertain.

> . . . quite frequently (though not always) submitting an application means automatic loss of employment and therefore one's livelihood. Everything depends on just what kind of employment it is, and on the attitudes of the local authorities. Often a person will leave his work voluntarily in order to avoid many of the inevitable and unpleasant consequences. . . . [A]nd most important, the individual takes a great risk in submitting the application. It cannot be known in advance whether permission will be granted or denied.[6]

Until 1971, applying to leave the Soviet Union was risky indeed, and those who did so were usually motivated by intense religious or

nationalistic commitments. Later, when the number of permissions granted increased, applying to emigrate no longer seemed a hopeless endeavor and people with a variety of motivations, not only those with Zionist beliefs, began seeking permission to leave. Soviet Jews, of course, are a heterogeneous group; aside from Zionists, there are traditionally religious Jews, Jews attracted to Yiddish cultural life rather than religion as such, and Jews who feel no particular identification with a Jewish community and have no explicitly Jewish associations. Many, especially in the larger cities, have embraced Russian culture as their own. They are dedicated to their professions, but find that, as Jews, they are unable to attain the desired level of responsibility. Their Jewishness prevents their social, educational, and occupational integration into Soviet society.

Although the occupations and the class backgrounds of the emigrants vary, it is not surprising that as many as half of them are professionals, especially when one considers the high levels of education characteristic of Jews in the European republics of the USSR. Between 1974 and 1980 nearly 10,000 Soviet Jewish professionals came to the United States with training in the humanities, in the arts and entertainment, and in medicine. With the engineers and technicians, they made up half the working immigrants.

Why Emigrate?

In a report on the emigrants, Zvi Gitelman has suggested that Soviet Jews, notwithstanding their heterogeneity, share a community of fate since they are seen by Soviet society as members of a Jewish community and are identified as Jews in their internal passports.[8] It is interesting that this perception of community should exist in spite of the absence of Jewish organizations and Jewish schools in the Soviet Union, where the few remaining religious communities are tiny. Many Soviet Jews have experienced anti-Semitism in their own lives and fear that their children will encounter discrimination, particularly when it comes to gaining admission to certain institutions of higher learning.[9] This has been a major concern of emigrant families. The feeling of being an outsider, or simply of having to do especially well in school and at work, may exist even when one's

personal situation and one's colleagues are not threatening and are even friendly. While many Soviet Jewish professionals say that their Jewishness made no difference at all at work, the history of Jews in the Soviet Union, and occasional incidents in the very recent past, cause lingering feelings of uneasiness.[10] Gitelman found that a significant minority of Soviet Jewish emigrants reported only rare experiences of anti-Semitism, and he concluded that it would be wrong to see all emigrants as refugees.[11] Indeed, emigrants cite many other important reasons for leaving the Soviet Union.

Nearly all of the emigrants who have come to the United States had hopes that they could better themselves economically. Some were dissatisfied with the Soviet economic system and felt more disposed to the attitudes and culture of a free enterprise society. A few had at one time or another been involved in various illegal or semilegal enterprises in the Soviet Union. Yet even many who objected to the economic aspects of life in the Soviet Union still expressed warm feelings toward their former country.[12]

Others were dissatisfied with their occupational development. They may have been unsuccessful in gaining admission to a desired institution of higher learning or in finding suitable work. (It must be said that many in this group have had great difficulties pursuing their careers in the West as well.[13]) Still others who were well-educated and successful professionals in the Soviet Union were nevertheless frustrated by their inability to achieve what they had hoped for and by certain aspects of the system which impeded their activities, such as organizational inefficiency or the scarceness of equipment that they needed for their work. Some were irresistibly attracted to the possibility and adventure of beginning "a new life in a totally different society." There were many who had felt oppressed, spiritually or culturally, in the Soviet Union. These frustrations were felt most keenly, perhaps, by those involved in the humanities and the arts.

The Plight of the Soviet Artist

Many of the reasons artists cite for leaving the Soviet Union echo those of other emigrants: hopes for a better standard of living,

irritation with the inconveniences of everyday life, dislike of the general political atmosphere, resentment of restrictions on foreign travel, and sometimes, the desire to escape anti-Semitism. But artists have special reasons for emigrating which are not shared by other former Soviet citizens. Artists complain that they were unable to develop freely in their work in the Soviet Union. They could not always obtain the materials and supplies they needed; they felt isolated from many developments in the contemporary art world; they could not exhibit what they thought worthy and important to share with a large audience. Their life as Soviet artists had its positive sides too, of course.[14] Nonetheless, they were inspired to believe that there was an alternative to living with the restrictions and inhibitions on their artistic development which they experienced in the Soviet Union, and that if they were able to emigrate they could anticipate satisfaction and success.

Many of the artists had been criticized for "advancing the bourgeois course" because their paintings were "decadent," or simply not in the style of socialist realism; one had experienced difficulties because he did lithographs dealing with Jewish themes. Often such criticisms had real consequences, including nonacceptance for membership in the Union of Soviet Artists, or expulsion from it. The recent history of cultural development in the Soviet Union includes many instances of artists having difficulty exhibiting work that deviated from the accepted styles. Some who managed to obtain permission for an exhibit had it closed within a few days or even a few hours. Consider these excerpts from painter Mikhail Chemiakin's exhibit biography:

1962 First exhibition at the Star Club. Duration: two weeks— great success.

1964 Exhibition at the Hermitage Museum. Exhibition forbidden after three days: Museum Director loses his job.

1965 Exhibition at the Star Club. Graphic exhibition and illustration of Dostoevsky and Hoffmann. Exhibition forbidden after two days.

1966 Exhibition at the Rimsky-Korsakov Conservatory. Exhibition of paintings and engravings. Forbidden after a week.

> 1967 Large exhibition at the Science Academy of Novosibirsk
> where were held some very famous exhibits: Filonov,
> Lissitzky, Falk. . . . Duration of Mikhail Chemiakin exhib-
> it, a month and a half. Since then the Novosibirsk Gallery
> has been turned into a billiards academy and a cafe.[15]

The best-known story about this sort of problem concerns the sculp-
tor Ernst Neizvestny's confrontation with Nikita Khrushchev at an
exhibition at the Manège in 1962, marking the thirtieth anniversary
of the Moscow section of the Artists' Union. The two had a heated
argument about the quality and legitimacy of the modern works on
exhibit.[16] In March 1969 Oscar Rabin, Boris Sveshnikov, Vladimir
Nemukhin, Dmitri Plavensky, and Lev Kropivnitsky planned an
exhibit at the Institute of World Economics and International Rela-
tions. It was closed forty-five minutes after the opening: the secre-
tary of the local party organization announced that the hall was
needed for a meeting and ordered the artists to take their paintings
away. Oleg Tselkov's one-man show at the Architects' Center in
1971 was closed after fifteen minutes.[17] People viewing paintings by
Vitaly Komar and Alexander Melamid in Melamid's apartment
were taken to police headquarters for interrogation.

In September 1974 the destruction of an exhibition of "un-
official" art set up on a vacant lot in Moscow attracted international
attention. Several Western journalists witnessed the event and sent
an open protest letter to the Soviet government which gives a clear
description of what happened:

> The artists and numerous spectators were met at the exhibition site
> by police in civilian clothes with dump trucks and bulldozers. The
> artists' pictures were taken away and their arms twisted and dislo-
> cated. The bulldozer drivers literally chased artists and specta-
> tors. One bulldozer driver, after running over pictures by Oscar
> Rabin, knocked the painter off his feet, and another ploughed into
> a confused group of people. Water cannons scattered artists and
> spectators with powerful jets of water. Eighteen pictures were
> mutilated and burned by uncontrolled young thugs. . . .[18]

In the wake of an international protest, the situation improved some-
what. A large open exhibit was eventually held in a park, lasting

several hours and attracting thousands of spectators, many of whom remained afterwards discussing what they had seen. Several artists showed their works in cafes and apartments, and some did succeed in getting authorization for exhibits.

Some of the artists who are now in the United States were never involved in "unofficial" exhibits and so were not directly affected by the dramatic incidents described here; their difficulties manifested themselves in a more subtle manner, which will be discussed later. But there is one problem that was shared by all the artists, whether "unofficial" or "official," who created modern art considered unconventional in style: the difficulty of becoming known to others, of getting publicity. Even those who succeeded in obtaining permission for an exhibit, or who were not harassed for showing their work more informally, had few opportunities to publicize their art. They had to depend on friends and small circles of interested people for their audience. Typically, the artists were not mentioned in the newspapers, their shows went unannounced and were not discussed by the art critics. A few of the unofficial artists received mention, but mainly in critical satirical articles; yet even this recognition, however negative, at least gave them some sense of being professional artists and the hope of eventually reaching a larger audience. The following anecdote told by the collector Alexander Glezer suggests what efforts are required to have success under these conditions.

> I made the acquaintance of the Lianozovites and other unofficial painters in December 1966, felt impelled to help them, and offered to arrange an exhibition in the Druzhba Workers' Club on the street called Chaussee Entuziastov, whose manager was an acquaintance of mine. This exhibition by twelve nonconformists . . . opened on 22 January 1967 and caused a sensation. For this was the first occasion on which it had been possible to get tickets printed and thus give the show wide publicity . . . the printers accept only texts that have been approved in writing by the censorship. . . . Subterfuge was the only way. The censorship—known officially in Moscow as *Glavlit*—was submitted invitations to the opening without any mention of the names of the artists involved. The censors overlooked the

omission. . . . In two hours the pictures were seen by two thousand people, including Moscow writers, poets and art historians, and foreign diplomats and correspondents.[19]

The lack of official recognition of unconventional art continues in the Soviet Union, despite the absorption of more artists than ever before into the "official" art world. Artists who hold small exhibits in their apartments will boast that as many as two hundred people come to see their work. Sometimes an artist's work is taken out of the country by foreigners and shown abroad, confirming once more that there is an audience for it somewhere, even if the work remains virtually unknown in the Soviet Union. This interest can reinforce an artist's hope in the possibilities of finding success and recognition outside the country.

Where to Go?

After succeeding in their long struggle to leave the Soviet Union, many emigrants settle not in Israel but in other countries, especially Canada and the United States.[20] Their reasons are many. Some felt little sense of Jewish cultural or religious identity; they were more strongly motivated by their dislike of the Soviet system than by a desire to live an intensely Jewish life in a state they considered basically religious. In North America they expected to be able to live comfortably as Jews, with neither the commitment to become traditionally religious nor the pressure to assimilate. Soviet emigrants who chose not to go to Israel may nevertheless view it "positively," for example as "a peaceful-loving, fairly developed country, basically capitalist, not socialist and fundamentally Jewish."[21] (It is, of course, possible that this attitude develops after emigration, in contact with an American Jewish community strongly supportive of Israel.) Others who decide against settling in Israel are more critical of the Jewish homeland. They see it as a Middle-Eastern rather than European country, a country surrounded by enemies and involved in dangerous wars, a country with intolerable weather—too hot for comfortable living.

After 1973 there was a considerable increase in the numbers of

Jewish emigrants who changed their destination from Israel to the United States once they had left the Soviet Union. The great majority of the emigrants from the major cities of Moscow, Leningrad, Kiev, and Odessa settled in the United States rather than Israel. By 1976, half of the emigrants passing through Vienna decided to go to the United States.[22] Since the peak year of 1979, nearly 70 percent of the 83,000 Soviet Jews who have left the USSR did not go to Israel.[23] Of the Soviet emigrants who have settled in Israel, one-quarter are from Georgia and one-third from the Baltic republics, although only about 6 percent of the Soviet Jewish population resides in these republics. Central Asian and Moldavian Jews are also overrepresented in the Israeli immigration; those from the Russian Federation are underrepresented.[24] Although many of the Soviet emigrants who go to Israel are culturally and geographically European (about 35 percent, compared to 87 percent among those who come to the United States), the proportion of more traditional Jews from Central Asia and Georgia is far greater.[25]

Through correspondence with their relatives and friends, Jews in the Soviet Union become well aware of the difficulties of emigrants who have settled in Israel. They know that the economic situation there is difficult and that the job market is tight. Soviet professionals in Israel complain about the new positions they receive, which may not match their earlier achievements, as they see them. They resent their comparatively low status and they dislike being perceived as people who need help, rather than as contributors to Israeli society. Women have complained about Israeli attitudes toward the working woman. In the Soviet Union women are expected to work and generally are equals on the job, despite some remaining differences in choice of occupation and level within the occupation itself.[26] In Israel they are frustrated when absorption authorities treat them as ''second bread-winners'' and when men receive preferential treatment in hiring over more highly qualified women.[27] Of course, immigrants have economic difficulties in the United States as well and, as we shall see, Soviet artists in particular have many complaints about their lives in American society.

The artists I interviewed who had settled in Israel before coming to the United States had very positive experiences there. They spoke

with enthusiasm about the support given to them and the interest shown in their work. Artists arriving in Israel are allowed a paid year to settle, learn the language, paint, and look for work.[28] Two of the artists said they had never worked in such large studios. Their art was exhibited in museums and galleries and reviewed in Israeli newspapers and journals. Aside from such support, Soviet immigrants carry on a rich cultural life in Israel; they can attend concerts and readings in Russian as well as the exhibits of other immigrant artists. Still, after a while, some of the immigrants grow eager to move on. Their restlessness may have been kindled by other Israeli artists, many of whom leave Israel for long periods of time to partake of the "international" art scene in Paris and New York. They complain that Israel is too small, too provincial, and that they have to leave, at least for a time, if they are to do their art. Rejecting Israel may also have something to do with having a certain conception of oneself as a member of the Russian intelligentsia. One Soviet emigrant describes this identity:

> We are not like the others, we are better, we know more; but they do not value us, they don't want to help . . . we are aristocrats of the mind, we live our own internal lives, we are intellectuals, we are members of the Russian intelligentsia, we are the third wave of the Russian emigration. We are in Israel by chance, just as we could be in Canada or in France, by chance.[29]

Two of the interviewed artists had been urged to move from Israel to the United States in order to further their careers and did so, though they remain Israeli citizens. Another had concluded that in some ways being in Israel was like being in the Soviet Union; he wanted to be a "professional" artist rather than an integrated member of a community.

> "Despite many good experiences in Israel, I was tired of the pressures. In the Soviet Union, I was pressured to produce a certain kind of art. In Israel, I was pressured to serve in the army, again and again. I wanted to be left alone. In America, no one wants you, neither the government nor the army—and that's positive! I was sure that would be the case in America."

Of our respondents, four of the artists and one of the gallery owners had spent some years in Israel before coming to New York; two artists and an art collector had spent long periods of time in Paris, a home to many emigré artists. All of the others had come directly to the United States and headed for New York, which is not at all surprising. They knew that New York was one of the most important centers of artistic life in the world—whether they gleaned this from the foreigners who showed interest in their work or from international art journals they had been able to get hold of in the Soviet Union—and they were eager to be part of that milieu. They thought of New York as a newer, more modern and less traditional city than Paris and therefore more appropriate for starting a new life. They knew that New York had numerous galleries and many customers for modern art, and they dreamed of having large studios and earning huge sums of money for their work. They were excited by the prospect of unlimited opportunity—and they anticipated recognition and an immediate understanding and acceptance of their art. In part, the artists were encouraged in these beliefs by contacts with American visitors to the Soviet Union who knew their work and wanted to buy it. A few of them had even had their work exhibited and written up in journals and newspapers before they arrived in the United States, and this fueled their conviction that America was eagerly awaiting them. One dealer from California did six broadcasts on the Voice of America promising Soviet artists that a gallery was waiting for them, and for a while he did handle the work of several of the emigrés.[30]

* * *

Why a particular person decides to emigrate and what it is he or she seeks to attain in a new world is difficult to know. Such issues are so complex that often an individual does not even understand his or her own strivings and motivations. From analyzing a set of interviews and studying the results of interviews with other Soviet emigrants, we have gained a sense of some general patterns, based on what each emigrant has been able and willing to articulate. These patterns set the stage for understanding the issues that concern us in this book:

the efforts of Soviet emigré artists to establish themselves in New York, their views on the role of art in society, their former and present relationships to colleagues, and their changing conceptions of themselves as artists, as related to the contrasts in the role and organization of art in the two societies.

We turn first to a discussion by Igor Golomshtok of the role of art in the Soviet Union, its historical development and present organization. Next, I trace the experiences of artists who leave that environment and attempt to establish their lives and careers anew in the United States. Finally, Janet Kennedy examines the creative development of Soviet emigré artists who have settled in New York.

Notes

1. This approximate figure represents the number of artists considered truly professional by members of the art community in New York. Dodge and Hilton estimate that the number of emigré professional artists trying to support themselves through their art or working full-time as artists is two to three hundred. They estimate that about fifty artists are in Israel and thirty-five in Paris, and that others are scattered over Western Europe—in Vienna, Berlin, London, and other cultural centers. See Norton Dodge and Alison Hilton, "Emigré Artists in the West (USA)," Second World Congress on Soviet and East European Studies, Garmisch, 1980.

2. I interviewed twenty-five of the most prominent Soviet artists in New York and Boston, two owners of galleries specializing in Soviet art, one manager of a gallery specializing in Soviet art, one curator of Soviet art, three owners of galleries who had exhibited the work of a Soviet emigrant, three Soviet art historians, and a number of collectors of Soviet art. The interviews lasted from one to four hours and were conducted over a period of five years—1979–1984. In the summer of 1983 I accompanied Janet Kennedy on her visits to a number of emigré artists to explore the changes in their art since emigration. These talks were further supplemented by a two-week trip I made with students from the Rhode Island School of Design to Moscow and Leningrad. During our visit we met "official" as well as "unofficial" artists, spent time at the Union House of Artists in Moscow, the Academy of Arts in Leningrad, a special school for children especially gifted in art, and two art salons.

3. Zvi Gitelman, "Soviet Immigrant Resettlement in the United States," *Soviet Jewish Affairs*, Vol. 12, No. 2, 1982, p. 3. Others maintain that the Armenian emigration is considerably higher.

4. Yoel Florsheim, "Demographic Significance of Jewish Emigration from the USSR, *Soviet Jewish Affairs*, February 1980, Vol. 10, No. 1, p. 5.

5. HIAS figures.

6. Igor Birman, "Jewish Emigration from the USSR: Some Observations," *Soviet Jewish Affairs*, Vol. 9, No. 2, 1979, p. 54.

7. Gitelman, "Soviet Immigrant Resettlement in the United States," p. 7.

8. Zvi Gitelman, "Demographic, Cultural, and Attitudinal Characteristics of Soviet Jews: Implications for the Integration of Soviet Immigrants," *The Soviet Jewish Emigré*. Proceedings of National Symposium on the Integration of Soviet Jews into the American Jewish Community (Baltimore Hebrew College, 1977), p. 74.

9. Children of mixed marriages may be registered in the nationality of either parent. One woman I spoke with in the Soviet Union expressed confidence that her son would not encounter discrimination because, although she was half Jewish, she was registered officially as Russian. I heard several such comments. See also David Harris, "A Note on the Problem of the 'Noshrim,'" *Soviet Jewish Affairs*, 1976, Vol. 6, No. 2, pp.104-113.

10. This experience has to be seen against the background of what once seemed to be great promise. Many Jewish artists and intellectuals embraced the Russian Revolution as a liberation from oppression. Such hopes were fast disappointed. In a lecture on Marc Chagall and the Russian Revolution, given at the Royal Academy, London, in February 1985, Harry Shukman of St Antony's College, Oxford, described the despair many Jewish artists experienced only a few years after the revolution, as the new regime increasingly sought support through appeals to nationalism and chauvinism. Within a generation, virtually all Jewish and other independent cultural institutions had been destroyed. For a contemporary account of personal relations between Jewish and non-Jewish professionals, see Marilyn Rueschemeyer, *Professional Work and Marriage: An East-West Comparison* (London: Macmillan and New York: St. Martin's, 1981), pp. 141–42.

11. Gitelman, "Demographic, Cultural, and Attitudinal Characteristics of Soviet Jews," p. 76.

12. Birman, "Jewish Emigration," p. 56.

13. Ibid.

14. On the life and work of Soviet artists and their role in Soviet society, see Igor Golomshtok and Alexander Glezer, *Soviet Art in Exile* (New York: Random House, 1977); John Berger, *Art and Revolution: Ernst Neizvestny and the Role of the Artists in the USSR* (London: Weidenfeld and Nicolson, 1969); Norton Dodge and Alison Hilton, *New Art from the Soviet Union* (Washington D.C.: Acropolis Books, 1977); Paul Sjeklocha and Igor Mead, *Unofficial Art in the Soviet Union* (Berkeley and Los Angeles: University of California Press, 1967).

15. *Mikhail Chemiakin* Catalogue, Eduard Nakhamkin Fine Arts, Inc., New York.

16. Those interested in the details of this event should read John Berger's *Art and Revolution*.

17. Alexander Glezer, "The Struggle to Exhibit," in Golomshtok and Glezer, *Soviet Art in Exile*, pp. 111–12.

18. *Ibid.*, p. 114.

19. *Ibid.*, pp. 109–10.

20. If an emigrant first settles in Israel, and only later decides to move from Israel to Western Europe, Canada, or the United States, the Hebrew Immigrant Aid Society (HIAS) will no longer accept responsibility for the emigrant's welfare, since Israel is not considered a country of stress nor the emigrant a refugee.

The Soviet emigrant who has attempted to live in Israel but then moves to another country must depend on friends, relatives, and other social welfare agencies for initial aid. See Betsy Gidwitz, "Problems of Adjustment of Soviet Emigrés," *Soviet Jewish Affairs*, Vol. 6, No. 1, 1976, p. 27.

21. Zvi Gitelman, "Demographic, Cultural, and Attitudinal Characteristics of Soviet Jews," p. 80.

22. Zvi Gitelman, "Recent Emigrés and the Soviet Political System: A Pilot Study in Detroit," *Slavic and Soviet Series*, Vol. 2, No. 2, Fall 1977, p. 41.

23. Jonathan Kirsch, *California Magazine*, July 1982, p. 65.

24. Gitelman, "Demographic, Cultural, and Attitudinal Characteristics of Soviet Jews," p.62.

25. Gitelman, "Soviet Immigrant Resettlement in the U.S.," pp. 4–6.

26. On the situation of women in the Soviet Union, see Dorothy Atkinson, Alexander Dallin, and Gail Warshofsky Lapidus (eds.), *Women in Russia* (Stanford, Ca.: Stanford University Press, 1977); Feiga Blekher, *The Soviet Woman in the Family and in Society* (New York: John Wiley & Sons, 1980); Wesley A. Fisher, *The Soviet Marriage Market: Mate-Selection in Russia and the USSR* (New York: Praeger, 1980); Alena Heitlinger, *Women and State Socialism: Sex Inequality in the Soviet Union and Czechoslovakia* (London: Macmillan, 1979); Peter Juviler, "The Family in the Soviet System," paper prepared for the Annual Meeting of the AAASS, Washington, D.C., 1982; Gail Warshofsky Lapidus, *Women in Soviet Society: Equality, Development and Social Change* (Berkeley, Ca.: University of California Press, 1978); and Marilyn Rueschemeyer, *Professional Work and Marriage: An East-West Comparison.*

27. Tamar R. Horowitz, "Integration Without Acculturation: The Absorption of Soviet Immigrants in Israel," *Soviet Jewish Affairs*, Vol. 12, No. 3, 1982, p. 26.

28. Conversation with an Israeli woman who works with emigrant artists.

29. Simon Markish, "Passers-by—The Soviet Jew as Intellectual," *Commentary*, December 1978, p. 35.

30. Press cuttings of Chemiakin refer to Gene Basin, La Jolla, California.

The History and Organization of Artistic Life in the Soviet Union

Igor Golomshtok

The Phenomenon of Emigration

That Russian artists should emigrate is not something new. In the Soviet era the history of the emigration of art and artists begins with the history of the Soviet state itself, and has had two high points over the course of time: in the mid-twenties and fifty years later, in the mid- and late seventies. The first of these waves was an emigration from revolution, the second an emigration from reaction, a flight from a total doctrine of revolutionary and proletarian art, and a flight from the totalitarian doctrine of state socialist realism. . . .

Yet this is but a simplified portrayal of a reality that is by no means simple. Reaction against avant-garde art in Soviet Russia began quite early— just five years after the victory of October, when the party and state leadership, its hands and minds once freed from the vicissitudes of the civil war, threw itself in earnest into the politics of art. Whereas during that first period, the proponents of what was then labeled "bourgeois" realism turned up in the emigration (and this included Ilya Repin himself, the "Leo Tolstoy of Russian figurative art"), after 1921 the radical turn in Soviet policy on art drove out many of the greatest representatives of the most

revolutionary currents of Russian art: Wassily Kandinsky, Marc Chagall, Antoine Pevsner, Naum Gabo, David Burlyuk, Nikolai Punin, and others all left the country. The first wave of emigration stripped Russia of what were essentially the most powerful forces in prerevolutionary art.

By the late twenties the state had erected an impregnable barrier to this exodus and only a few isolated individuals succeeded in finding their way through. During the Stalinist period the very thought of abandoning the bastion of all progressive mankind was regarded as a crime against the state, punishable as treason to the fatherland.

The curtain lifted a bit after Stalin's death, and in the mid-fifties the cultural vacuum created in the country over many years began to influence the atmosphere on the other side of the curtain through the opening that had been created. A crack had formed in the monolith of socialist realism, and out of the flood of Soviet art a stream branched off which, gathering strength, grew with time into the mighty current of "unofficial" art.

For almost thirty years artists in the Soviet Union have been waging a struggle for what would seem to be an elementary right: the right to exhibit one's own work to the public without censure from official institutions. After an unofficial art exhibition held on a vacant lot in Moscow was wrecked by police bulldozers, the plight of the country's artists once again came under the spotlight of international press coverage. With pressure steadily increasing not only from below but also from abroad, the state decided it was time to let off "excess steam." The most active oppositionists and all manner of dissidents, including nonconforming artists, were driven out of the Soviet Union, some under threat of arrest, but most through the channel of Jewish emigration. This second wave of emigration of artists, begun in the late sixties, reached its culmination in the mid-seventies.

There are many reasons—political, ethnic, religious, moral, and economic—why people leave the Soviet Union at their first opportunity, despite the tremendous difficulties and risks. But for the artist, and indeed anyone in any of the arts, regardless of nationality or ethnic affinity, political and religious beliefs, or material status, the

one most fundamental and important thing is the inability to work freely because the state has a total monopoly over all means and forms of artistic life, and rejects absolutely any aesthetic doctrine other than that of the proletarian culture or the principle of socialist realism.

Creative and professional problems were the main causes of both the first and second waves of emigration of Russian artists, but there the similarity between them ends. At the beginning of our century, the forms of artistic life in Russia and in the West coincided in many respects; the work of Russian artists evolved in the mainstream of contemporary art and they felt themselves to be an inseparable part of European culture. A move to Munich, Rome, or Paris was no more difficult for them than undertaking a journey from Moscow to St. Petersburg. But decades of Soviet power fundamentally changed the artistic life of the country.

The Bolshevik revolution was welcomed by artists involved in the most radical aesthetic currents. For them, the social revolution seemed a spontaneous torrent that was sweeping all barriers to free creativity—a natural continuation of the aesthetic revolution which they themselves were accomplishing in the world of art. Thus, Kazimir Malevich spoke of cubism and futurism as "revolutionary movements in art which anticipated the revolution in economics and politics in 1917."[1] The constructivist El Lissitzky traced what he thought of as victorious communism directly to the suprematism of Malevich.[2] *The Futurists' Gazette* published by Mayakovsky, Burlyuk, and Kamenskii beginning in 1917, appeared with the motto "revolution of the spirit." The artist's psychological affinity for revolution was given direct expression by Marc Chagall, who was for a time Commissar of the Arts under People's Commissar of Education Anatoly Lunacharsky. "Lenin turned Russia upside down just as I do in my paintings," wrote Chagall in his autobiography.[3]

The goal of the Soviet revolutionary avant-garde was to rework the whole of the objective environment and social life, with the goal of constructing the society of the bright communist future. All previous aesthetic theories, styles, and forms of artistic life were regarded as "bourgeois" and hence destined to die out. The revolu-

tion literally swept from the face of the earth all the "Tsarist" institutions on which the structure of artistic life in old Russia had rested: the Imperial Academy of Arts and the art institutes of the country were abolished, and all museums, exhibition halls, and private collections were nationalized. With them, of course, went the institutions of private and social patronage that had played an enormous role in the artistic life of Russia early in the century. A period of revolutionary experimentation in the arts, education, and organizational structures commenced, producing heady theories about the fusion of art with life, and the absorption of the creativity of the artist into one single democratic activity of building a new world in which the profession of the artist as such would no longer exist. This period did not last long—only for five or six years after the revolution.

Then, in 1925, at a meeting with Soviet intellectuals, party theoretician Nikolai Bukharin bluntly told artists, writers, and scholars what the Communist party and state had in mind for them: "We need our intellectual cadres to be trained ideologically in a specific manner. Indeed we shall mold intellectuals, we shall manufacture them, as in a factory."[4] This reference to the factory by a "liberal" such as Bukharin was not a backslide into a futurism not yet quite dead; the party ideologue was simply stating the intention inherent in any totalitarian vision: to reconstruct reality through a megamachine, the controls of which are in the office of the leadership. Soviet intellectuals humbly assented to this technical operation; in Soviet artistic life, the megamachine was built up over the thirties and forties and perfected over the decades that followed.

The foundations of this machine had been laid in Lenin's time. In 1918 a special decree of the Council of People's Commissars established the People's Commissariat of Education (Narkompros), with a Department of Fine Arts (DFA) which was to control the entire artistic life of the country in the areas of painting, graphics, sculpture, and architecture. In the first years after the revolution, members of the most radical avant-garde movements in art occupied key positions in this organization. The liberal Lunacharsky headed Narkompros, and Shternberg, "close to the futurists," headed the DFA. The Art Committee of the DFA included Mayakovsky,

Altman, Punin, and Brik. Tatlin was appointed Chairman of the Moscow Committee. Indeed it was the material and moral support of Narkompros that made possible the abrupt upsurge of revolutionary avant-garde art that occurred in Russia in the early twenties.

Lenin and other leaders of the Soviet state took a distinctly negative view of avant-garde art from the very onset, however. Its heady theories about transforming life through art were for them not merely aesthetic abstrusities, but also a dangerous intrusion into the domain of politics, where the party held the monopoly on the right to transform the world. Lenin, who indiscriminately called all new trends in art "futurism," looked on all this as a mutiny of a bourgeois intelligentsia "gone mad." Trotsky, more experienced in questions of culture, viewed the highest achievements of avant-garde art merely as "exercises in the literary and sculptural music of the future" and thought that it was "better not to bring them out of the workshops and not to show their photographs."[5]

The new regime had no time for art during its first chaotic years, but the battles of the civil war had no sooner subsided than the politics of art received its most assiduous attention. A campaign to clear the soil of Russian culture of the weeds of formalism, avant-gardism, and modernism was begun, while in that soil the state planted, "like the potato in Catherine's time" (Boris Pasternak's expression), the seeds of a healthy, life-affirming art intelligible to the broadest masses, an art that would celebrate the country's great socialistic achievements. The first thing that was required was a radical transformation of the entire organizational structure of the artistic life of the country.

In late 1920, on Lenin's instructions and with his direct participation, a long process of reorganization of Narkompros was begun, and with it reorganization of the entire structure of artistic life. As a result, control over art was divided up among several party and state institutions. The Department of Agitation and Propaganda (Agitprop) of the party's Central Committee became the supreme ideological organ for the control of the whole of cultural life. This department was to operate under various names throughout the entire subsequent history of the Soviet state. At the same time the Chief Administration of Political Education (Glavpolitprosvet) was

created, which Lenin's wife Nadezhda Krupskaya was to head for many years, and the DFA was transferred to it from Narkompros. In February 1921 it was empowered to "impose a political veto on anything produced in art and science."[6] Academic life (art education, research institutes, museums, periodicals and art publications) was left for the most part under the control of Narkompros.

The system of Agitprop-Glavpolitprosvet-Narkompros existed as a virtual monopoly until the early thirties.[7] One of the first fruits of its activities was the destruction of revolutionary avant-garde art: the party leaders simply closed off the channels of its material and ideological support. However, bureaucratic bullying, ideological pressure, and material fillips were still not enough to drive the entire mass of Soviet artists to the Procrustean bed of state art. A multitude of artists' groups, unions, and associations continued to exist in the Soviet art world until the early thirties, and each had its own ideas on how to serve the party, the proletariat, and the people, and its own interpretation of the principles of ideological art for the masses. The stylistic range was still quite broad: from mannerist naturalism to monumental heroic realism, from the Russian forms of expressionism and surrealism to constructivism. From the viewpoint of the new Stalinist ideologues in the machine created to control art, one basic element still was lacking: something that would make it possible to control the individual artist's creative process.

By a special resolution of the Central Committee of the Communist Party (Bolsheviks) of April 23, 1932, all art groups in the country were disbanded; two years later, socialist realism was proclaimed the high road, the one and only and the universally obligatory line of development for Soviet art. The doctrine of socialist realism, formulated in 1934 by the chief Stalinist exponent of culture, Andrei Zhdanov, has remained unaltered down to our own day: "Socialist realism is a faithful reflection of reality in its revolutionary development for the purpose of the ideological training and education of the toiling masses in the spirit of socialism." In 1933 the Union of Soviet Artists, bringing together all the working professional artists in the country, was established to replace the disbanded groups of artists. Its original statutes (still in force today)

state that a member of the Union of Soviet Artists must adhere, in his work, to the principles of socialist realism. Disagreement with these principles deprives artists of their candidacy, and violation of them can lead to expulsion.

With the creation of this organization, the artist found himself in a peculiar situation: being an artist henceforth meant being a member of the Union of Soviet Artists. An artist who was not a member of the Union and did not work in any state institution would be subject, like any other Soviet citizen, to arrest under the law against parasitism, for which he could be convicted and exiled to forced labor in the remotest corners of the country. Moreover, the materials and instruments an artist needed to practice his or her trade— canvas, paints, paper, gypsum, bronze, marble, and so forth—were distributed only by the Union under the state monopoly, and only among its members. And this is not to mention lithographic machinery and other potential means of mass circulation, which were under the strictest government control. It was practically impossible to acquire any of these things on the open market. Thus, by making acceptance of the principles of socialist realism a condition of membership in the Union, and membership in the Union a condition for being able to practice professionally, the state provided itself with a convenient mechanism for steering the creativity of every artist into the channels it required.

All of this would have made for a perfect system, if only it had been known what socialist realism was. The official definition, however clear it may be ideologically, is vague stylistically. At different stages in its history, the theoreticians and ideologues of socialist realism have alternately narrowed the definition of "a faithful reflection of reality" to the descriptive realism of the nineteenth century (as was the case under Stalin), or widened somewhat the range of the permissible (as it is today for example).

To fit the works of all members of the Union (of whom there are currently about 15,000) into the protean mold of this dogma is no easy matter. But if, as Marxists would have it, theory follows practice, so with time did the "standards" of socialist realism take form utterly haphazardly, being based on the aggregate of artistic production created within the Union. In 1940, annual Stalin prizes (100,000 rubles in old money plus a gold laureate badge for the first

level, smaller sums for the next two) were introduced for the winners. Within the complex hierarchy of Soviet art, the laureates of these prizes—now renamed State prizes—came to be the true guardians and keepers of the sacred principles of socialist realism. Eventually this function became anchored in the organizational structure of Soviet artistic life, that is, the Academy of Arts of the USSR, which was formed in 1947.

A restricted number of the Academy's highly paid active members and correspondent members form the elite of socialist realism.[8] Its presidents are appointed for life. Presidents Gerasimov, Ioganson, and Serov, laureates of the Stalin and State prizes many times over, were the best-known portraitists of the party leaders and eulogists of the "unprecedented achievements" of the Soviet regime; the current president, the sculptor Tomsky, carved out his career with cyclopean monuments of Comrade Stalin, which flooded the entire country in those somber years. Once this elite group had formed, there basically was no longer any need for a logical definition of socialist realism. Socialist realism in Soviet figurative art is *de facto* what the members of the Academy of Arts of the USSR are doing, and of course they, being members of the Union as well, usually occupy key positions in its leadership and thus control the entire activity of Soviet artists. But the chief function of the Academy is to educate future artists: the entire system of artistic education in the country is under its control.

The third mainstay of control is the Ministry of Culture of the USSR, established in 1953; previously its functions were carried out by the Committee on the Arts attached to the Council of Ministers of the USSR. The Ministry of Culture controls all art museums and directs all exhibitions, and through a State Purchasing Committee it is the principal allocator of state funds to artists and art organizations. Ministry bureaucrats (like members of the Academy) are permanent members of all exhibition committees, juries, and selection committees. In addition, they are leaders of the Union of Soviet Artists and are on the editorial boards of the publishing houses. Through these various affiliations, they exercise ideological control over all creative activity in the USSR.

The Union of Soviet Artists, the Academy of Arts, and the Ministry of Culture are formally independent of one another, but since

they receive their guiding instructions from the Department of Culture of the Central Committee of the CPSU (formerly Agitprop), they are *de facto* subordinated to this Department. They are closely interlinked through a system of party control and together constitute a single finely tuned mechanism for regulating the whole of the country's artistic life. All educative, creative, exhibiting, publishing, museum, and scholarly activity in the domain of art is under their control. The chart below shows the distribution among these three units of all the principal agencies and institutions in all the main spheres of artistic activity of the country.

	Central Committee of the CPSU Department of Culture		
	Union of Soviet Artists of the USSR	Ministry of Culture of the USSR	Academy of Arts of the USSR
The press:			
The periodical *Iskusstvo*	X	X	X
The periodical *Tvorchestvo*	X		
The periodical *Dekorativnoe iskusstvo SSSR*	X		
The newspaper *Sovetskaia kul'tura*		X	
Education:			
Surikov Institute, Moscow			X
Repin Institute, Leningrad			X
Institute of Decorative and Applied Art, Moscow			X
Scholarly research organizations:			
The Research Institute for the History and Theory of Fine Arts			X
The Research Institute for Art History		X	
Museums and galleries:			
The State Tretyakov Gallery, Moscow		X	
The State Pushkin Museum of Fine Arts, Moscow		X	
The State Hermitage, Leningrad		X	
The State Russian Museum, Leningrad		X	

The chart encompasses the whole of official artistic life through-
out the USSR. Each of the fifteen Soviet Socialist Republics has its
own republic Union of Soviet Artists and Ministry of Culture; these
in turn are controlled by the Department of Culture of the republic
Central Committee of the party. The regions, districts, and munici-
palities have their own sections of the Union, and the functions of
the Ministry of Culture are performed by the cultural or ideological
sections of the regional, district, and municipal party committees
and executive committees. Linked by a vertical command system
with the central party, state, and artistic organizations, they form a
gigantic multileveled pyramid of control over art.

Having studied the workings of this system from the outside, one
Westerner observed quite accurately that "In rationalizing the pro-
duction of art and placing its distribution under control, the Soviet
Union created a monster, but this monster operates with frightening
efficiency."[9] In the half century it has been functioning, a self-styled
"culture of a unique type—Soviet culture" has been created in the
Soviet Union; this culture is nested firmly in the mainstream of
socialist realism, and in the USSR has been officially proclaimed to
be "a new and higher stage in the over-all development of
mankind." It rests on principles of the relations between artist and
state, artist and society, artist and public, and producer and consum-
er which are completely different from the principles of Western or
Russian prerevolutionary culture. Within this culture, which has
developed in nearly total isolation from the rest of the world, its own
peculiar mechanisms of birth, development, and functioning began
to operate. Finally, in the context of implementing its general pro-
gram of "educating the toiling masses in the spirit of socialism," or
"forging the new man," a new type of artist was also forged, an
artist with quite specific notions about the role of art and society and
of his own status within the state.

The emigration of an artist from the USSR is primarily a flight
from this system, and his problems in the West cannot be understood
without an understanding of the situation that originally prompted
this flight. As we have seen, this situation assumed a definitive
shape in the early thirties, reached its high point in the last years of
the Stalinist regime, survived a dangerous jolt in the brief period of

Khrushchev's "Thaw," and began to stabilize in the mid-sixties, tending more and more toward classical forms without having yet attained them. It is within this broad chronological perspective that it must be understood, not only because the eldest representatives of the second wave of Russian artists into emigration received their education in the thirties and forties, but also because all later stages were but the logical continuation of those preceding; a few modifications have been introduced, but the system of art has not been altered. We will examine the workings of this system which traps the artist-in-training, beginning with its very first level, art education.

Art Education and the Academy of Arts

> True, we do not know altogether how much suffering the Academy of Arts has brought on through the oppressiveness of its canonical, dead forms, but we presume it is limitless. . . . The Academy of Arts, as history is our impartial witness, not only has not stimulated the growth of Russian artistic culture, it has acted as a crude and unrelenting brake, for the most part due to its crudely hewn traditions, the traditions of a century and a half of existence. [10]

Thus did the Petrograd Committee of the Arts under Narkompros evaluate the role of the Academy of Arts in Russian culture from the time of its founding in St. Petersburg in 1758. In the summer of 1918, a decree by the Council of People's Commissars signed by Lenin, Lunacharsky, Stalin, and Chicherin abolished the Academy "as an institution that has not justified itself historically." The declaration itself affirmed with this act the unshackling of "free creativity which had been defeated by vanguards of the empty formulas of academic canon." The principal centers of artistic education were abolished and the Free Workshops created; in 1920 these were transformed into the Higher Artistic and Technical Workshops, the VKHUTEMAS, which became the center of the Soviet revolutionary avant-garde in the twenties.

The subsequent turn of Soviet art in the opposite direction fundamentally changed this situation. In 1947 the Academy of Arts was

resurrected and restored to the status it had had during Catherine's reign: "the highest organ governing all aspects of artistic education and the artistic culture of the country." As stated in its statutes, the Academy of Arts of the USSR "was formed to contribute to the creative development of the principles of socialist realism in the practice and theory of the Soviet multinational artistic culture." Its first president (who was also chairman from 1938 to 1954 of the Union of Soviet Artists), the chief portraitist of Stalin and his "court," Alexander Gerasimov, never concealed his credo on cultural policy:

> It has always seemed to me that there are so many bad paintings that it is simply a shame that so many special depositories are filled up with them. For example, there are stacks and stacks of "paintings" by the futurists, the cubists, etc. stored in the Tretyakov Gallery. We might well ask how much does it cost the people to store these "masterpieces"? How much paper is wasted on their account? How many people are necessary to store this trash at a scientifically set temperature? One finds oneself saying "I'm afraid for mankind."[11]

These were no empty words coming from the mouth of this preeminent administrator of Soviet fine arts. The first act of the newly formed Academy was to eliminate the Moscow Museum of New Western Art, which housed one of the world's best collections of Western art from impressionism to cubism. It was the only one of its kind in the USSR, and had been compiled in the early part of this century by the Russian collectors Shchukin and Morozov. The presidents and the secretariat of the Academy occupied spacious offices in the building of this museum on Kropotkin Street in Moscow (formerly Shchukin's private residence); its main rooms were set aside for the members' regular exhibitions. And with this truly symbolic act, "the empty formulas of academic canon," which was what socialist realism had become, took their ultimate revenge over the notion of unshackled creativity.

Once the Academy of Arts of the USSR was created, there was no longer any necessity for theoretical deliberations, formulations, or definitions of the nature and principles of socialist realism: the

standard and the archetype of Soviet official art was now and hence-forth would be what the members of the Academy were producing. It was from this that all the members of the Union were guided in their works, while future cadres of Soviet artists learned the technology of that production in all the art institutions of the country, all of which without exception were now subordinated to a single center.

Like the system of general education, artistic education in the USSR is divided into three principal levels: higher (art institutes), secondary (art training schools), and lower (art schools). The two chief institutions of higher education in the country—the V. I. Surikov Art Institute in Moscow and the Repin Institute of Painting, Sculpture, and Architecture in Leningrad—are an integral part of the Academy of Arts of the USSR. Through the Surikov Institute the Academy exercises methodological (and ideological) leadership over the Moscow Regional Art Training School (named in honor of the 1905 revolution), the principal center for secondary art education, and similar schools in different cities throughout the Soviet Union. The same Institute formally supervises instruction in the Moscow Art School. This formal administrative subordination is reinforced by actual instruction at all levels of the unified structure. Members of the Academy of Arts of the USSR are appointed to the principal departments and artists' workshops in the Surikov and Repin institutes. Usually, instructors of these institutions occupy key teaching positions in the secondary art schools, and their graduates are assigned teaching posts in lower-level art schools. This constitutes a smoothly functioning mechanism for the production of Soviet artists all molded on the same pattern, "as in a factory."

A child of thirteen or fourteen years who enters art school must pass an examination in drawing and composition from life. Then the same subjects, in more complicated form, are studied by the student for three to four years of elementary instruction, and then at a secondary art school or institute. This roughly is the way instruction took place in European academies one and two hundred years ago, where students were taught the basics of their craft to give form to an established canon. If the student shows any superfluous elements of fantasy and imagination in his interpretation of a model, diverging from it in search of "pure" formal relationships, for example,

he must pay a price: either he is given a failing grade on his examinations or otherwise screened out in the education process, or efforts are made to correct his aberrations by prolonged training and coaching on specimens of Soviet academicism and Russian nineteenth-century realism, exemplified by the works of Repin and Surikov, for whom the two leading art institutes of the country are named.

Despite all the shortcomings of this system, it must be acknowledged that it does give a future artist a rather good basic professional skill. The level of its graduates' academic drawings is usually quite high. But this is not enough to create the highly ideological works of socialist realism. The socialist realist artist does not simply copy from life. He must "faithfully reflect reality in its revolutionary development," i.e., distinguish in it the progressive from the reactionary, the typical from the nontypical, that which examples the very essence of Soviet life from the vestiges or blemishes of capitalism which still exist in it. Put briefly, he must see reality through the eyes of the official ideology and reflect only those aspects of it which at the particular moment have been pronounced typical and progressive. A considerable portion of the curricula of all art institutions in the Soviet Union, from the lowest to the highest, serves the goal of educating the future artist in the spirit of this ideology and instilling in him this vision of reality.

As in all the country's educational institutions, a certain portion of the curriculum consists of general educational subjects that are mandatory for all. These are the history of the CPSU, the history of the USSR, political economy, and the philosophical disciplines, historical and dialectical materialism (a number of unsuccessful attempts have been made to introduce scientific atheism as a mandatory subject as well). In the final examinations for graduation from an institution of art education, the grade on the Fundamentals of Marxism-Leninism (which is itself a potpourri of all the above subjects) is perhaps even more important for the artist's further career than his grade on the examination in his specialty. All this is intended to educate the student in the same spirit in which later he himself, as a socialist realist artist, will educate the toiling masses through his works.

The history of art, taught at all stages of formal schooling, occupies a special place in this educational process. Its foundations are laid early in art school, and in the institutes it is methodically developed, as described in the trenchant student expression "from the bison to the Barbizon"—that is, from the very first cliff drawings to the French Barbizon school of landscape painting. The purpose of this subject is to acquaint the future socialist realist artist with the culture of the world of which he is the lawful heir and successor, although of course in the new and higher socialist realist stage; indeed, all of the artistic activity of mankind is fashioned in consonance with this aim. The driving force of this history is the unceasing struggle between realism and antirealism, i.e., between progressive and reactionary tendencies. Thus, at the very dawn of humanity, in the paleolithic cave drawings, a realistic approach to representational art is manifest; however, a decline in artistic skill set in during the neolithic age. The Egyptian masters of the Old Kingdom strove for maximum verisimilitude in portraits, but during the Tel El Amarna period they slid into reactionary decadence and stylization. Progressive antique classicism was followed by decadent Hellenism, followed by the impenetrable darkness and ignorance of the Middle Ages (the Gothic, Russian icons, etc.). The democratic aspirations of the minor Dutch painters contended with the antidemocratism of the Baroque; Rembrandt's interest in the lives of simple people forced its way through the layers of his religious prejudices. Realism carried the final victory in the second half of the nineteenth century, reaching its zenith in the works of the Russian "Peredvizhniki" (Wanderers).[12] "I have seen European museums many times over," Gerasimov once mused, "and I can honestly say, without any crass patriotism, that such masters as Repin and Surikov were not to be found, and indeed hardly anywhere could one find anything even comparable with [their masterpieces] *Religious Procession in Kursk Province* or *Boyarina Morozova*."[13]

The most striking aspect of this course in art history is its chronological limits: only "to the Barbizon." All that has taken place in the artistic culture of the world since the rise of realism in the nineteenth century, in effect the entire twentieth century from

cubism onwards, is defined as an art of "decline," "decay," "putrefaction and decomposition," as the expression of an "imperialist" even "fascist" ideology alien to us, as something not only unnecessary, but even harmful to the education of the student, something that might lead him into temptation and defile the purity of his perspective on the world. In the Stalinist years, impressionism, the works of Cézanne, Van Gogh, and Gauguin, the "Mir iskusstva" (World of Art) group, and so forth also belonged to this category. "I don't think the history of American art would lose anything if it did not contain an analysis of such modern artists as Mark Tobey, Arshile Gorky, Robert Motherwell, Mark Rothko, Willem de Kooning, and so forth," observed Professor A.D. Chegodaev in his basic history of art in the United States,[13] in which he himself consistently adheres to this principle. In the same way, instruction in the history of Soviet art gets along without the names of Kandinsky, Chagall, Malevich, Tatlin, Filonov, and Lissitzky, and Western European art gets along without Picasso (except in his earliest pre-Cubist period), Braque, Ernst, Dali, and Dubuffet, not to speak of others closer to our day. In short, the Soviet artist spends his entire formal education in the artificial atmosphere of the problems and ideas of the past century; he is wholly and completely cut off from the real process of art. As a consequence, if somewhere in semi-official circles (more about this later on) he should happen upon contemporary works, it is fully conceivable that he might take the systems of Kandinsky or Pollock for the last word in art and, following in their footsteps, begin to invent a wooden bicycle. These artists are safely excluded from the curriculum of Soviet schools of art, for the whole system of academic education in the USSR is constructed so as not to permit contacts between the student and the real problems of contemporary artistic life.

With the restoration of the Academy of Arts were resurrected (resuscitated is more accurate) not only the old notion of a realistic reflection of reality, but also the hierarchy of art genres that marked both the system of academic education and the structure of artistic life in old Russia and elsewhere. Just as, in the eighteenth century, the academic view considered the historical (or mythological) composition and the full-face portrait to be the most important genres,

so did Soviet aesthetics extol "the thematic painting." Thematic painting was the high road of socialist realism. First there are the ostentatious portraits of party and state leaders: Lenin, Stalin, Khrushchev, and Brezhnev on tribunes, at meetings with workers, looking over maps of military operations or standing in the front-line trenches, in national parades, with gigantic new constructions in the background, in symbolic daybreaks. . . . Second, there are the epic canvases of the heroic struggle for the establishment of Soviet power and the national propensity under its aegis. The leading laureates of the Soviet Union are masters of this genre; they make up the core of Academy members, and the lion's share of state art funds, prizes, awards, and laureate badges goes to the development of this genre. Next in order of importance after the thematic painting is the portrait, especially of the bosom companions of the Leader and the best representatives of the Soviet people: distinguished steel workers, collective farm workers, writers, actors, generals, etc. Then comes the landscape, the scenes of everyday life genre, and the still lifes. That is how the history of Soviet art is written and taught to students—not as the encounter between different ideas, currents, creative methods and conceptions in art, but as the development of specific genres in painting, sculpture, or graphics.

True, this generic schematization is not fixed in the actual structure of academic education. Students in the art schools and colleges do not learn in genre classes, as at the old academies, but study under the categories and types of art—the departments of painting, sculpture, graphics, monumental or applied art, etc. In this the Soviet Academy does indeed differ from the Tsarist Academy, owing to a different ideological attitude toward the social function of art as a whole and the role of each particular genre in it. After all, the genres of Soviet art do not exist for themselves. Together they must compose a single ideological whole, coalescing into a single magnificent and heroic picture of the epoch, in which each descriptive element serves merely as background, but part of a general joyous hymn, to the greatness of the Soviet era. Hence, under the brush or chisel of the Soviet socialist realist artist, a commonplace genre scene acquires the bombastic name "They Saw Stalin" or

"Our Happy Childhood." A portrait of a particular individual assumes the features of a general type and becomes "A Foundry Worker," "The Woman Delegate," "The Komsomol Girl." A corner of a landscape becomes "The Expanses of Our Fatherland," or a place where "Soviet Transport Is Repaired." A still life becomes "The Fruits of Collective Farm Abundance," etc. (These are actually the names of some of the best-known socialist realist canvases.) When he finishes the art institute, a student does a painting to earn his diploma (or a sculpture or a graphic series), gives it a name of similar tone, and presents it for examination to an academic committee. How the work will be evaluated depends not only on the level of its execution, but also on the timeliness of its "ideological content," on how closely it corresponds to the aesthetic and ideological standards of the particular moment and fits into the general picture of "a faithful reflection of reality." The subsequent fate of the Soviet artist, and his professional career, depend in many respects on this evaluation.

The Path to Creativity

Having obtained his diploma from one of the institutions of the USSR Academy of Arts, the former student embarks upon his professional career. The opportunities open to him depend very little on his creative potential; often the opposite is true.

The most "controllable" students, having absorbed from their education not only the technique, but also the ideology of socialist realism, and having secured the requisite party testimonials and recommendations, remain in the art workshops of their institutes, i.e., they continue their studies in a kind of postgraduate course of the arts. These are the future leading cadres of official art who will carry on the work of their teachers. Some of them who have shown their worth not only creatively, but also ideologically, are sent to teach in art schools, while others are given jobs in general secondary schools where drawing is the least important of school disciplines. The job of school teacher provides the artist not so much with the means of livelihood (the wages are quite miserable) as with the

official status of a Soviet civil servant, which exempts him from the watchful eye of organizations outside the domain of art, such as the police.

However, the vast majority of young artists in the USSR do not have this status. For them there is but one possibility: they must try independently to keep their head above water in the precarious waves of "free enterprise," the limits of which are quite narrow in the Soviet Union. Illustrators and graphic artists have the most opportunities. There is a vast number of educational publishers in the country, specializing in such educational areas as ideology, science and technology, that require designers; in the past two decades, graphic design (labels, trade marks, etc.) has grown along with this specialty. The percentage of illustrated art books published in the USSR is far greater than in the Western countries, not because there is a special demand for illustrations among Soviet readers, but because those in the profession must have a little money to live on. Some graphic artists obtain permanent work, but most operate on a contractual basis. To keep a watchful eye on this sector of the profession that is not in the service of the state, the Moscow Soviet has its Municipal Committee of Graphic Artists, which is something akin to a trade union. If a member can prove that the number of orders he receives is enough for a minimal livelihood, he is granted something like an official status. Essentially, that is all the Municipal Committee of Graphic Artists has to do for its members.

The situation of young artists and sculptors is even more ill-defined. Most of them muddle through somehow with off-hand commissions, e.g., to do the staging and decor for revolutionary festivities, paint the portraits of leaders, make banners and posters, work on film publicity, etc. For them creative work bears no relation to their incomes or subsistence. The young artist cannot sell his works to the state because he cannot compete with the venerable members of the Union of Soviet Artists. Nor can he sell them to private individuals, for two reasons: first, private commerce (including the sale of one's own works or wares) is forbidden by law in the USSR, and second, there is no commercial demand among the artist's potential clientele for the socialist realist art he learned to

produce at the Academy. To interest an illegal buyer in his works he would have to abandon socialist realism and obey the promptings of his own creative intuition (if he has one) or follow Western examples. But this means embarking upon the slippery path of the "unofficial" artist (more about this further on), which sooner or later would attract the attention of the guardians of ideology and thus hang the sword of Damocles over his head. This might take the form of a sudden knock at his apartment door by some policeman growling "Why are you not working and on what are you living?" and a conferring of the threatened status of parasite.

Under such conditions the only practical aspiration is to attain the standards required for acceptance into the Union of Soviet Artists. In exchange for conforming to Union standards, the artist obtains the material benefits due him and the possibility of plying his trade. The Union of Soviet Artists is eager to accommodate such aspirations. Hence, within its municipal divisions there are youth sections (or committees) that work with artists who are just beginning their careers, including those who have not yet become members of the Union of Soviet Artists. These youth sections help young artists to obtain the needed materials not freely available on the market, and sometimes (on rare occasions) advance them funds, arrange creative educational trips, and provide passes to the "houses of creativity" where they receive room and board, in a quiet, fashionable resort setting, to work. But their chief function is to arrange annual official exhibitions of young artists' work in Moscow, Leningrad, and other cities.

Against the background of the dismal semi-official humdrum of Soviet artistic life, the youth exhibitions are always an event, and sometimes even a sensation. In addition to the young members of the Union of Soviet Artists, the participants also include artists who have not yet become members. The criteria of selection, made by juries of the youth sections, are relatively liberal; departures from realism are written off to creative immaturity. Indeed, at these exhibitions one may see sparks of talent not yet crushed by academic education, and the daring of quests not yet wasted forever by routine work on official orders.

It is extremely important for artists to exhibit at these events because participation in official exhibitions is the primary condition of membership in the Union of Soviet Artists. But this does not mean that it will be the most brilliant and most talented participants who become the lucky holders of a Union membership card. Across the artist's path to official recognition lie the layer upon layer of filters of the Soviet ideology of art.

To apply for membership in this organization, there is a second condition which must be fulfilled: the artist must obtain the recommendations of two members of the Union of Soviet Artists. This usually is not difficult; among the many thousands of members, you can always find a few who consider themselves to be your comrades. However, any further progress is like a steeplechase in which, the closer you are to the finish, the higher are the hurdles you must overcome. The youthful candidate's application must make its way through several levels. First it is reviewed by the office of the pertinent section (painting, graphics, sculpture, monuments, etc.) of the municipal division of the Union of Soviet Artists. Then the office's decision, if it is positive, is ratified (or reversed) by its board of directors. Finally the decision of the board of directors of the municipal division receives an official stamp of approval of higher (republic and All-Union) levels, where the same academic laureates and party bureaucrats, often having nothing to do with art whatsoever, decide everything. The criteria of ideological selection become more and more stringent the further one moves up the rungs of this hierarchical ladder, and the more talented the artist and the bolder he is in his quests, the more difficult it will be for him to force his way through the rigid parameters of the ideologically determined aesthetic standards. But most do enter this unworthy race, striking a bargain with their own conscience, "with their song stuck in their throats" (Mayakovsky), trying to come up with something especially dull and run-of-the-mill for the various juries and committees, and putting off until some time in the future the day when they will see the fruits of their own ideas. Where an absolute monopoly exists over all the means and forms of artistic life, there is only one way to become (in the Soviet sense of the word) an artist: to become a member of the Union of Soviet Artists.

The Union of Soviet Artists
and Professional Activity

The Union of Soviet Artists was founded, as we have mentioned, in 1933, soon after the resolution of the Central Committee of the Communist Party (Bolsheviks) of April 23, 1932, which eliminated all previously existing art associations, trends, groups, and what have you, and along with them the last vestiges of creative freedom in the country. Initially the Union was not the monolith it is today. It consisted, first of all, of a number of municipal, regional, and republic organizations which formally were not subordinate to a single administrative center. Second, it was created under the banner of unifying the various forces and tendencies in Soviet art, and hence its leadership at that time included, in addition to the zealous adepts of socialist realism, representatives of left-wing currents as well. Malevich, Tatlin, Shternberg, and other former representatives of the avant-garde were members of the Union.

But this diversity in its composition and leadership soon waned. In 1939 the Organizational Committee of the Union of Soviet Artists was created by Aleksandr Gerasimov, with the purpose of bringing all the local sections of the Union under its control. The war put the brakes on this process, and it was not until 1957 that the Union of Soviet Artists became the Union of Soviet Artists of the USSR, its hierarchical pyramid topped off with a supreme body, the All-Union Administration of the Union of Soviet Artists, which controlled all the municipal, regional, and republic sections. The first Congress of Soviet Artists convened in February–March of that same year. But this was also the year of Gerasimov's fall.

The Union of Soviet Artists, like other artists' associations in the USSR (the unions of writers, composers, and cinematographers), is a powerful organization. It has no parallels with artists' unions and associations in democratic (as opposed to totalitarian) countries when it comes to the functions it performs and the material assets given it by the government.[15] In contrast to many of the clichés of Soviet propaganda, this statement emanating from the ideological section of the Central Committee of the CPSU does contain a grain of truth:

> The situation of the Soviet art worker in socialist society, and the opportunities open in our country to artists' associations, have no equal anywhere in the world. Vast material assets are available to them. . . .[16]

Officially, the Union of Soviet Artists is an art organization dedicated to assisting and promoting the creative development of its members. Of course, creative development is understood wholly within the context of socialist realism, however it is conceived (which depends on the historical stage of development). Hence the creative function of the Union is inseparably linked with its ideological function.

> The unions organize their activities to help the artist find his place in the struggle for communism. . . . The success of this work will depend on how efficiently the unions have organized the education of artists and artisans in the noteworthy traditions and achievements of Soviet literature and art to achieve a profound understanding of the class nature of socialist culture and of its irreconcilability with any distortions in its nature, a sense of struggle against attempts to nurture a noncritical attitude toward avantgarde currents in art and the formalist trends of the twenties which have long marked the course of Soviet art.[17]

In service of these tasks, the Union must descend to the lowlands of commerce so scorned by the ideologists, and perform economic functions as well. This role is fulfilled by the Art Fund of the Union of Soviet Artists of the USSR. While the Union is headed by ideologues, laureates, and party functionaries, the Fund is run by people who can only be compared to the slick operators of a "big business," for the Art Fund is a giant fodder bin. It feeds all the 15,000 members of the Union and an even greater number, all told, of individuals and organizations serving them. It provides artists with the tools and materials necessary for their work, gives them cash advances, pays for trips of artistic purpose, and maintains the "houses of creativity," the art salons, the exhibition halls, the special shops, hospitals, workshops, etc. belonging to the Union of Soviet Artists.

What is the source of the means to support such an ambitious

enterprise? A certain digression might be useful here. Anyone who has ever traveled among the cities and towns of the Soviet Union, strolled along their streets and squares, or visited various Soviet institutions, will surely have noted some of the unique and specific features of all this entourage, to which the Western eye is unaccustomed. In the office of any official one finds sculptured busts, painted portraits or reproductions (depending on the importance of the particular figure) of Marx, Engels, Lenin, Dzerzhinsky, and Brezhnev. In the vestibule of any state institution, school, hospital, hotel, production enterprise, etc., the visitor sees the same busts and the same paintings, depicting the heroic struggles for socialism and the national flowering it brought; in the parks and squares he inevitably encounters monuments to the founders of Marxism, the leaders of the revolution and the state, the heroes of labor and of the war. And if this guest were fortunate enough to be present at one of the holidays of the revolution in any inhabited place in the USSR, he would be literally swept off his feet by the flood of products of figurative art: the portraits of the members of the whole of the Politburo staring down from the main administrative buildings, and artistically designed stands, posters, canvases, and banners at every step depicting the great achievements made by the country, the republic, the region, or the district in the period just past. The budget of every municipal committee, rural soviet, factory, school, and ministry includes funds allocated by the government for the acquisition of such objects of artistic propaganda. Only a negligible portion of this output consists of original works of Soviet artists; most are copies from the most renowned masterpieces of the laureates of socialist realism. The Art Fund of the Union of Soviet Artists of the USSR produces all this material in its principal workshops for painting, sculpture, graphics, and decorative-monumental art. Busts of the great leaders are produced in gypsum or bronze in runs of millions, monuments are cast, posters and graphics are printed, movie theaters, clubs, revolutionary festivities, sports stadiums are designed, etc. The Art Fund also has a network of salons and stores for the sale of original works by Soviet artists. Since this output is not matched by demand from private citizens, it is intended basically for these self-same state institutions and organizations. Through its export section the Art Fund sells this output to foreign

countries to obtain hard currency, some of which is used to pay for travel abroad by top members of the Union; for them, trips to the West are virtually the highest form of social privilege.

Thus the Union of Soviet Artists, through its Art Fund, exercises the state's monopoly on the mass production and mass sale of works of art. It alone does what in democratic countries is the business of hundreds of thousands of independent galleries, firms, and salons. The money received through this monopoly is the "solid material base" which the Artists' Union has at its command. The ideological superstructure of the Union of Soviet Artists, i.e., the actual creative activity of its members, rests on this material base, although it is not dependent on it. The Soviet artist receives most of his means of livelihood from another source: the system of state orders.

The life's blood of Soviet art is official exhibits, the vast majority of which are thematic in nature: the Fifth, Tenth, Twentieth, Fiftieth, or Seventieth Anniversary of the Red Army, the Soviet State, the Bolshevik or the Communist Party, the Lenin Komsomol, or the Soviet Police; the birth or death of Lenin, Stalin, or Pushkin; "Socialist Industry," "The Great Construction Projects," "Glory to Labor," "The Homeland," "Soviet Space," etc. etc. All this requires heroic trappings and provides the themes and the names for the numerous exhibits organized each year in the USSR at the national, republic, and regional levels. The organization of such exhibitions is the principal task of the Union of Soviet Artists, while for its members it is the principal means for snatching a piece of the state. To this end, all the local branches of the Union have exhibition committees whose job it is to distribute orders for thematic paintings among their members. With each order an artist receives upfront money (nonreturnable) amounting to 25 percent of the sum of the order, and can claim another 35 percent when the work has reached a certain stage of completion. The recipients of these orders will depart on a work holiday at the Union's expense to Lenin memorial sites, the fields of great battles or great construction projects, the fishing collectives in the north or the fruit-growing state farms in the south, where they receive creative inspiration and gather visual impressions in direct contact with the toiling masses. On their return, many of them fill the Union's "houses of creativity," where they complete the works they have begun. The finished work is presented to the Exhibition Committee, which

judges it in terms of its fulfillment of the stipulations of the order and pays the rest of the sum agreed upon. The artist may rest assured: only departures from the specified theme or from the stylistic standards of socialist realism in force at the particular moment will prevent him from receiving the money due. A joke making the rounds of Moscow, very close to the truth, illustrates this procedure quite well.

It was 1964. The launching of the next Soviet sputnik into orbit was awaited, and the Moscow section of the Union of Soviet Artists was feverishly preparing an exhibit on the theme "Khrushchev Meets the Soviet Cosmonauts." Orders were sent out, advances were paid, and trips were organized. But while the cosmonauts were spinning about in airless space, back on earth Khrushchev was deposed, and the space heroes were received by a completely different person. The members of the Moscow section of the Union of Soviet Artists flocked through the doors of the Exhibition Committee with their finished work to receive the rest of their stipulated fees: ideology or no ideology, a completed order demands its rightful rewards. But one of the members, evidently remembering the old days when it was dangerous to portray the countenance of a deposed leader, hastily redid his painting: he placed the head of the new leader on Khrushchev's body, and then proudly presented his work for review. "Where's Khrushchev?" asked the Committee. ". . . But . . ." "The painting doesn't conform to the order" was the Committee's decision. "No money."

As this sad tale shows, independence is the last thing that is encouraged, even when it leans in the direction of loyalty, let alone its abandonment to arbitrary thematic or stylistic adventures.

The entire output of the Union of Soviet Artists, thousands upon thousands of works, is presented to the spectator, mounted on pedestals or stretched on frames, at a number of thematic exhibitions. The annual All-Union exhibitions bring together the results of all this activity in the largest exhibition hall of the country, the Moscow Manège, where the latest and prime achievements of Soviet art over the past period are solemnly presented to view.

But where does this artistic output of the Union end up? Who in the USSR is the real consumer of art, and what is its function in the Soviet society? To answer these questions we must know something about the activity of the Ministry of Culture of the USSR.

The Ministry of Culture of the USSR
and the Cultural Vacuum

From its origins in the bureaucratic bowels of the Union of Soviet
Artists, passing through the filters of official exhibitions, the im-
mense annual output of Soviet art works, numbering in the tens of
thousands, flows continuously into the reservoirs of the Ministry of
Culture. Through its State Purchasing Committee the Ministry of
Culture acquires works of art for all the art museums of the country
and for its own holdings. Usually the works of Soviet artists ordered
by the exhibition committees of the different sections of the Union
of Soviet Artists and presented at thematic and All-Union exhibi-
tions are automatically acquired by the State Purchasing Commit-
tee. By means of this simple operation, money is pumped from the
state coffers into the funds of the Union of Soviet Artists, and the
works of art become the property of the state in the person of its
Ministry of Culture or, more accurately, the Board of Art Exhibi-
tions and Panoramas attached to the Ministry.

The Board of Art Exhibitions and Panoramas of the Ministry of
Culture of the USSR is responsible for organizing all art exhibitions
within the USSR and abroad. It packs and ships, decorates exhibi-
tion halls, etc. It also has huge warehouses where meter upon meter
of painted canvases and thousands of tons of marbles and bronzes
created by Soviet artists are sent after purchase to be stored. Some
of them are transferred to the holdings of museums of Soviet art in
the hinterlands, and some are chosen for the numerous traveling
exhibits making the rounds of cities, villages, and military bases
throughout the country each year. Every so often, some of the
especially ideologically harmful works (for example portraits of
Stalin, Beria, or other leaders fallen into disfavor, or the works of
the most hateful recent emigrants) will be written off and destroyed
(from special lists). Or, conversely, sometimes someone who had
been considered aesthetically inadmissible will float up into the light
of day from the old inventories. But the bulk finds eternal peace in
this huge sepulchre of Soviet art.

Thus, in the Soviet Union, between the producer (the artist) and
the consumer (the viewer) stands the state. It is essentially the sole
customer and purchaser of art work, as well as its chief arbiter and

merchant. Soviet art "belongs to the people" and is not geared for individual consumption. It may be looked at but not owned. A Soviet citizen cannot, for example, purchase a masterpiece of his choosing from any of the official exhibitions of Soviet art, although it is possible to buy graphic art at an official salon. This is not merely because Soviet wages are so paltry when compared with the prices on the paintings; there is simply no one who would be eccentric enough to lay out his money for such universally deplorable works of socialist realism. It is said that even the highest ranking party officials prefer to decorate the walls of their private houses and dachas with something more modern, even unofficial.

The entire activity of the megamachinery of official Soviet culture derives from a conception of the special function of art in socialist society. In the first decade after the revolution this function was directly and candidly defined in the very epithet given to this type of activity: "The art of Soviet agitprop." Later it incorporated the official definition of socialist realism: "Education of the toilers in the spirit of socialism." Essentially nothing has changed. Even today, the chief function of Soviet art remains that of depicting for the toiling masses in artistic images the great achievements of the party and the Soviet state, propagandizing for these achievements, and in this way "educating the masses in the spirit of. . . ." The state plans and carries out these functions through its Ministry of Culture.

The Ministry of Culture of the USSR is a wide-ranging institution, multileveled in both its activities and its organizational structure. In addition to the fine arts, it has a multitude of other concerns as well: the theater, the cinema, museums, foreign connections, etc. It is the supreme organ for carrying official ideology into all spheres of artistic life and for seeing that that ideology is observed. The Ministry of Culture, in close cooperation with the ideological sections of the Central Committee of the CPSU and the leadership of the Academy of Arts and the Union of Soviet Artists, draws up annual plans for thematic exhibitions and makes decisions about what Soviet citizens should see at the particular moment and what they will be forbidden to see. Through its foreign section it approves the organization of exhibitions of foreign art in the USSR and of

Soviet art abroad. Its representatives often have a decisive voice on the editorial boards of art journals, in the editorial councils of art publishing houses in the discussion of publishing plans, in various art councils and exhibition committees, in the academic councils of museums when museum exhibits are discussed, etc. Essentially it has total control over all the art information received by Soviet citizens.

For a quarter of a century (the early thirties through 1956) this institution, which until 1953 took the form of the Committee on the Arts of the Council of Ministers of the USSR, did not arrange a single exhibit or publish a single book on contemporary Western art or the art of the Russian avant-garde. The exhibits of the Tretyakov Gallery, the Leningrad Hermitage, the Moscow Museum of Fine Arts, and all the other art museums in the country stopped somewhere in the 1880s. During the period of the "struggle against cosmopolitanism," the Museum of Modern Western Art in Moscow was abolished under its sanction, and in 1949 the Museum of Fine Arts, housing the only collection of classical foreign art in the capital, was converted into a permanent exhibition of gifts to Comrade Stalin.[18]

The net effect of all this was to create a thorough cultural vacuum in the country. A deep dissatisfaction with the cultural bric-a-brac of socialist realism, and a nostalgia for world culture, developed among many people, demanding an outlet. This cultural vacuum had engendered the most fantastic notions about art, its language, and its role in the life of man and society. At the same time it had nurtured an unusually sensitive, receptive audience that reacted with keen interest to any artistic phenomenon that diverged from official standards.

The period from 1955 to 1962 was unique in the history of the Soviet state because of the intensity of its cultural ties with other countries. Large foreign exhibits were arranged in Moscow and Leningrad for the first time in several decades: contemporary English, French, Belgian, and American art, the works of Picasso, Barlach, Guttuso, Léger, Käthe Kollwitz, etc. In the whole history of exhibitions throughout the world, it would be difficult to find anything similar in terms of the interest and stir that these exhibitions provoked among the Soviet audience. In the summer of 1955,

mile-long lines extended up to the entrance of the Moscow Museum of Fine Arts, where the "Treasures of the Dresden Gallery" were being exhibited; people stood in line for days, taking turns at night, for the entire three months of its running. The crowds that burst into the Picasso exhibit had to be restrained by mounted police, and the discussions reached such a point of acerbity that in Leningrad some of the most vociferous of the crowd were arrested. This contact with twentieth-century art literally caused a cultural explosion and a revolution in consciousness, not only of the spectators, but also of the country's artists.

The cultural vacuum created an audience, and the audience created an atmosphere beneficial to the emergence of artistic nonconformity. As soon as the pressure of state control was eased, the first shoots of a new art began, determined to replace the sterile art of official ideology. Such is one of the mechanisms of artistic life in totalitarian countries. Thus, in the mid-fifties a phenomenon emerged in the Soviet Union which later came to be known as "Soviet unofficial art."

"Unofficial Art" in the USSR

In the Stalinist period no such thing as unofficial art existed in the Soviet Union. True, some veterans of the avant-garde of the twenties who had not emigrated (Malevich, Tatlin, Lissitzky, Rodchenko, and others) were still working, even though they had not as yet declared their faith in the new art ideology. However, what they did create in those days did not leave the walls of their workshops, and went no further than the narrow circle of friends; it therefore never assumed the character of a social or public aesthetic phenomenon.

The development of unofficial art was a spontaneous process, occurring in a brief interlude of confusion when the Soviet art leadership, implicated in Stalin's crimes and fearing possible reprisals, eased somewhat the reins of control. In this brief period (roughly from 1956 to 1962), artists began intensely to create, and the public, just as intensely to consume anything that differed to any degree from the aesthetic standards imposed by the state.

There were two main sources for the opposition. In the mid-fifties, a "left wing" arose among a group of young artists in the

official Union of Soviet Artists, many of whom had entered the art schools fresh from the front, severely wounded and with battle ribbons on their breasts. Without coming out against the principles of socialist realism, they endeavored to broaden its understanding of "life's truth" and to master a whole set of modern artistic devices to give expression to that truth. They still painted portraits and landscapes, scenes of work and war, and built monuments to the dead, but instead of doing all this in the pompous style of a trite and formal realism, they endeavored to depict life in its dramatic, and sometimes even tragic, conflicts. Also in the 1950s, a creative association was formed within the Moscow section of the Union of Soviet Artists (the first one since the twenties!), called the "Group of Eight." United only by their personal relations, these artists had but one aim: the organization of joint exhibitions. New names began to appear more and more frequently in official exhibitions, squeezing aside some of the venerable academicians, and evoking an ecstatic response among the public; they began to figure in the pages of the Soviet press as the most talented representatives of the young generation of artists.

All this aroused anxiety among the orthodox upholders of Stalinist socialist realism. To stem the danger, in December 1962 they brought Nikita Khrushchev to the exhibition of the "Thirtieth Anniversary of the Moscow Branch of the Union of Soviet Artists" in the Moscow Manège.

The President of the USSR Academy of Arts at the time, Serov, gave his explanations. His aim was to show the head of state what ideological liberalization had led to, how the sacred principles of socialist realism were being besmirched in the work of young painters, and how the country's money was being spent on pernicious daubings. His comments hit home: Khrushchev, who understood nothing about art, saw only pornography and charlatanism in the efforts of the young painters. There began a long period of criticism of the liberal creative intelligentsia.

But the days of Stalin were past and the old methods were no longer operative. After a hysterical campaign in the press there came an unexpected lull. Within the bowels of the state apparatus, however, the mechanisms of the cultural megamachine were silently

set in motion. Slowly and systematically, without any unnecessary noise or bloodshed, by means of hushed commands, administrative decrees, secret instructions and telephone calls, it methodically embarked on a restaffing of artistic institutions. Liberal editors and the members of various juries, councils, and boards were quietly moved to less responsible posts and replaced by old ideologues, dragged out of temporary oblivion. By the end of the sixties, opposition within the Union of Soviet Artists had been almost totally repressed as a result of this reshuffling: some artists were forced to make compromises but the most talented of them (including Sidur, Neizvestny, Weisberg) joined the ranks of unofficial artists.

Another (and the most important) source of this opposition were those artists who from the very start had renounced the dogmas of official ideology. The eldest among them were artists following individual paths who had arrived at a nonconformist position for many different reasons—through the experience of the Soviet labor camps (like Boris Sveshnikov or Lev Kropivnitsky) or because of the influence of their teachers or the specific circumstances of their lives (Oscar Rabin and Vladimir Nemukhin). But the majority of them were still young students (Zverev, Dmitri Plavinskii, Mikhail Chemiakin, Oleg Tselkov, and others). Many of them paid for their nonconformism with expulsion from their art schools or institutes.

The stimulus for this movement of unofficial art was the Sixth World Festival of Youth and Students held in Moscow in the summer of 1957. Three two-storey pavilions in the Sokolniki Park of Culture housed an enormous exhibition of over 4,500 works by young artists of fifty-two countries. For the first time in a quarter of a century Russian artists saw the living art of the twentieth century, inhaled the vital atmosphere of its quests and innovations. It was here that many of them discovered for the first time each other's existence. It was here that hopes were born which were destined not to be fulfilled, but it was here also that contacts were first made that would later develop. As a result of these contacts, in the late fifties, joint unofficial exhibitions began to be organized, first in Moscow, and then in Leningrad and other cities. They were opened semi-legally in student and workers' clubs, engineering institutes, and private

apartments. They were the only channel for links between the artist and the public. Through them, information about unofficial art in the USSR began to leak abroad. The news was sparse, the openings were short-lived (since as a rule the authorities closed these exhibitions as soon as they were opened), and the participants were reviled in the Soviet press, which called them parasites and lackeys of bourgeois ideology. Yet, all this created the illusion of an unofficial artistic life and raised hopes for the future.

In the mid-sixties (after Khrushchev's visit to the Manège), the unofficial artists were placed under strict prohibition; every mention of them disappeared from the Soviet press, as if their art was tacitly declared not to exist. For the artist, this was tantamount to creative death.

In this situation there remained but one thing for the artists to do: openly proclaim their existence even under the threat of arrest. On September 15, 1974, a group of artists marched out onto a vacant lot in Moscow to show their works. This first free open-air exhibition was wrecked by the authorities with bulldozers and firehoses. Plainclothes policemen burned paintings on the spot, and some of the people present, including foreign correspondents, were physically attacked. This exhibition, however, was a turning point in the development of Soviet unofficial art. Because of the bulldozers the artists' opposition movement in the USSR became a focus of attention of the Western press; encouraged by this support, the participants resolved to continue their struggle for the right to exhibit their works.

Astonishingly, the authorities decided to backtrack and made a compromise. For four hours, in the summer of 1975 in Izmailov Park in Moscow, a huge flood of people visited the first permitted exhibition of unofficial artists. This exhibition was followed by several others in Moscow and Leningrad. What is more, in 1976 the Moscow Municipal Committee of Graphic Artists organized a "painting section," a buffer of sorts between the Union of Soviet Artists and the stream of uncontrolled art, and nonconformist artists began to be accepted into this organization. They were occasionally granted the opportunity to show their works under what by Soviet standards was quite limited censorship, with the proviso that the mass media would make no mention of their activity. That is how the

authorities thought to control creativity. At the same time, the pressure on the most active members of the movement was stepped up and many of them were forced to leave the country under direct threat of repression. In many respects these events determined the situation of Soviet art today.

The stylistic development of unofficial art over the twenty-five years of its existence can be divided into three main stages.

If we take the intrinsic content of the phenomenon, rather than the practical aspirations of the nonconformist artists, the driving force in the first stage of its development was opposition to official socialist realism. In the works of the founders of this movement, reality was interpreted in the forms of reality itself, but the nature of this interpretation differed from, and even opposed, the official interpretation. Instead of the glorious facade of socialist society, the artists depicted its seamy side, those nooks and crannies of everyday life hidden from the eyes of the uninitiated; in place of the official injunction to extol the material beauty of the world, they tried to burrow into the spiritual—the aesthetic, the ethical, and the religious—essence of life. Thus, in the works of the older generation of artists, figurative stylistic elements tended to dominate: surrealism, expressionism, and fantastic realism, as well as other contemporary currents from both Russia and the West.

The second stage (the sixties) was marked by a broadening of the stylistic range of art and an accelerated development. Artists discovered the values of the Soviet avant-garde of the twenties and of the most recent Western currents. Tendencies such as constructivism, abstractionism, and conceptual art moved into the forefront. Within a strikingly short time, artists and groups of artists traversed the path from Russian Cézannism to pop art, from constructivism to the Western happening. In the process, unofficial art entered its third stage, beginning in the seventies.

In this stage, Soviet unofficial art joined the mainstream of world art. New currents and forms emerged, synchronous with those in the West, but with a coloration specific to Soviet Russia. This stage is still with us. Its identifying feature is the extreme polarization of tendencies that were already to be observed in the early stages of development. On the one hand, there was a flight into parody, and levity; and on the other, a veritable soaring into the heady regions of

the soul, that is, a conception of the creative as a domain of the sacred, which opens the door to the metaphysical, mystical, and religious essence of being.

The concept, the happening, and the performance were character- istic of the first of these polar extremes. They appeared as early as the sixties, but did not acquire their real meaning and character until the early seventies, in the works of artists such as Vitaly Komar and Alexander Melamid. Their "sots art" (as they called it) included elements of classical painting, as well as the happening, the concept, and the performance, but the name they gave it put the accent on the parodic aspect of everything they did. Indeed, this stylistic parodying was more befitting the consciousness of the seventies' generation of artists than the social (or antisocial) seriousness of the happening and the performance in the West or the earlier stages of development of Soviet unofficial art. Even Soviet culture was an extremely fertile soil for the development of these genres: it was suddenly transformed into such a collection of dead clichés that young artists, who had by now assimilated other values, found themselves experiencing the natural aesthetic reaction of putting these clichés to shame, destroying them, and doing a dadaist buffoon's dance on their national graveyard.

Such impulses will be engendered not only by an official culture, but by any culture that shows a tendency toward stagnation and inertia, and by nonconformists and dissidents themselves, who put forth their own hierarchy of values and personages, their own heroes and moral standards. Hence, in the new groups' performances, everything is subjected to ridicule—parades and the common drunk, Pavlik Morozov and Klim Voroshilov, even the conduct of a dissi- dent in the prosecutor's office. At a recent "apartment" exhibition, a block of salt and one of sugar, called "Solzhenitsyn and Sakharov" (the Russian words for salt and sugar are *sol'* and *sakhar*), were exhibited as sculptures, and visitors were invited to lick either of them. What is happening in unofficial art at this level is equivalent to what Bakhtin, discussing the Middle Ages, called a "carnival" culture or "the culture of the ridiculous," with no prescriptive norms. The absence of the ridiculous in Soviet culture has always been especially keenly felt, even more, perhaps, than the

absence of a critical attitude toward life. Now the happening and the performance, already clearly on the way out in the West, are experiencing a boom in the Soviet Union.

The other pole of unofficial art in the Soviet Union is also quite specific to the country, and to our times; whereas in contemporary Western avant-garde art, the religious theme (especially in painting) has been utterly marginalized, in the USSR it began to creep steadily into the forefront in the sixties.

> In the early sixties, the traditional Russian question: "What is to be done?" was posed in quite definite terms. And the quite definite answer was: "Live in the spirit." Spirit and metaphysics— these are the most popular words of this period.[19]

Thus did the art critic Patyukov describe the situation in the journal *A-Ya* (Alpha-Omega), published in Paris, in an issue dedicated to unofficial art. "Metaphysical synthetism," "meta-realism," "meditative painting"—these and other phenomena with similar names, or even without names, appeared in Moscow and Leningrad. In the view of their successors, they represented various ways to reveal, with the means of art, the divine principle and spiritual values, both in themselves and in the life around us.

When this Russian phenomenon is compared with Western culture, it is often concluded that the West is undergoing a spiritual crisis while Russia is experiencing a religious renaissance. It is difficult to agree with this. As a matter of fact, the requisite ecclesiastical elements— crosses, cupolas, icons, etc.—have literally flowered in the works of unofficial artists from the very beginning of this movement. But if we look upon this as a whole, what would seem to be essential in it is not a turn to God, but nostalgia for a national culture, which had been steamrollered by Marxist-Leninist-Stalinist ideology; an attempt to restore a continuity between past and present, and to fill the yawning gap in the historical sequence of events. The artist's spirituality is first and foremost a reaction to the impressive lack of spirituality of official culture and life, and on this point the two poles of unofficial art converge: because even the culture of parody and ridicule, for all the stylistic earthiness it

sometimes shows, also endeavors to portray itself primarily as a purely spiritual phenomenon.[20]

These two extremes have grown in Soviet unofficial art since the mid-seventies, driving the stylistic tendencies characteristic of its earlier stages into the background. The emergence of a kind of "official unofficial art," represented by the artists of the painting section of the Municipal Committee of Graphic Artists, which the more moderate, including some of the founders of artistic non-conformism, had joined, played a certain role in this. The official output of the members of the Union of Soviet Artists is at present discarding the earlier stylistic rigidity of socialist realism. It has become possible to use a few formal innovations, provided the general rules of the ideological game are observed. For the noncon-formist artists of the seventies, both socialist realism and "semi-official" art had gone over to a stylistic manner, which for some became the object of "lofty paradism" (Patyukov's term), while for others it became the standard of a soulless and even diabolic principle which deserved only to be disregarded. Many artists car-ried this aesthetic and ideological division from the USSR to the West as their cultural baggage.

From the Realm of Necessity to the Realm of Freedom

In December 1962, when the Stalinist Academy of Fine Arts re-solved to join battle with the Moscow section of the Union of Soviet Artists, at that time bubbling over with liberalism, and its leader-ship brought Khrushchev to the Manège exhibition, the work of the young Ernst Neizvestny was among the items shoved under Khrushchev's nose as graphic proof of the danger to which the process of liberalization might lead. In the stream of indignities which Khrushchev heaped on the sculptor, a "juridical" note was also sounded. But where did this riff-raff (Khrushchev used a stron-ger expression) find this hard-to-get bronze for his formalistic fabri-cations?

Indeed, where (if not from the funds of the Union of Soviet Artists) does an artist get the bronze, marble, special paints, canvases, etc., which are not to be had on the free market?

Any machinery must be oiled if it is to run smoothly, and artistic life is no exception when it becomes a piece of machinery. "No grease, no go" says one of the most popular proverbs in the USSR. For Soviet artistic life, it is the system of unofficial relations between individuals, existing somewhere on the margin of legality, and sometimes slipping beyond it, that serves as lubrication. Were it not to exist, all the bearings and bushings of this machinery would have ground to a halt long ago. What is usually crudely called "corruption," understood as an exceptional phenomenon harmful to society, is a necessary and indispensable part of life in the Soviet Union. The scale of corruption that pervades Soviet society from top to bottom is too well known to need describing here. At the highest level, it is fed by the thirst for power and gain, and at the lowest, by the need to survive. Of course, an artist may (and frequently does) acquire hard-to-get materials through bribery (a bottle of vodka to a worker, or a commensurate reward to an official). However, this is not the source of his subsistence as an artist.

Where a totalitarian system or one approaching that extreme form of rule defines relations between the individual and the state, most people use a double standard in their practical lives: one the public, ideological, and official standard coming from an abstract customer, and another personal, internal, and aesthetic standard. The official standard in no way satisfies either the intellectual needs of the average person or the creative aspirations of the artist, and the lower we go down the professional hierarchy, the wider is the gap between personal aspirations and public interests.

Most Soviet intellectuals wish to broaden the limits of the permissible, and thereby acquire more space to walk in their calling. In this regard most of the rank-and-file members of the Union of Soviet Artists are in opposition to their stagnating leadership; the Union as a whole is in permanent latent conflict with the Academy of Arts, and a good number of the artistic intelligentsia do what they can to circumvent the control of party functionaries and bureaucrats. During periods of ideological indulgence (as during the Khrushchev Thaw) this opposition is able to gain a word in the press, and on the podium at congresses and meetings; in periods of freeze, it recedes into the tacit sphere of human relations, where it continues its existence as a constructive factor of Soviet artistic life. In this

unofficial realm, away from the gaze of the state controllers, it can give succor to all that deviates from the rigid official ideological standards in aesthetics and many other spheres. It is here that the successful member of the Union of Soviet Artists sees that his indigent but free fellow artist gets scarce materials, plucked from closed stores, and it is here that jury members enter into collusion to push "one of their own" at an exhibition, a newspaper editor risks his career by mentioning the names of dubious persons in an article, a staff member of a publishing house that puts out tons of socialist realist pulp publishes the book of a forbidden author under a pseudonym, an administrator slips work to a dissident through straw men, etc. This "corruption," which functions at the very top levels of society as a criminal conspiracy, at its lower levels very often becomes a means for extending and receiving professional and personal assistance, constituting a necessary part in the over-all machinery of Soviet culture.

People are not usually guided by considerations of profit in these gestures. If any element of self-interest exists in them, it is a self-interest of a special type, belonging to the category not of material advantage, but of intellectual enrichment and professional competence. Today the Soviet artist (art historian, art critic, art teacher, publishing house employee, etc.), with the exception of the very top ranks of the laureates, is unable to maintain a professional level of competence without elementary knowledge of both what has taken place and what is going on, within the country as well as abroad, in the artistic culture of the twentieth century. But as we have said, neither the educational system nor the mass media provide the positive information an artist needs for his profession. The situation would be on the brink of an impasse if there were not this realm of nonofficial personal relations: in the USSR, the dinner table has assumed the role of morning newspaper, television screen, and discussion club.

So we find artists, critics, and art experts gathered evening after evening in Moscow kitchens where Western catalogues and albums on Pollock, Rauschenberg, pop art, and conceptualism, having been obtained from foreigners or on the black market, pass from hand to hand, where foreign articles or films are described and where the burning problems of contemporary art—about which one can read in

any established specialized journal in the West—are posed and re-solved on the spot. In a cultural vacuum people are drawn to one another, just as in the West they are drawn to the television screen, so that when the next unofficial exhibition is ready to open, a huge crowd will already have gathered before the exhibition hall without there having been a single mention of it in the mass media. A BBC report about the wrecking of some unofficial exhibition becomes common knowledge to the entire Moscow public within a day.

The upshot is that only at the very top and at the very bottom of the Soviet hierarchy do people have information of some sort about contemporary artistic life: at the top, through access to closed (often secret) sources of information, and at the bottom through contact with foreigners, the black market, and Western radio transmissions. Those at the top keep this information to themselves or share it only with their own kind; people at the bottom are glad to pass it on to anyone at all. This is all somewhat reminiscent of the final chapter in Ray Bradbury's novel *Fahrenheit 451*, but in the Soviet Union, groups form around these walking sources of information, unlike the walking bibles and Shakespeares of the American anti-utopia, and social discussion groups spring up that attract the most lively, interesting, and capable representatives of their professions. It is useful and beneficial to any professional to come into contact with these groups, although at times this is not without a certain risk to one's career. In them, information is exchanged and personal and practical relations are established: an indigent artist finds someone who might be able to give him work, a persecuted nonconformist finds moral and sometimes even material support, an editor finds a talented author, and so on.

The visiting foreigner who encounters such a situation around a Russian dinner table is usually moved by the special atmosphere of hospitality, openness, goodwill, and mutual understanding, which is often ascribed to the warmth or profundity of the Russian (and sometimes even the Soviet) soul. Without wishing to detract from the established clichés, I think a few corrections are in order. The warmth and sincerity of the Russian dinner table may in part stem from the ethnic peculiarities of the Slavic soul, but it is also created by the social conditions of the Soviet state, where people need each other's support to a much greater degree than they do in a free

society. Because of this need, the artist in the Soviet Union (like the member of any creative profession) spends the better part of his life in the refined atmosphere of friendship, support, help, and intellectual conversations.

The special status of the artist in Russian society had its beginnings in prerevolutionary times. Not only various revolutionary democrats, from Belinsky and Chernyshevsky to the futurists and constructivists, but even the country's succession of rulers from Nicholas I to Lenin and Khrushchev firmly believed in the social and powers of art as a means for subverting, or an instrument for consolidating, state power. From the days of the Wanderers, the artist has been regarded as life's teacher and the fighter for progressive social ideals. Having placed its stamp on culture, Soviet ideology officially secured and strengthened this status of the artist, and invested him with the role of "educator of the nation's broad masses" and "front line fighter in the ideological struggle." Tradition and the megamachinery helped shape the artist's psychology, self-esteem, and understanding of his place and function in the society in which he lives.

On these terms the artist in the USSR is not so much a private as a public person; to be an artist is not merely a profession, but an honorary title conferred for special services to society and entailing a number of privileges. Even membership in the Union of Soviet Artists is a privilege since it is not given to everyone, and only the state can confer it. In becoming a member of the Union of Soviet Artists one is transformed into "a Soviet artist," and if his career is a successful one, this may be followed by some truly honorary titles such as Meritorious or People's Artist of a Soviet republic or of the USSR, laureate of a state prize, Corresponding or Acting Member of the Academy of Fine Arts of the USSR, etc. Membership in the Union of Soviet Artists is an abstract privilege, but it does carry with it a number of specific privileges and practical advantages as well.

In housing, for example, an iron rule of nine square meters per person has been established for most citizens, but a member of the Union of Soviet Artists automatically acquires the right to an additional 20 square meters. Moreover, the Union either provides the artist with a workshop, or he himself may acquire and equip a studio

from the "nonresidential reserves," as they are called, by arrangement with the local authorities. (The term "nonresidential reserves" is somewhat inflated; they are usually rooms in cellars or attics.) Given the universal corruption, once a few bribes are given to local officials, such a person will often become the possessor of an apartment that will be the envy of 95 percent of the capital's population. There are practically no useful statistics in the Soviet Union, but we would probably not be far off in saying that the material status of the official Soviet artist is considerably above that of a mere teacher, physician, or engineer.

In practical terms, the artist in the USSR works to establish and maintain his material and moral status in the society, and to do this he fashions his works to the requirements of the only client he has. He does not present his works to numerous potential buyers, but fulfills a social command to standards set by the state. He fashions his work in roughly the same way a commercial artist in the West creates ads for Coca Cola, in line with standards prescribed by the firm. In this respect, i.e., from the standpoint of the relationship between producer and client, Soviet socialist realism is purely commercial art. But in the USSR the artist is raised from childhood to despise the commercial side of his profession, the bourgeois art market, and the Western merchant mentality. Subjectively, he makes "fine art" exclusively—even when he does the equivalent of a Coca Cola ad or paints a thematic picture. He feels himself to be the creator and bearer of certain intellectual values, for which he has a tribute coming from society.

The status of the official artist is determined by his position in the Soviet art hierarchy, i.e. by his duties (membership on various juries, boards, commissions, etc.), titles, and the size of his fees. The unofficial artist is totally outside this network of relations. Yet he too has a status, in the "second culture" that has developed in the country over the last quarter-century. He too despises commercial art, especially that of his official counterparts, and prefers to live in penury. He too creates exclusively "fine art" and engenders "intellectual values," but genuine ones, unlike the "false" ones of official artists, and in so doing acts as the conveyor of a new aesthetic information that is of use to society. In the Soviet Union, this all requires talent and courage, and earns the nonconforming artist the

respect and support of that part of Soviet society it would not be wrong to call its better part. What is most important is that it represents a huge potential audience for him, an audience that keenly and disinterestedly responds to the nonconformist aspect of his works. The half-empty halls of the ubiquitously publicized official exhibits, and the rooms packed full to bursting at any unofficial exhibition, are perhaps the clearest indicator of the moral status of the unofficial artist in the USSR, that "privilege" for which almost any of his materially prospering colleagues will envy him.

This system of art is the only system Soviet artists know, whether they work officially or unofficially. They lack the opportunity to understand the totally different internal structure of Western artistic life, how it functions, its professional relations, its values and its assessments. For the artist, therefore, emigration from the USSR must inevitably be a leap from illusion to reality, as well as from the realm of necessity to the realm of freedom.

Translated by Michel Vale

Notes

1. K. Malevich, *O novykh sistemakh v iskusstve* [On New Systems in Art] (Vitebsk, 1919), as quoted in Troels Andersen, ed., *Essays on Art*, Vol. 1 (London, 1969), p. 94.

2. S. Lissitzky-Küpper, *El Lissitzky: Life, Letters, Texts* (London, 1968), p. 327.

3. Marc Chagall, *My Life* (London, 1965), p. 135.

4. "Sud'by sovetskoi intelligentsii," *Sovetskii rabochii* [Soviet Worker], 1925, p. 27.

5. Leon Trotsky, *Literature and Revolution*, pp. 145–49.

6. Sheila Fitzpatrick. *The Commissariat of Enlightenment. Soviet Organization of Education and the Arts under Lunacharsky* (Cambridge: Cambridge University Press, 1970), p. 236.

7. At this stage the political directorate of the Red Army played a very important role. It had huge, practically uncontrollable means for propaganda and agitation; the Soviet generals of that time were the principal patrons of the growing forces of total realism.

8. According to figures for 1969 the Academy had 31 active members, 69 corresponding members, and 20 honorary (foreign) members. If there was any change in its composition over the years, it was only an increase in numbers.

9. P. Smith, "Soviet Art Reconsidered," *Art Monthly*, London, October 1981, p. 7.

10. *Sovetskoe iskusstvo za 15 let* [Soviet Art after 15 Years] (Moscow, 1934), pp. 125–126.

11. A. Gerasimov, *Moia zhizn'* [My Life] (Moscow, 1963), p. 77.

12. This schema was adhered to in its pure form under Stalin; it has now lost its rigidity, but in essence it is unchanged.

13. Gerasimov, *Moia zhizn'*, p. 216.

14. A. Chegodaev, *Iskusstvo SShA* [Art of the USA] (Moscow, 1960), p. 101.

15. Academy of Social Sciences under the Central Committee of the CPSU, *Iskusstvo i ideologicheskaia rabota partii* [Art and the Ideological Work of the Party] (Moscow, 1976), p. 22.

16. The only—and not accidental—analogue is the Reich Chamber for Fine Arts established on September 22, 1933, under Joseph Göbbels's Ministry of Propaganda.

17. *Iskusstvo i ideologicheskaia rabota partii*, p. 46.

18. The State Museum of Fine Arts was revived soon after Stalin's death; the Museum of New Western Art was never resurrected, and its collections have now been distributed among the Moscow State Museum of Fine Arts and the State Hermitage Museum in Leningrad.

19. V. Patyukov, Eric Bulatov, Eduard Shteinberg, in *A-Ya* (Paris), 1981, No.3, p. 14.

20. One may easily convince oneself of this by a mere glance at *A-Ya*, many of whose writers, interpreting this phenomenon in an apologetic manner, draw in the first instance on philosophical rather than aesthetic categories, and, in explaining often quite simple things, invoke the entire panorama of Russian and Western intellectual culture from Kierkegaard to Heidegger and from Dostoevsky to Florinsky.

Soviet Emigré Artists in the American Art World

Marilyn Rueschemeyer

Soviet artists come to New York "to paint the way they want to," but they soon learn that the art world in the United States is a complex system of relationships and is imbued with its own standards of what is acceptable art. Mediating between art as it is produced by artists and the audience that purchases it, or even looks at it, are galleries, museums, funding agencies, and critics. Art schools, critics, and galleries as well as the most prestigious painters and sculptors influence what even artists themselves deem worthy of consideration as art. The Soviet art world in which the emigrés trained, developed, and worked is a very different system.

How do these artists make their way in the art scene of New York City? Their adjustment involves not only a coming to terms with some practical realities, but also a clash of artistic ideas and standards, and the confusion and despair as well as the elation that individual artists experience in the confrontation. Although they have rejected the official standards of Soviet art and its bureaucratic organization, the emigrés bring with them to the United States cherished values and assumptions that were formed in the world they left behind. There were features of their lives as Soviet artists

that they experienced as rewarding and worthwhile, and may have taken for granted.

The cultural and social outlook of the immigrants is of course not only determined by their artistic work and experience; it is also shaped by their past participation in Soviet society in general. The expectations they bring with them, which are shared by other Soviet emigrés, further complicate life in the early years in New York. This essay begins with a consideration of the emigré artists' professional backgrounds—their education and their work experience in the Soviet Union—and also their political experiences. We will explore in some detail the particular life histories of individual emigré artists I interviewed in New York, without assuming that they reflect the average careers and encounters of artists in the USSR. We then turn to the emigrés' experiences in New York and their attempts to work again as professional artists—to become part of a new artistic milieu, expand their artistic sensibilities, and get their work exhibited, reviewed, and sold. Their discoveries encouraged them to reflect on the nature of art, on the role of art and artists, and the effect of the ways in which people live and work on their art, in two very different societies. All of these issues will be discussed below, whenever possible in the artists' own words.

The Education and Work Experiences of the Emigré Artists

Becoming an artist in the Soviet Union requires rigorous academic training in the arts, and before beginning formal study one must meet high admission standards. Working as an artist in the Soviet Union requires conformity to accepted artistic standards, for which the rewards are security and membership in the Soviet intelligentsia. Most of the emigré artists who have come to New York are themselves the children of professionals; they were brought up in households where reading, music, and the arts were greatly valued. It is of course possible for the child of a worker or a collective farmer to attend art school, since art education is free, but it is can be a rather difficult transition. One artist, whose father was employed by the railroad, described his experience:

"The first time I tried to gain admittance to the art institute I failed. I couldn't believe it, but they wouldn't accept me. My father dressed up and came to the school for an explanation. They told him I should do what my father did. I cried and said I was going to be an artist. I participated in art clubs and after the tenth year, I tried again and then succeeded—but I believe the children of well-known artists were admitted without difficulties."

Generally, the schooling of the artists I interviewed varied tremendously. Some had attended art schools for especially gifted children; a few had studied in schools attached to the Academy of Arts, such as the Repin Institute in Leningrad or the Surikov Institute in Moscow. Most of the artists, however, graduated from an ordinary ten-year school and then began professional studies. Some had attended the special art schools that hold classes after the normal school day is over.[1] Applicants to these classes must submit a portfolio; those who are not accepted are referred to art programs run by the Young Pioneers. The after-school classes are geared not only to training professional artists, but also to developing artistic creativity and interest in youngsters who will work in other professions.

The next step for future artists is attendance at a specialized art school for five years, or perhaps a specialized technical school. These institutions vary considerably in their rigidity of administration and orthodoxy of practice and outlook. The Academy of Arts is the most prestigious art institute and the primary educational and research center in the country. It is also the most conservative, both in its methods and in its administrative arrangements. One of the artists had been in a special school for gifted children attached to the Academy, but chose not to go on to study in the Academy itself because of its rigid atmosphere; he attended a design institute instead. Another said he had chosen a graphics institute over the Academy because it gave him more freedom to do the work he wanted to do. A few of the artists were asked to leave the Academy because their work deviated from the tenets of socialist realism; they switched to technical institutes. Several had studied in specialized institutes that prepared them for such fields as theater and cinema design, decorative ceramics and glass. Still, even within the Academy there is some variation in what is acceptable art; architecture, for

example, is more innovative than painting and sculpture. Despite the compromises students at the Academy have to make, however, most are eager to remain there because of the prestige attached to being an Academy graduate.

The work experiences of the artists are as varied as their courses of training. Some painted or did sculpture full-time; others combined their art with work that was more or less closely related. Several worked for publishing houses designing bookcovers, magazines, and posters. One of the artists did ceramics, another designed for the theater, a third designed costumes for the circus. One man worked as an architect for several years before concentrating more intensely on his painting. One of the women earned money as an editor in a publishing house; another continued the psychology research she had begun while still an art student. Several of the artists had been able to work at their art only at night or on weekends and did not begin to paint full-time until they arrived in the United States.

It is difficult to describe the artists as a group, especially with respect to their standing as ''official'' or ''unofficial'' artists in the Soviet Union. Official artists belong to the Union of Soviet Artists. Typically they paint in the more conventional style of socialist realism for state commissions and sales in the government-run salons, yet some who belonged to the Union worked in a more innovative style in their private studios. Even those who were unofficial artists compromised at times in order to earn money with their art. The artists describe two levels of artistic existence in the Soviet Union—one that is acceptable to those who control commissions and the granting of contracts, and another that is not, but conforms more to the artist's inner standards. ''I wish I could be strong,'' said the wife of an artist still in the Soviet Union, who expressed feelings of powerlessness and hesitation about the way they lived. ''But sometimes I'm so afraid that I will not see the change happen and realize that I might not be able to help my friends or myself—and that what we do will just make things worse for ourselves.'' Painting in a nonconventional style does not always result in a lack of formal recognition and acceptance; much depends on who the artist's admirers are. There are examples of artists who do not follow the official line yet earn a great deal of money for their work and are

officially rewarded with commissions.[2]

The Union is of critical importance in the artist's relationship to Soviet society. It is a channel for benefits and patronage and at the same time it monitors and influences the art produced. Younger artists who are still preparing work for exhibitions belong to a youth section of the Union. Of the 2,500 members of the Union of Soviet Artists in Leningrad, for example, 500 belong to the youth affiliate.[3] Although formally they are not yet members, they are entitled to some Union privileges. This attachment of young artists to the Union may have a profound influence, because the early years of professional practice can be decisive in shaping one's later outlook. Most of the artists I spoke with in New York had been members of the Union for at least some period of their working lives. They experienced some acceptance of minor artistic innovations, particularly if they were in certain affiliates of the Union, for example youth sections, or city branches controlled in part by local boards, which have sometimes been more open and liberal than the Union as a whole. The Union of Graphic Artists has included a variety of interesting artists among its members. Vladimir Nemukhin, Dmitri Plavinsky, and Valentina Kropivnitskaya belonged to the Amalgamated City Committee of Moscow Artists and Draughtsmen, which is a branch of the Union of Cultural Workers, not part of the Union of Soviet Artists. Membership entitled them to be free-lance artists once they had completed their commissioned work.[4] In 1976 the City Committee established a painting section and invited nonconformists to join, except for Oscar Rabin, who had been expelled earlier, and his son Alexander.

The Union of Soviet Artists has changed over time. There have been power struggles among the members, and opportunities for diversity have been greater at certain times than at others. Igor Golomshtok writes of one period, in the late fifties, when a more "liberal" group committed to portraying social reality truthfully in painting "significantly affected the composition of exhibition selection committees, art councils, the editorial boards of art journals and publishing houses, educational institutions and museums."[5] For a time the sculptor Ernst Neizvestny played an active role in the "left wing" of the Moscow section of the Artists' Union, and new

members were admitted whose unconventional art received positive responses. There have also been periods of tension between the Union and the Academy. The Manège incident in 1962 took place when the Moscow Section of the Union "was about to propose to the government that this expensive organization, which acted as a spur to Soviet art, should be abolished altogether."[6] The situation became more difficult for artists in the early seventies, a restrictive counterpoint to the earlier period of de-Stalinization. Nevertheless, some art that was previously considered outrageous had become acceptable; the notion of realism had broadened somewhat. Golomshtok and others remain pessimistic, however, about the depth of the changes that have taken place, believing that "the guardians of Socialist Realism close their eyes to these formal innovations, as to preserve intact the essence of Socialist Realism itself—namely its propagandistic character and its social optimism."[7]

The well-known history of Ernst Neizvestny, who now lives in New York, illustrates the unpredictability of a nonconforming artist's "career." For a while he was supported by the Union. During some extraordinarily difficult years when he was "unofficial," Neizvestny did manual labor to earn money and buy materials on the black market. In his last years in the Soviet Union he received tremendous recognition and support, both from officialdom and from foreigners interested in his work.

Partly because of the international recognition the unofficial artists have received, there have been efforts over the past few years to incorporate those considered most talented into the system, perhaps through membership in a more "liberal" Union affiliate. On occasion a gallery run by the Union of Artists will exhibit works that are slightly more modern and innovative than the norm. Some older, established artists have lent support to their younger colleagues—arranging exhibits, getting them into the official unions, and defending them against conservative critics. A few official artists have even participated in unofficial exhibits, hoping to legitimate them.

Some of the "official" artists I interviewed in New York regarded the "unofficial" artists as amateurs. In their view Union membership implied that an artist had met professional standards of

artistic quality. Similarly, two of the younger artists praised the more innovative artists still in the Soviet Union and claimed not only that excellent artists were still working there, but furthermore that the more interesting artists had not emigrated. However, not all of the alternative routes for the more experimental artists are still open. Some of them have been asked to leave even the more liberal branches of the Union, and now must continue their work without that support. Vitaly Komar and Alexander Melamid were dismissed from the Moscow youth section of the Artists' Union in 1972, after they showed some of their work satirizing Soviet propaganda art to Union officials. They asked for a one-day show; instead they were kicked out of the Union. They subsequently joined the Union of Graphic Artists, but were expelled from it after they applied for exit visas.

Artists who are refused membership in the Union, or are asked to leave it, may pursue other avenues. Sometimes editors in publishing houses hire them, or officials give them commissions to paint portraits or public murals. The wife of one unofficial artist succeeded in getting orders from the state for three or four years, which enabled the couple to live comfortably. Some of the artists I interviewed had been sought out regularly by members of the intelligentsia, scientists, and even government officials who tried to arrange exhibits in institutes, youth cafes, and private homes. There are ''unofficial'' salons that exhibit work, and even a few private collectors. George Costakis, a Greek citizen who resided in the Soviet Union, managed over the years to acquire and show modern paintings there. He now lives in the West and was able to bring part of his collection with him. Diplomats, journalists, and tourists have brought examples of Soviet unofficial art to exhibits held in Western Europe. This attention and support has permitted a few unofficial artists to devote more time to their creative work.

The problems the artists had in the Soviet Union were not primarily material ones. Several of them, though certainly not all, had had separate studios and nice apartments. Established artists were able to earn money through their art and some even did their own creative work during the week. Several of the emigrés had had considerable success as ''official'' artists and had participated in exhibits

at the Hermitage, the Manège, the Tretyakov Gallery, the Pushkin Museum, and the Russian Museum, to name only a few of the most important. Some had been among those chosen to represent the Soviet Union in group exhibits held in Eastern Europe. A few artists, both official and unofficial, succeeded in having their work exhibited in Western Europe and in the United States, both in individual shows and in group exhibitions of Soviet contemporary art. These exhibits of their work, and articles about them in the Western press, gave the artists satisfaction and encouragement. On the other hand, those who bypassed official channels and sold their work independently, especially to foreigners, frequently had no idea of where their work was. Much of it disappeared in foreign countries. Furthermore, because they were unable to share their art with a large Soviet audience, these artists felt uncertain, even hopeless, about their future identities.

One last aspect of the emigré artists' varied backgrounds involves the part of the country in which they lived and worked. While most of the emigré artists are from Moscow, and about a quarter from Leningrad, there are others who come from outside the Russian Federation. In particular, there is a small group of artists that emigrated from Soviet Armenia; many of them are now in California and New York. Although artists are subject to the same broad regulations in Erevan as they are in Moscow and Leningrad, there are a few significant differences. Armenia, like some other parts of Transcaucasia and also the Baltic republics, has enjoyed a somewhat livelier tradition in the visual arts. There is a Museum of Modern Art in Erevan, and an ongoing exchange with the Armenian Artists Association of America, organized in 1973 by Richard Tashjian, a resident of Boston. There have been official visits by Soviet Armenian artists to the United States, and the Armenian Artists Association of America has had an exhibit in the Erevan Museum. Such exchanges have given Soviet Armenian artists a direct exposure to Western art.

The Armenian emigrés had been very successful in the Soviet Union. They belonged to the Union. Their work was exhibited. They lived in four- or five-room apartments (generous by Soviet standards), had studios, and were able to work as full-time artists. In

addition to selling their art to the state, they had many private commissions. One of the artists was featured in an article in *Soviet Life* a few years ago. Still, their reasons for leaving were similar to those of other Soviet artists: they wanted complete freedom in their work and freedom to move and travel as they wished. They hoped to earn a lot of money with their art. An American who had gotten to know some of these artists in the Soviet Union commented: "Of course by American standards, they didn't earn all that much. Once I asked what one of the artists earned for doing an elaborate stage design for the theater. I was astonished with what he told me and mentioned that for all the work he did he would earn much more in the States." One artist claimed that in Armenia he had been unable to work with religious motifs, but others vehemently deny this and maintain that religious art is being done in Soviet Armenia. Still, all are aware that one well-known and rather outspoken young artist, Minas Avedissian, died mysteriously in an automobile accident in Armenia, and many draw a connection between his death and his nonconformity. The significance attached to such incidents indicates that the artists did not harbor illusions of acceptance and inviolability.

Settling in New York

It is a devious journey from Moscow to New York. Soviet emigrants first arrive in Vienna. There they are met by officials of the Jewish agency, the Sachnut, which serves as a link between Israel and the Jewish diaspora. One of its functions has been to organize and facilitate the immigration of Jews to Israel. Those who do not want to settle in Israel are directed to the Rome office of the Hebrew Immigrant Aid Society (HIAS), a U.S.-based organization.[8] Most Soviet emigrants waiting to enter the United States spend several months in Rome. The strangeness, the difficulty of dealing with the various bureaucratic organizations, and the tensions of obtaining temporary housing and medical and financial help while waiting to enter their chosen country are all still vivid to them.[9]

In the United States the immigrants may be aided by HIAS and a variety of other welfare organizations. Local Jewish agencies decide on how many and what kinds of immigrants they can help to resettle.

The immigrants receive financial aid for a period of several months as well as language instruction, career counseling, and help in finding a place to live. Although Soviet Jews have settled all over the United States, New York has accepted more of these immigrants than any other city. The present living conditions of the Soviet artists in New York are shaped by the great variety of neighborhoods, streets, and milieux that exist in Manhattan, Queens, Brooklyn, and even Jersey City. They tend to move into outlying neighborhoods where housing is less expensive, often mixing with other immigrants and minority groups, rather than to areas of the city where there are concentrations of American artists.

One older artist, who had lived through the Second World War and the Stalin era, chose to live in a Brooklyn neighborhood where many Soviet emigrés have settled. Here it is possible to walk through the streets and hear Russian spoken, buy in shops run by Soviet emigrés, and eat and drink in familiar style. His wife, luckier than many emigrés, has found work in her profession as an architect. The artist has a studio in an office building in Manhattan. He goes there every day, mingling with business people, shoppers, and visitors from every part of the world and all walks of life.

Another artist in Brooklyn lives and has his studio in an old apartment house. The street below appears poor and run-down; among the shops there are fast-food stores selling falafel and pizza. The apartment is small, with a kitchen, living room, and bedroom, where the artist works. He is employed part-time as a guard and tries to earn just enough to be able to spend the rest of his week painting. Only a few streets away, there are lovely one-family homes. Several of the residents are orthodox Jews.

A third lives with his wife and son in a one-family house on a quiet, tree-lined street in Queens. It is a pleasant middle-class neighborhood. Previously the family had lived in a large apartment house a few streets away, but found it too noisy. The artist's wife works as a bookkeeper. Her earnings and the sale of his paintings and lithographs enabled them to buy their home. They also own a car.

Another lives in a housing project in a lower-middle-class neighborhood in Astoria, Queens. The project is not for families on

welfare but for employed workers. Surrounding this huge project are blocks of small one-family houses. The artist told me that the neighborhood is ethnically very mixed, with many Greek and Italian families. He said he liked this environment and felt at home in the apartment house. Outside the entrance to his building I observed an elderly white woman having an animated conversation with a young black boy she appeared to know well. The elevator and hallways were spotlessly clean. There was a sign indicating the building was tenant-patrolled. The artist's studio was in the apartment and the walls were filled with his paintings. There was a large glass-enclosed bookshelf and a collection of classical records. His wife works full-time as a commercial artist. They have two children.

One artist who began his life in the United States in a small American city moved to upper Manhattan after his divorce. His former wife is employed as a professional musician. They have one son. The artist's apartment is on the top floor of a huge apartment house. A guard at the entrance screens visitors; the hallways appear secure and unthreatening. The families living there seem to have come from all over the world; each time I visited I heard a variety of languages. The apartment itself is small and bright. The living room, which is also the artist's studio, overlooks the city.

One of the most famous of the Soviet artists lives and has his studio in SoHo. Visitors unfamiliar with the vitality of the area are initially impressed by the shabby appearance of his street. However, when one looks closer, there is a modern bar, a Chinese restaurant, a new French restaurant, and intense street life. The artist's huge studio is filled with sculpture. There are usually apprentices working with him; the last time I visited, two spoke Russian. Only the frequent interruptions of telephone calls made him seem a bit more the entrepreneur than the traditional master-sculptor. His wife and daughter remain in the Soviet Union.

When I began these interviews, few Soviet artists lived in SoHo or even in Manhattan. As we shall see, living outside the art centers has been a problem for the artists. Those who have been most successful or who manage to find other good sources of support move to Manhattan. One older artist was finally able to move his studio to SoHo after he had lived and worked for a few years in

Queens. Another, who had had considerable success in Paris, moved to a large and beautiful studio in SoHo. A young husband and wife team found an old apartment behind a garage in SoHo and turned it into a studio. However, those artists who have succeeded in moving to Manhattan are still the minority.

Three of the artists I spoke with live in Jersey City. Many Soviet families were settled there in an attempt to bring "new life" to the area and improve a blighted neighborhood. Only a few years ago the street where one of the artists lives was considered so dangerous that the police refused to patrol it. This artist had lived for a while in Manhattan, in SoHo, the area where so many of his colleagues yearn to live and work. However, in Jersey City he has been able to afford a house for his family—his wife, who recently started working as a draughtsman, and their sixteen-year-old daughter. Parts of the house are in poor condition and still need to be repaired. Upstairs, however, he has built a large and beautiful studio. Several of the houses on the street are potentially very attractive and in the process of being renovated. His neighbors, he said, are determined to improve the area, and everyone thought the street was already much safer than it had been only a few years ago.

Not too far away a new museum, the Museum of Soviet Unofficial Art, is being constructed from a nineteenth-century stone building that had once housed the administrative offices of the local fire department. It is to be directed by Alexander Glezer, an amateur art collector who became known for a series of unofficial exhibitions he helped to organize in the Soviet Union. He also founded the Russian Museum in Exile at Montgeron, outside of Paris, which exhibits contemporary Soviet unofficial art. Glezer's plan was to model the Jersey City museum after the one in France. In additon to exhibiting works of art, the museum holds extensive biographical materials on the artists. It is still uncertain whether the museum in Jersey City will succeed in attracting as many visitors as Montgeron. The organizers—Joseph Shneberg, executive director of the Committee for the Absorption of Soviet Emigrés, Abba Goldberg, who chaired the group, Alexander Ginzburg, the Soviet journalist and a human-rights activist, and Glezer—hope that the museum will be supported and used not only by the many Soviet

families living in the area but also by visitors who are interested in Soviet art and artists.

Gaining Entry to the American Art World

As soon as the emigrés find housing and recover from the initial shock and excitement of their arrival in New York, they begin to think concretely of how they can continue their lives as artists. In the Soviet Union, some had made contacts with Americans. They now turned to them, hoping for encouragement and help. Others have tried to strengthen their ties to the European galleries that had shown an early interest in their work. Some become a bit nostalgic for those "care-free" months in Italy, which many other emigrés describe as tense because of the difficult living conditions and their fears about the unknown future. One artist was helped by a professor from Bologna to set up an exhibition. Another spoke of the greater respect for artists in Italy, a difference that had tangible consequences: "I was able to pay for the rent with my paintings." One artist remembered a restaurant owner in Rome who, after watching him paint, insisted that he eat without paying. Although one artist had the terrible misfortune in Vienna of having his portfolio stolen, and with it seven years of his work, most of the other artists spoke of their initial enthusiasm and of the warmth and excitement they experienced in Europe, which made this period an especially memorable one for them. Perhaps there was an additional important factor. While in Rome, the artists had strong hopes for their future in the United States which were not yet challenged by reality.

Those artists who had succeeded in arranging exhibits in the United States or in Europe before they emigrated had a little additional money and, equally important, some feeling of professional continuity. A few of the artists had been contacted before they left the Soviet Union by art collectors and gallery owners who were themselves emigrés and had a special interest in promoting the work of Soviet artists.

The emigrés, then, began to rebuild their professional lives in this country using the various routes available to them. They contacted the Americans they had met in the Soviet Union, hoping they would be interested in purchasing their art, in helping them to arrange

exhibits, and in introducing them to American artists, gallery owners, and other important people in the art world. They took their work to general art galleries, they exhibited their work in special collections that traveled to Jewish communities throughout the United States, and they contacted the few galleries and private dealers who were especially interested in Soviet art. The artists, although grateful for what they were able to accomplish, had difficulties and feelings of ambivalence with regard to all of these undertakings.

The first difficulty, shared by American artists as well, is that although there are many galleries in New York, their owners and managers are not waiting with open arms to exhibit new artists. Some of the better-known art galleries will not even look at an artist's work unless the artist is recommended by the right people. Others will not take chances with art that does not conform to the international style—in all its variety—of the accepted avant-garde. Still others refuse artists because they are not impressed by the quality of their work against less sharply defined standards. Whatever the standards are, the artist who comes to New York from an environment as aesthetically insular as the Soviet Union faces a tremendous and potentially devastating problem. Even if the artist begins to understand the critical standards in all their subtlety, other issues remain: the need to be true to one's past work, and the ambiguities of submitting to critical standards that remain external even if well understood. Although nearly all of the artists had participated in at least one group exhibit or one-person show in a "normal" gallery in New York City, success in exhibiting in known art galleries or museums was much rarer than they had anticipated. Several have had occasional exhibits in little-known art galleries. One reported: "I had an exhibit in a small gallery that an American suggested to me. I sold one piece to a collector. I sold a bit more in Maine and the Hamptons." A small number of younger, stylistically experimental artists who managed to find studio space in SoHo and were good entrepreneurs succeeded in getting a series of exhibits in "alternative" SoHo galleries, which pleased them. They criticized their older compatriots for being too serious. One art curator who had emigrated from the Soviet Union said that most of the emigrés

failed "to move with the time or live intensely enough in the present." A few of the artists described how difficult it was to have their work exhibited and how so much depended on being introduced or becoming known to the "right" people.

> "My wife's professor was well acquainted with the owner of the S. Gallery in New York City. He introduced me and I was given a contract and exhibit. However, he's ill now and I don't know what will happen if he dies. I sent my slides to another gallery but they weren't interested."

This particular artist had the unfortunate experience of having two paintings stolen during his first exhibit in Connecticut.

Komar and Melamid's success in New York provides a dramatic example of how important initial connections with respected dealers and collectors are. Tourists and diplomats had been bringing Komar and Melamid's work out of the Soviet Union for some time. A Soviet activist named Goldfarb, now in the United States, approached several galleries, indicating the artists' interest in emigrating if they could become known in New York. Ronald Feldman, their present dealer, related in an interview that Goldfarb had approached other galleries without success before visiting him.[10]

> "The American art public was becoming aware of unofficial art in the Soviet Union when the authorities bulldozed the Moscow outdoor art show. After I looked at the work of Komar and Melamid and listened to the explanations of their art by Goldfarb, I became very excited about what they were doing."

Some of the artists—those who identified themselves as Jews or who incorporated Jewish themes in their art—had had their work shown in Jewish community centers, synagogues, and local galleries throughout the United States. This was not the solution to their problems, however. Although the artists were appreciative and even glad of the support they received, they did not consider these exhibits as entries into the "real, professional art world." If at first some emigré artists had a rather imperfect understanding of the art market in the United States, they soon learned that the typical buyer at a

provincial community center was not likely to be intimately connected to the New York art scene or even educated about art.

The few Armenian artists who came to New York had similar experiences. So remote was the chance of their having an exhibit in an established gallery that they turned in desperation to the Armenian Artists Association of America for help in showing their work. It was useless to advise them to submit portfolios and slides to as many galleries as they could; they did not have enough money to publicize themselves. The association and the Armenian community function as a kinship group and make great efforts to help those in difficulty, whom they consider as members of an extended family. The emigrés, however, hope to become successful American artists rather than depend on "national" ties for support and acceptance. If eventually they are successful, it is quite likely that many of them will loosen their connections to the Armenian community and become integrated into a community of American artists.

A similar issue exists for those artists—and this includes nearly every one I spoke with—who exhibit mainly in the one or two art galleries that specialize in Soviet art. The emigrés fear that by remaining attached to a "Russian gallery" they will isolate themselves from the New York art world and be considered Soviet exiles rather than *artists*. They want to become part of the American art scene. A few said that they did not consider themselves Soviet, but American, and refused to identify themselves in any way with their Soviet colleagues: "I want to become an American artist—not like the old immigrants who only associate with each other." Several indicated that they exhibit with a Russian gallery only because they have no other choice:

> "I don't believe in having only a 'Russian' gallery. I don't believe in this nationalism, as if everyone wears the same socks. . . ."

> "For months, I tried to get into other galleries. You can't walk in the front door; you have to know someone."

The owner of one of the main galleries exhibiting Soviet art in New York, Eduard Nakhamkin, is very sensitive to these problems.

"When I met Soviet artists, no one knew them, promoted them or even cared about their work. The artists I had at first weren't all good, but then a few excellent ones brought in their art and the gallery got a good reputation . . . the artists were afraid to exhibit their work in a gallery that might close in a few months; they considered themselves great. Now the gallery is a business of hundreds of thousands of dollars. When we began to promote the artists, it became easier for them to go elsewhere."

Several of the emigrés thought of themselves as not only competent but extraordinarily talented artists. They expected to receive great sums for their paintings and were deeply disappointed when this did not happen.

"I thought I would get thousands of dollars for each work I did; the galleries offered me much less . . . Of course, now I understand the situation wasn't what I expected. I was unknown. At first, I was terribly hurt that my prices weren't accepted, not even for my lithographs."

A gallery manager added:

"They may be big names in the Soviet Union, but on the world scene they are unknown, even if they are good and deserve more recognition. They say their paintings are worth a great deal of money, but there is no real market for Soviet art."

The artists were concerned about the fact that their need for cash meant they had to produce and sell more than they had in the Soviet Union.

"It takes me a long time to complete a painting, sometimes a few years. You can get poor in America that way."

"Here you can have what you want but you have to work hard. In Russia, you could live off a painting for several months. Here, you can't live off it for one month."

''There is more security in the Soviet Union. Now you get a studio and an income whether you exhibit or not, if you belong to the Union.''

''I see now that America is good for big artists.''

It is rare for Soviet artists to earn money doing commercial work in New York, although a few with specialized skills that are especially marketable manage to do so. Most of the artists I spoke with intended to do only their own creative art; but even if they were interested in getting work as commercial artists, they were handicapped by their inability to communicate well. Since most of their work is done in isolation, the artists do not have as much opportunity as other Soviet emigrés to become fluent in English. One artist built lofts and painted buildings in SoHo in order to earn money. A couple has been successful in getting commissions to restore damaged paintings, work they very much enjoy and which leaves them considerable time for their own projects. Another artist teaches young people in order to earn additional money; his students are the children of Soviet emigrés. Norton Dodge and Alison Hilton estimate that only a dozen of the Soviet artists in New York are able to support themselves and their families from the earnings of their art, and that of these less than half make as much as $50,000 a year.[11]

A few of the artists are on welfare; one such unfortunate emigré is the Armenian artist who was featured in *Soviet Life* some years ago. Several of the artists are divorced or separated from their families. Many if not most of the male artists who have remained with their families have spouses who earn enough to contribute substantially to their endeavors to remain full-time artists. Generally, Soviet emigrés tend to have a fairly high divorce rate—both predating their emigration and afterwards.[12] For some of the artists, then, emigration to America not only meant coming to a very different society and adjusting to a new way of being an artist, but also involved a radical break in their personal relationships. The continuing links that estranged husbands and wives often maintain exist only for those emigrés with ex-spouses in the United States. If either husband or wife remains in the Soviet Union, the separation is complete.

Some of the artists insist that earning great salaries is unimportant in comparison to continuing to develop artistically. A few had huge projects they wanted to complete, or theories of art they wanted to expound to the American intelligentsia. One had been working for two and a half years on a project that had fifty-six pieces; he was searching for a place in New York large enough to exhibit it. The sculptor Neizvestny has a major project called "The Tree of Life," which has been described as an "international monument to the heart and mind of man, all of whose accomplishments are here blended into a polyphonic design of spatial union."[13]

Yet, despite the "bravado" many of them display to outsiders, some of the tension the emigrés experience undoubtedly stems from a lack of confidence in themselves as artists, in an artistic environment they neither belong to nor even clearly understand.

"My first exhibit was a reaction to life in the Soviet Union and I'm uncertain of it. . . ."

"I had an exhibit and sold a lot, but it was a period of trial and I wasn't satisfied."

One artist, who had been very successful in the Soviet Union, and was even interviewed on television upon his arrival in the United States, soon found himself overwhelmed by frustrations.

"I am unstable and unsure of my style; I am uncertain of where to turn. I don't know what Americans want. I don't understand them."

We will hear many such reflections. It will become increasingly evident that the Soviet emigrés are trying to make their way in an art world that has remained rather incomprehensible to them. The artists anticipated more public recognition and acceptance than they found. The many complicated problems they faced on arrival in New York produced in them a certain insecurity about what they were doing and unclear expectations for the future.

However, the difficulties these emigrés talk about should be

understood in a larger context—their generally positive evaluation of an artist's life in the United States. There is still excitement about the possibilities open to them, and a lingering memory of what had disturbed them in the Soviet Union. One artist, recalling with nostalgia the material security he had once enjoyed, added:

> "But on the other hand, I was afraid even to telephone foreign friends . . . and if I can't exhibit everything I want to, it's not a professional life. In time, I'll find that if I'm a real artist, I'll make it. I'll be written up. It will come."

The Special Problems of Women Artists

Among the emigrés, women artists have particular difficulties in rebuilding their lives as artists. They are busy seeing that their families are well settled and only then do they begin to reestablish their careers; moreover, unless they are working in collaboration with their husbands, they must do this alone.

According to socialist theory, a woman has to work outside the household if she is to participate on an equal basis in the society and in her family. Ideally, then, the family is based on human affection rather than on the economic dependence of the woman and children on her husband. In the Soviet Union, 88 percent of women work outside the family, nearly all full-time or as students.[14] Soviet women participate fully in professional life, although their distribution over different fields is not the same as that of men.[15] At the end of 1974 women in the Soviet Union constituted about 55 percent of the population between the ages of twenty-five and fifty-nine and 59 percent of the total number of employed specialists with higher or specialized secondary education.[16] Women's participation in the arts is strong. In 1974/75 the proportion of women studying in some field of the arts in higher educational institutions was 68 percent and in specialized secondary schools 81 percent.[17] This is not especially surprising. What is remarkable to a Westerner is the strong presence of Soviet women in "nontraditional" occupations: 40 percent of Soviet engineers are women, 57 percent of designers and

draughtsmen, 40 percent of scientific research personnel, 77 percent of doctors and dentists, and 53 percent of medical administrators.[18]

We do not have exact information on the percentage of women in each branch of the arts, but according to a representative of the Union of Artists, women comprise more than half of those employed in the applied arts, pottery, weaving, etc., while most painters and sculptors are men.[19] This imbalance is also characteristic in the emigration.[20] However, the situation is more complicated than the statistics may suggest. The women artists I spoke with, like many of the men, may have gotten their formal training in an applied field, but put their major energy into the creative work they do on their own. A woman may, for example, be trained in graphics, take employment in a publishing house for income, and put her heart into painting in her studio when she can make the time for it.

One of the emigrés I interviewed had studied linguistics at the University of Moscow and had been employed at a government publishing house. She had worked on her own art during the rest of the week and in the evening, as did her husband, an artist who had worked as a costume designer in the circus. They had collaborated on many art projects and met regularly with other unofficial artists in the Soviet Union.

Another woman, also married to an artist, had studied at the Moscow Polygraphic Institute. Since her student days, she has had employment three days a week in the psychology department of a university, creating programs for children. While a student she had been able to do a great deal of work independently at home. She said that her friends in more traditional art institutions had envied her comparative freedom. She, too, had been deeply involved in a community of artists with her husband, his collaborators, and their friends.

A third woman had attended one of the special art schools, described earlier, three times a week before she entered the Polygraphic Institute. She had worked on a free-lance basis with various publishing houses, as well as doing her own art. She had succeeded in entering Ely Beliutin's studio and there was able to work and exhibit paintings that were unorthodox by Soviet stan-

dards.[21] However, after Khrushchev's visit to the Manège exhibit, in which she had participated, the studio group was officially disbanded.

In spite of the drastically changed role of women in Soviet society, some of the artists I interviewed saw men and women as intrinsically different in artistic creativity. Reflecting about why there were relatively few women artists, one of the women observed that the power for great creativity is "thought to be male." A male artist added: "There were great female artists. You couldn't tell the difference [between] their work and the work of male artists. Now I always can. Somehow, the women have gotten weaker."

Historically, there was some tradition in Russia of women in the arts. Margarita Tupitsyn speaks of a new phenomenon in the history of women's art that emerged in the period preceding the revolution in 1917—"the collaboration and mutual influence between male and female artists and poets."[22] These women worked with men, artists and intellectuals, who were critical of traditional marriage and a family life that made women dependent. They spoke of, and lived, their ideas of free "marriage" and of relations between the sexes based on love, relations that could easily be broken if either partner were dissatisfied. Many of these ideas subsequently became public policy. But not all the consequences of this rather sudden emancipation were favorable to women. When divorces became easier to obtain, many men simply left their wives and children. Promised day-care centers and other public supports for the new modes of family life remained underdeveloped. Women became integrated into the labor force but still had to meet the demands of child and household care.

During the period of the 1920s, however, many women artists managed to live an intense personal and professional life. The collaboration between men and women in the avant-garde was extensive during this period and resulted in exquisite works of art. Women not only worked as fine artists, they designed books and posters and directed art schools. Popova and Stepanova established textile print factories, which "allowed them to carry their innovative ideas beyond the studio and, by means of constructivist design and clothing, to influence the appearance and sensibility of women as well as

their surroundings.''[23] The 1930s brought both the entrenchment of socialist realism in art and social policies that reinforced the validity and stability of traditional family life—although women remained in the labor force. Only a very few women artists continued to pursue the nontraditional lifestyles celebrated by the avant-garde, or to work independently without conforming to the standards of socialist realism. By the time of the Khrushchev ''thaw,'' women were a small minority in nonconformist circles; in Tupitsyn's words, they remained ''under the spell of the severe stereotypes propagated by socialist realism.''[24]

Most Soviet women artists today work to contribute to the family income and spend time caring for their children and households. Yet, the women artists I spoke with saw themselves as professionals and no less committed to their work than their husbands were. They did not see their art as something they did on the side, ''as a hobby.'' Here is how one woman described her way of life before emigration:

> ''As in so many Soviet families, my parents lived with us and helped care for the children and the household. Each person in the family had a task. My husband took care of the heavy work, bringing the laundry to be washed, getting the potatoes, etc. It was too much for me, but it was too much for all of us. . . . Still, I was greatly involved in my work. The studio was my life. I worked intimately with the others; we showed each other our work and we solved problems together.''

Another woman said she took charge of most of the tasks at home, but that her husband helped whenever she asked him to:

> ''When I worked, he took the children. There was no choice. However, we have friends now in the Soviet Union who put all the jobs to be done on the refrigerator and then divide them up. We never did it that way.''

This woman was intensely affected by the experience of emigration. She and her husband had decided to settle in Israel, where it took many months for her to start working again. Her artist husband and his collaborator made plans for their projects a year in advance and

their work was not much affected by the physical environment, but she needed to know the land and to work with the materials around her.[25] Once she was able to start, she found that her work went well and that Israelis were interested and supportive of what she was doing.[26] When her husband left for New York with his collaborator, she remained in Israel with their two children, continuing her work, but later moved to the United States on the advice of her husband's gallery owner. This move, too, required her to adjust to a new environment, in order to be able to begin working once again. She has spent months walking around New York City, learning to know it, and although her art has been exhibited, she has not yet begun any new work.

A similar problem existed for another woman artist who moved with her husband from the Soviet Union to Boston, where he had relatives and employment. She, too, was unable to paint in her new environment and it took several years to "get started again, to understand the world, and to feel like a human being." In Rome, where she and her family had stayed before coming to the United States, an Italian artist helped her set up an exhibit and she sold all her paintings. Soon after she arrived in the United States, three of her works were chosen for the American Painters in Paris exhibition. But access to American galleries remained a problem. When the artist finally found one in SoHo that was interested in her work, the gallery was sold to someone else.

She is astonished by the reaction of most people when she tells them she is an artist:

> ". . . they don't understand that I was trained as a professional artist and that I worked professionally. They think I paint pretty flowers and otherwise take care of my family and make my husband comfortable. I decided to tell people I am a book designer; that has also been my training and somehow it sounds more professional to them."

For years, she has tried to find work in publishing houses. Once in a while she succeeds, but the competition is severe.

"I loved my work in the Soviet Union and I was successful doing it. It took me ten years to become really established as a book designer and illustrator because I worked free-lance and the profession is competitive. Here, I have the feeling that people don't believe a woman can do the work. In the Soviet Union, although the director at the highest level of the publishing house is usually a man, eighty percent of the directors on the next levels are women."

Surprised and disappointed with her professional development in the United States, she commented:

"There are many bad things in the Soviet Union, but I was working in publishing houses and painting. I never felt the way I feel here. I expected the United States to be a progressive country and in many ways it is, . . . but with respect to women artists, it's in the Middle Ages. In the Soviet Union, I didn't feel that difference."

This artist agrees with the women's movement's critique of American professional life—that discrimination continues to exist in nearly all professions. However, she does not condone the "dichotomy," which, as she sees it, American women have set up between commitment to work and commitment to family life:

"They are only now beginning to understand that it's possible to do both. They have enough money to pay for babysitters. They have to make some compromises. Even if they hand over their entire salary, they maintain their profession. They stay alive. On the other hand, working doesn't hurt family life. It enhances it."

Living in Boston, this artist feels estranged from the center of artistic life. She shares this complaint with a close friend, an American artist from New York. "At least we have each other. It's bad for artists to be isolated."

Perhaps the easiest adjustment was made by the young woman artist who works with her husband. The two, who had often worked together in the Soviet Union, continue their joint art projects and art

performances. Because a "performance" involves the reactions of viewers, they enjoy more intimate contact with their audience than many of the other artists. In one such performance, "Zoo," they exhibited themselves nude in a cage as animals with the label, "Homo Sapiens, group of mammals, male and female." They are among the few emigrés who have not experienced a severe disruption of their sense of community since leaving the Soviet Union.

The American Response to the Emigré Artists

Over time, most of the Soviet emigré artists have succeeded in selling some of their work, but still they are generally disappointed with the response they have received. It remains difficult to get journalists and critics to come to some of the galleries that show their work, so it can never be taken for granted that an exhibit will be reviewed in the newspapers or in art journals. In fact, very few exhibits are reviewed unless the artist is well known or the exhibition is held in a well-known art gallery. One gallery owner specializing in Soviet art observed:

> "If an artist is born in the United States, he has connections and people will come. The Russian artists have skills and sometimes they are excellent but nobody knows them. Some of the American artists are mediocre. . . . It's painful. You see the names of the same artists all the time and people buy them. It's so hard to get the important art critics to come. I've never met N.N. or had a chance to show him the work I have here. If we could speak, [they] would see. [They] would really be impressed."

Again, this problem is not unique to the emigrés; many small and good general galleries have difficulties bringing their artists to the attention of the critics. Indeed, a few of the younger Soviet artists were well aware that many of their American colleagues had never been, and probably never would be reviewed, and that some of the attention they themselves attracted was precisely because of their emigration from the Soviet Union. One disappointed artist reported:

> "The reactions to my work were actually two-fold. People were interested in me; yet some of the critical articles ridiculed my work."

Some of the emigré artists have gotten very positive reviews, but in general, the impression of the critics seems to be that Soviet art is not easily accessible—intellectually or aesthetically—to Americans, and that much of the art is uninteresting, old, imitative. One Soviet art historian agrees with the reactions of these American critics:

> "Artists think they're all geniuses. In the Soviet Union, abstract art is a revelation. In America, it doesn't have any meaning. Most of their work is mediocre; in the West the kind of art they do was done years ago. The talented will eventually be discovered."

Other critics, including Igor Golomshtok, sympathetic to what the emigrés are trying to do, strongly oppose these negative evaluations, contending that Americans do not understand Soviet art. They insist that the Soviet artists' work is varied and distinctive; that what they do may include surrealistic, expressionistic, and other traditional approaches, but that their art is more than that, that it is new, and transcends the specific style. Some go as far as to suggest that Americans have no tradition for understanding their own contemporary art because the art has no meaning (we will discuss these different concepts of "true" art below), whereas Soviet intellectuals do have access to their art and in any case are not intimidated by unfamiliar techniques or symbols.

What do the emigré artists think of the critics who review their work? In the Soviet Union, unofficial art, even if exhibited, is rarely reviewed. It is common that exhibitions and the participating artists are never even mentioned. Moreover, official criticism adheres to traditional Soviet standards, and for the most part the artists found this criticism uninteresting. They do, however, refer to the existence of "deep and serious" art criticism in the Soviet Union. Studies of folk art and the art of earlier centuries are often considered excellent, and so is some of the "underground" criticism of unofficial art, which they welcomed—"desperate for a kind word."

It is from this experience that the artists derive their expectations and the standards by which they judge American art criticism. From the beginning, the emigrés were interested in, and felt that their futures depended on, American critics. They had high hopes, not only for good reviews of their work, but for the understanding that art criticism would give them of American art. Those who understood English took the reviews they read very seriously. There was much more variation than they had expected. Soon, however, they grew critical, and sometimes even suspicious, of the reviewers. Some, of course, were dismayed that their own work was evaluated negatively, if at all. But more generally, the emigrés were often confused by American criticism. Just as they lacked a very clear understanding of the structure of the American art world, they did not always grasp—and often were not aware of—the many kinds and methods and levels of art criticism that have a place in that world.

"Art criticism here is sometimes funny and sometimes serious. Often the art world is strange. Some of the reviews are serious and deep and at other times they are filled with rumor and gossip. Art criticism here can be superficial and does not touch on the philosophical basis."

"Generally, art criticism in the United States is on a much higher level because it is free and it is not necessary to use the ideas of the Party. On the other hand, the underground criticism we did for each other was on a much higher level; it involved philosophical discussion."

"In the United States, art critics explain their theories of how painting becomes alive. Even the artists don't know that. When mediocre artists understand what critics like, they'll begin to paint that way . . . The critics aren't independent. I was at an art exhibit after I had read the criticism. Either there's a complete absence of taste or a commercial interest—the critic makes a percentage of the money. I ran to see an exhibit I read about. The critics had written about the wonderful reds and greens. It was nothing."

Does art criticism have a place at all? And if so, what role should it play? One artist asserted that "Only artists should criticize each other." But another declared that critics helped to build the future of art. Most of the emigrés believed in some form of art criticism, although they disagreed about its purposes.

"The criticism should be written for those who know about art. Lots of books are good but the articles in magazines and newspapers seem to be written for high school students."

"They should explain the art to the people. . . . On the other hand, it's important not to tell people what to think."

The emigrés are filled with ideas for communicating the philosophical basis of their art. Their ideas range from bringing critics together for a discussion to publishing a journal that would include pictures as well as extensive commentaries. They retain the hope that once the critics have a greater understanding of their art, they will respond more positively.

Another disappointment for many emigrés has been the public's reception of their work. Many of them had once thought of the American audience as an appreciative support group for Soviet unofficial artists. The gallery owners have perhaps a more realistic sense of the American art market. One emigré gallery owner noted that the artists whose work he exhibited differed greatly from one another and suggested that the different styles appealed to different audiences:

"For some it's decoration, for others nostalgia. The modern art of Chemiakin and Neizvestny is more intellectual. The viewer has to understand these artists to accept their work."

Some Americans who cannot react easily to the Soviet art try to place it in a context that is more familiar to them. A gallery manager observed:

"The Americans like to compare: 'This artist looks like Chagall . . .' If they say 'it's interesting,' they don't like it; if

they think 'it's different,' they hate it; if they mention that the price is 'reasonable,' they won't buy anything.''

Over and over again, there were comments about the broad interests of intellectuals in the Soviet Union as compared to Americans.

"Generally, the educated people in the Soviet Union are broader and better educated than their American counterparts. The average viewer may be the same, but a Soviet physician or a Soviet physicist also knows literature and art.''

"I dragged intellectuals to SoHo but they have no relation to modern art. In the Soviet Union the intelligentsia enjoys modern art but in America it means nothing.''

There were some minority views among the artists suggesting that those with interest in their art were the same types in both societies.

"My art isn't for simple people; they won't understand it. Culture doesn't matter. Educated people share the same world.''

A few artists suggested that in fact Americans have more understanding than Soviets for stylistic variation. The majority, however, thought that while the people who buy art in the Soviet Union may be especially intelligent and well-off, the Americans who buy art are the rich and near-rich. Rarely did the emigrés appreciate the investment considerations that motivate the decisions of many art buyers; they looked primarily for artistic sensibility in their audience. They criticized Americans for their lack of understanding and faulted them for not buying more original art works.

"People talk about the decorating possibilities of what they see, how it would look over their sofa—it's depressing.''

"People react well, but not with money . . . But galleries buy and show for money.''

"The gallery manager has a party for the Americans but the guests want to talk to each other. They stand around with their

backs to the paintings, drinking. After the opening, the Americans come back and consider. Then they go home again to consider and come again to look and to speak. These people are rich. When they spend a thousand dollars for the evening, they don't think about it as much.''

"The people who buy my work are the Russians who have just come.''

The artists disagreed about the willingness of Americans to trust their own judgments about art. Two of the artists thought that anthing could be sold somewhere in the United States, even with negative reviews or none at all. Most of the artists, however, thought that Americans were reluctant to trust in their own reactions.

"Americans are afraid of a dramatic style and of an unusual content. That's different in the Soviet Union and Europe. . . . In America, they want to know what school you belong to. If you belong to a school they don't know of, they're not interested. It's hard to be an individual.''

Margarita Tupitsyn, curator of the Contemporary Russian Art Center of America in SoHo, suggests that the difficulty is twofold.

"The Soviet artists are not ironic enough and don't use the language of the time. The Americans cannot understand the imagery; therefore, Soviet art has to be explained.''

Komar and Melamid, who make aggressive use of Soviet motifs, observed:

"We wanted to be Americans but we realized we couldn't. Part of our past, for example the Stalinist period, belongs to everybody. It may be misinterpreted by Americans. Still, people are interested because the art looks like another civilization with its own secret interests.''

Actually, the American public was more immediately receptive to the first Komar and Melamid exhibit than to most of the work shown by emigrés. The advance preparations for the exhibit were elaborate, and included making available to art writers extensive information on Soviet society and the specific setting of Komar and Melamid's work.[27] Gallery owner Ronald Feldman believes that the art critics who explained Komar and Melamid's work were crucial for the success of the show. When Komar and Melamid's "Biography," consisting of small, spread-out pictures, was exhibited, people stood waiting for turns to see it. Feldman phoned the artists in the Soviet Union to tell them about the show's success. When he reported that people were waiting on line to come into the gallery, Komar and Melamid were uncomprehending; for them, waiting on line was not at all an unusual event. Feldman had to explain that people in the United States did not often queue up to see contemporary art.

The disappointment that many Soviet artists experience with the reactions to their art is compounded by their isolation from viewers and buyers. The artists are rarely around when visitors come to the galleries and they have little opportunity to meet them at other times. From the gallery owner's point of view, which of course shapes the possibilities for contact between the Soviet artists and potential buyers, such relationships can be problematic.

> "Artists often don't know the people who buy their work. Most customers use the friendship to get cheaper art. They think it's cheaper art; often it's not. It's bad for us and bad for the artist. . . Such relationships destroy the market. The artists may sell a lot on their own at first—but then it stops."

> "Usually there's no follow-up in the relationship. They meet each other at parties and openings. If there are collectors in the gallery, they take pains to meet the artist. It's not so different in the Soviet Union. The real difference is in the relation of the viewer to the work of art."

A few artists maintained they did not need personal contacts with buyers, that it was more professional not to become friendly with

them. One artist who had received a list of the people who bought his work had no interest in meeting the buyers or in going to parties to see them. Yet many of the Soviet artists yearn for more contact and exchange. For those who sold work in their studios in the Soviet Union, there was the joy of having personal contact with people who supported them and cherished their art. If they sold their work abroad, there was the excitement of a wider, although still unknown audience. Now they wanted to work as "real, professional" artists, which meant selling their work in galleries rather than in studios to personal acquaintances.

> "In Russia, the people who bought art in my studio were friends or friends of a friend. They would call and ask if they could bring someone over to look at my work . . . I would like to know the people who buy my art here. Once I saw a young businessman come into the gallery and buy two of my pictures in a few minutes. The man seemed nice and full of life, but he walked out. Another time, someone bought a painting for a trade center out West. The gallery owner doesn't give me names. He doesn't want the artist to have the contact because the gallery gets half of the profit."

> "In the Soviet Union I didn't have personal contact except with the publisher who took my work. I saw the Union jury; sometimes they approved of my work and gave me money and sometimes not. Now I would like to see the people and speak with them. I don't understand why people buy what they do; I don't know why they reject something . . . it would be interesting to know."

> "I know one art collector here; the other people I haven't met. I will ask for it in my next contract because I want to know who they are . . . In the Soviet Union, aside from the galleries, intellectuals and musicians came to my studio to buy art."

Still, most of the artists were at least ambivalent on this point. They felt isolated and unappreciated but at the same time they saw themselves as leading a professional artist's life, something they

could not do in the Soviet Union.

The views the emigrés have of their audience in America do not give us a detailed and realistic picture of the American art audience. They do, however, give us a fairly accurate idea of how the American art scene—critics, galleries, buyers—is experienced by these artists who until recently lived and worked in the Soviet Union. Their experiences and reactions are quite varied, yet there are common notes. They dreamt of a quicker acceptance and a warmer response; still they are aware that they have had more attention than many of their American colleagues who struggle for years with little recognition. While often puzzled about the prevailing tastes and critical standards in the American art world, and preoccupied with the tension between their own past artistic identity and these different standards, they see the chance to work in America as a professional artist as outweighing such conflicts and frustrations.

The Dealers

Anyone who has some knowledge of the New York art scene can appreciate how bewildering that world must seem to a newcomer. There are gallery owners and private dealers who seem to have a profound understanding of art, and others who are interested only in the latest art fashion; many will only consider showing the work of artists who are well known and recommended; there are even wealthy amateurs who run galleries ''to have something to do.'' One emigré, after a fight with a gallery, began to send all of his work to a businessman who then marketed it. This relationship was perhaps atypically intense; it also was problematic for the artist, because it made him dependent on one individual who had no professional ties to the art world. Since my first interview with this artist the association has broken up and he can no longer count on these sales as a source of income.

Personal relations with dealers and gallery owners are, as we have seen, very important to the emigré in the early phases of settling in New York. They also have an inherent fragility. One artist had had a warm relationship with a gallery owner who recently died.

The artist expressed fears about his future association with the gallery:

> "He was a very nice man. I am so sorry he died. Before his death, he wrote to his personal dealer in Washington saying I was one of the best artists he had seen in ten years. But it was a closed professional relationship. . . . I wasn't invited to his home to eat or anything like that. We spoke only in the gallery."

This artist's fears proved justified. The gallery was eventually taken over by the owner's daughter, who decided not to renew the contract because "she wanted expensive artists."

The more complicated relationships, however, are probably with the Soviet emigré dealers. In a new, unknown atmosphere, the tensions of arranging exhibits and payments understandably feed suspicions of unfairness, being taken advantage of, and lack of appreciation. These feelings are not peculiar to Soviet artists, but they are probably intensified by the difficult circumstances. Emigré art dealers and collectors also struggle in New York; they, too, brought with them hopes and plans for what they would accomplish in this new and very different world. They are from a variety of backgrounds, and in some cases were not professionally involved with the arts in the Soviet Union. Some believed they could latch onto something with great financial potential, others were primarily committed to showing the American art world the contribution of Soviet artists; but all experienced difficult times and in some cases still face an uncertain future.

Eduard Nakhamkin, a gallery owner specializing in Soviet art, had little contact with Soviet dissident artists in the Soviet Union. Before coming to the United States in the late 1970s, he taught mathematics. He had many problems establishing himself, and was well aware that artists were reluctant to show their work in a new, unknown gallery. Now he has an established gallery on Madison Avenue that does considerable business and has been stable for several years, and another one downtown in a building he owns; he also has galleries in Los Angeles and San Diego.

Rowman Kaplan, an emigré who manages a gallery, taught litera-

ture in the Soviet Union and later in Israel. He had some training in art criticism while still in the Soviet Union.

One of the first emigrés committed to taking Soviet art abroad was Alexander Glezer, who opened the Museum of Russian Art in Exile near Paris and is now curator of the Museum of Russian Contemporary Art in Jersey City. While in the Soviet Union, Glezer translated Georgian literature into Russian. He was an amateur art collector and helped arrange exhibits of dissident art even before he emigrated to France. Some of the artists disapprove of his persistent emphasis on the political history of their lives as artists in the Soviet Union and the political themes he uses in promoting Soviet emigré art. A man of extraordinary energy, Glezer had great hopes for the development of the new museum in Jersey City, but the museum has been plagued by financial difficulties and there is some doubt about how long it will be able to remain open. He is puzzled by its lack of success and by the disinterest of Americans.

Margarita Tupitsyn, the curator of the Contemporary Russian Art Center of America in New York City, is the youngest of this group. She attended university for two years in the Soviet Union, specializing in art history, and is now in a doctoral program in the United States. Since becoming associated with the Center, Tupitsyn has written several informative brochures and articles explaining contemporary Soviet art and the work that is being shown in the Center. Financed by a private collector and not a commercial gallery, the Contemporary Russian Art Center shares with one of the emigré art galleries the eleventh floor of an otherwise empty office building. The hope was to develop an international art center with a restaurant or cafe. The opening, a gala event to which all the "star" Soviet emigrés in the United States were invited, included waiters dressed as Cossacks. For now, however, all these hopes remain unfulfilled: both the downtown gallery and the Center struggle for financial survival.

The artists understand that the "Russian" gallery owners have had to learn about the New York art world just as they did. If a gallery specializing in Soviet art were to falter and eventually close, some of the artists would have real difficulty exhibiting their work at all. They therefore understood that a gallery owner had to take a

substantial percentage of the price paid for a painting in order to keep the gallery open; nevertheless, they were prone to suspicions that they had not been paid adequately.

> "I needed money and went to M. He bought several lithographs for a certain amount of money and sold them for more—much more. I was upset. I was thankful because I needed the money then but I was upset later. I do trust him, though, in many ways . . . I think I could always go to him."

> "He is like a spider. He waits until the artist is in difficulty and then buys his paintings. He bought my paintings in advance and sold them for four to five times the amount he paid for them."

One gallery manager observed that the artists try to find out what their colleagues are paid in order to assess the fairness of their own treatment. That is one reason the owner of the gallery does not develop close personal relationships with the artists, and objects to his employees doing so.

As mentioned earlier, several of the artists would prefer not to identify themselves as emigrés and they hesitate to exhibit in galleries specializing in Soviet art. One informed me before our interview that he did not consider himself a ''Russian'' artist at all. If such a person has no choice but to exhibit in an emigré gallery, or decides that it is his best possibility for succeeding in a difficult situation, there is probably even more ambivalence in his relationship with the dealer than would normally be the case.

The artists are dependent on dealers for approval, for money, and for their link to the American art public. On the outside they may be friendly to the dealer and even somewhat trusting—they have to be. But deeper down, they feel competitive with other Soviet artists and suspicious that they are not earning as much money as they are entitled to.

> "My relationship with these people is purely a business relationship. P. took my paintings and put them in his museum. He sold them and didn't give me the money. I felt cheated."

"With M., it's mostly a business relationship. I don't drink vodka with him; I don't go home with him."

"All the dealers are businessmen, not my kind of people. I have the same reaction to all of them. There are people in this world who do and people who use. They use the work of others for profit. I also don't want to be in a Russian gallery. I wanted to come to America and be an American artist in an American gallery."

Two of the artists, while still in the Soviet Union, made contacts with European dealers who were very enthusiastic about their art. Because their work seems to be more successful in Europe and because of the strong commitment expressed by the dealers, these artists feel more supported by their European dealers and more appreciated by Europeans. They developed close friendships with the European gallery owners. Two artists expressed strong feelings of trust and gratitude for their American dealer; they feel he has helped them tremendously. Very few, however, expressed similar sentiments. There was a somewhat more positive reaction to one gallery manager, who is probably less involved in the financial negotiations with artists than the owner is; still, even he was described as "just a businessman" by a few of the artists. He, on the other hand, considers the artists his friends and sees them outside of the gallery: "It is not a business relationship."

Of course, some of the anxieties and suspicions emigré artists have in their relations with dealers are shared by their American colleagues. In a study conducted by Bernard Rosenberg and Norris Fliegel, American artists expressed a great deal of resentment of dealers, and only a few examples of good relations were reported. The American artists' complaints were not unlike the emigrés'.

Many artists feel that they are lifting the lid of corruption just a little to let us glimpse a hideous world they know too well. In their eyes many dealers are irresponsible ("they don't handle the person correctly"); actually cruel ("they'll pick up artists and drop them"); filled with resentment ("unconsciously they hate artists,

lots of them are frustrated artists who can't stand productive people and they take their revenge on us''); exploitative (''they take advantage of artists, but what's worse, they take advantage of ignoramuses who come to them for advice''); meretricious (''gimmicks are their stock-in-trade''). They are above all, powerful agents of a sick system and a sick society which no artist by himself has the strength to lick.[28]

Most artists recognize the necessity of the dealer, but the Soviet emigrés are a bit idealistic in their expectations, perhaps, since they see the art world in the United States as more professional, freer, and more varied than the one they left. However, those artists whose work is rarely exhibited in New York, or who lose their connection with a gallery there that has supported their work, feel a sense of doom. They may retain some connections to art galleries elsewhere, perhaps in California, but they are cut off from the city that is the center of the art world as they know it. It is these artists who may now condemn most galleries as crass commercial enterprises.

The artists who are more successful are often, precisely because of their success, aware in a different way of the tensions of making a transition from one world to another. Here we can observe an interesting development. Although these artists seek to understand and respond to the artistic sensibilities prevalent in the New York galleries, it seems that they also develop a new acceptance of their Soviet experience, both in personal life and in art. While they seek to reveal elements of this past experience in their work and to share it with their new audience, there is also a realization that in some important respects they are alone, outside both worlds.

The sense of being outside the system is, of course, experienced by many artists. However, its roots are only partly the same in the case of the emigrés, and their feeling of isolation, moreover, is the more poignant since many of them were once part of an artistic community which they know will never be recreated in the United States. Nearly all of the artists I interviewed spoke of the intense personal and working relations they had had with their colleagues in the Soviet Union. Although it may be tempting to idealize such relationships after emigration, to ignore feelings of jealousy and

other conflicts and tensions, it seems that the shared excitement and commitment to their art had indeed created a special environment.

The Colleague Group

Within the Soviet art world, there are many different ways for artists to maintain close contact. They may live and have their studios in the same building—there are several such special houses for artists. They are able to look at each other's work regularly and talk about what they are doing. Even if they do not live in such close proximity, artists frequently gather together in studios or apartments to talk and to drink, sharing ideas and dreams and dissatisfactions.

> "In Russia, everyone is in a group. You know everyone. There are different places for graphics or for ceramics. Most of my friends were together in one circle—or they were sculptors . . . In Russia, telephoning was hard so friends dropped by (without making an appointment). I lived thirty-three years in Russia and selected friends. I had the time—and it took time."

> "In Russia, one dreams about another life together because you can't only have this life. An intelligent man needs these dreams there . . ."

Some groups met to look at productions of contemporary art or to discuss and work on innovative art forms. One circle formed at the end of the 1950s around Oscar Rabin and his teacher Evgeni Kropivnitsky. Another met in the apartment of the art historian Ilya Tsirlin, who was chairman of the critics' section of the Moscow Artists' Union of Cinematography and director of the book section of the main art publishing house, "Iskusstvo."[29] A woman who had been in the Beliutin studio spoke of the understanding that existed among the members of their group:

> "We could speak about anything, admit to artistic problems as well as other difficulties. We helped each other progress in our art. We discussed creative problems."

The members of such circles lend each other art magazines from the West and teach each other new techniques they have learned. An American art student who made many contacts with artists during a visit to the Soviet Union[30] recalls their hunger for information:

> "I was both embarrassed and amazed at the incongruency in the level of knowledge and exposure. One artist in Moscow looked disgusted when I handed him a two-year-old copy of *Art in America*. He spoke knowledgeably of current artists . . .
>
> "The artists/feminists in Leningrad were avid readers of the conceptual magazine, *High Performance*, yet they had never even heard of Judy Chicago.
>
> "Another artist, a man in his fifties, turned to me in the middle of a 'rock' concert and asked me what I thought of 'New Imagism.' I squirmed in my seat and replied that I was not familiar with the term. Later, we handed him a box of oil paint sticks, . . . something he had never seen before. He made us read the words printed on the box several times and was so enthralled that he invited us to his house the next day to show him how to use them."

Rimma and Valery Gerlovin remember the Friday evenings when they used to get together with friends and vote on which journals they would read and translate. Vitaly Komar describes their gatherings in small studios to listen to translations of the latest issue of *Artforum*.

> How difficult it is to understand something you know nothing about . . . it is pure torment to get inside a foreign text . . . However, we were not deterred by such difficulties. We pored over those glossy pages with reverence, scrutinizing the colored splashes of the reproductions, the self-expression of distant and unknown American souls, until our eyes blurred.[31]

Out of such shared reading, translating, and studying came collaborative artistic production and the collective construction of performances. Collaborative work is an interesting phenomenon. It exists in the United States as well, but it is much more common in

the Soviet Union. The American art student mentioned above observed:

> "Collaborative work seems to be a popular technique among the Soviet conceptualists . . . They come together to gain strength and fertility in a piece. With all the governmental restrictions placed on these artists, they realized a need for collaboration. Artistically, this secure, open collaboration has reduced an overgrowth of the artist's ego which is commonly fatal to American artists."

I explored the process of collaborative work with Komar and Melamid. They begin by discussing their ideas and making separate sketches. They select parts from each sketch and then compose a final one. They then start two separate paintings and at some point switch and continue the other's work.

A very important product of the artists' groups are the performances they construct. The Moscow Collective Action Group, which includes both artists and poets, often works with concepts related to Zen—for example, the idea that art should not be different from life but an action within life.

> The . . . sense of contemplation and tranquility is reflected in such ritualistic performances as *Balloon* . . . The participants filled a large cloth sack with balloons for six hours in the rain. They put a bell inside the sack and let this inflated sculpture drift down the Klyazma River . . . [Only]the group members were present.[32]

During other performances, the goals of the group are different and viewers participate.

The youngest "art team" in Moscow is the Toadstools; the five members work in all media and are in close contact with the Collective Action Group. Both groups create books, some of which become part of their performance art. The Nest Group "emerged during a performance of *Egg Hatching* as the three artists 'hatched' eggs in a huge nest during an exhibition of unofficial art at the Permanent Exhibition of Agricultural Achievement."[33] This group

remains in close contact with Komar and Melamid and put on a
"Half-Hour Attempt to Materialize Komar and Melamid" on the
day of the artists' 1978 exhibit in New York, after the two had left
the Soviet Union.

The Collective Action Group, says Margarita Tupitsyn, consid-
ers the production of tangible objects to be without purpose since the
artists can not sell or freely exhibit them.

> "It advocates performance art as a medium more suited to a
> closed society since it gives the illusion of travel (most perfor-
> mances are outdoors) and active change. Furthermore, perfor-
> mance art seems more appropriate in a transient environment, an
> artistic milieu partly depleted with the emigration of so many
> colleagues. More importantly, these Soviet artists, now more
> informed about recent Western developments, want to finally
> bridge the gap existing between Russian and Western artistic
> sensibilities since the decline of the Russian avant-garde in the
> 1930's."

Often Soviet artists' circles include intellectuals from a variety of
fields who are interested in having discussions with them or even
working together on projects. Ernst Neizvestny recalls[34]:

> "Within my circle were people of the most varied professions:
> mathematical logicians, Marxist philosophers, poets,
> semioticians, topologists, and so on. All of my activity was really
> of a samizdat nature because I fulfilled their spiritual needs in
> sculpture and they fulfilled my spiritual needs in other fields. It
> was an exchange for us."

The intense friendship relations that flourish in these creative
collectives and discussion circles must be seen in the larger context
of Soviet society. Soviet artists, like others, find in their friends and
close colleagues an important source of emotional and practical
support. The commitment of "unofficial" artists to creating an
alternative to "official" art in the Soviet Union, and the complica-
tions they encounter in attempting to do this, are crucial components
of their attachment to their community and the importance of close

personal relationships in their lives. Mutual trust is highly valued because so much in one's life depends on that trust. The fact that the artists see philosophical and spiritual meaning in their art gives these friendship relations great intellectual substance. They share their artistic, metaphysical, and even political concerns with other questioning creative artists and intellectuals. This creates an ambience that is difficult to recapture in American society. [35]

Although a few of the artists I interviewed in New York stay in contact with other emigrés, the intensity of their relationships is often greatly reduced. There are many factors involved in this change. An obvious one is that the artists live far away from one another and therefore have to plan trips well ahead of time. Because of the distance, and because they now have telephones, dropping in unannounced is less frequent and visiting patterns become more like those of other Americans living in New York City. If an artist lives and works outside of the inner city, not only do colleagues visit less often, but relatively few people, Americans or Russians, ever see the artist's work-in-progress, in his studio.

The artists react to their new, more isolated lives in a variety of ways. Some miss the closeness they once had in the Soviet Union. "[At] first I had a sickness," said one. "There was no one to talk to." One of the women reflected: "I long for the intense life we had, not only with artists, but with students who worked with us; I don't know if it's possible to repeat it."

However, isolation is not only something imposed by geography. The emigré artists are very anxious about "making it" in the United States. For one thing, an artist has to produce more in the United States than in the Soviet Union, in order to be self-supporting. For another, many of the emigrés are still unsure about how the New York art world functions, and some are uncertain about their own artistic development. Overwhelmed by these problems, they use all their energy for their artistic and professional endeavors and have little left for other concerns, even for friendship, which is so valued.

"Immigrants don't discuss problems; they work as individuals, I had friends when I was young. Maybe it's age but there's tension now. There's no time for discussion. You have to establish yourself or get out. Maybe, after some years, I will have time to sit

down and have a beer . . . when I have established myself.''

"In France, people helped me. America is hard; no one has time to see you. Even my Soviet friends are too busy here with their own problems to see you too often.''

The artists must struggle so intensely to succeed that they often find it difficult now to appreciate the accomplishments of their fellows. Although a few take the energy and time to offer support, several expressed feelings of jealousy and a desire to avoid contact with most of the other emigré artists in New York.

"I see Russian artists only if I'm in the gallery. I'm not interested in being friendly with them.''

"I don't like Russian artists here. Two artists meet and there are three opinions. They hate each other. They express jealousy and have sensitive natures. I think I'm over these feelings.''

"In New York, the artists come from different cities, I know them but I'm not too close with them. In the Soviet Union I had good friends, but among the Russian artists, there are problems and competition . . . Americans are normal and quiet. Russians are a bit crazy and nervous. They're not comfortable to be with. They want too much, but people aren't interested in them . . . I want to forget. I don't want to see Russians, to be with Russians.''

Another aspect of making it in America derives not from competition and jealously, but from diversity of artistic development. In a new art world whose standards are partly understood and partly alien, the options for response are so numerous that former colleagues and friends who shared an artistic culture in the Soviet Union now drift apart.

Although two of the emigré artists I spoke with have American friends and colleagues, the contacts most of them have with Americans—artists or not—are very limited. One problem is language: the conversations they can participate in in English are "simple" and not particularly engaging. When I spoke with one of the artists about

learning more English, his daughter replied, "Why? He doesn't speak to anyone." Many emigrés remain hesitant about approaching American artists until they start to feel secure again about their work. One admitted, "My level isn't ready for American artists, but I dream. My dream is to talk to American artists and get to know them." When contact does come about, it can be disappointing, according to one artist who took the plunge. "I finally decided to see an American artist whose work I admired. He was polite and kind but refused to show me his paintings. I was shocked."

It is the view of one gallery owner that the Soviet emigré artists have no contact at all with their American peers *and* that American artists have no contact with one another. One emigré suggested that American artists do not have the same need for intense discussion that artists have in the Soviet Union.

> "American artists don't like to invite and discuss because it's all open. You can go and see everything you want to and evaluate yourself and others. There's nothing to discuss."

A few of the artists were relatively successful in making close contacts with Americans. One had lived in the United States for a considerable time—seven years. However, he had been terribly lonely until he divorced, left the small town where he was living, and moved into the inner city. A second was a well-known artist whose studio in the Soviet Union had been a gathering place for other artists and intellectuals. When he came to the United States, he was able to move to a large studio in SoHo. The artist told me that he has a circle now, although the people are much more spread out than in the Soviet Union. A small group of younger artists, in SoHo, have created a sort of community through their performances and their mail art. They conduct "mail-art exhibitions" by sending small folders of their work to other American and European artists, and through these contacts are able to move beyond the confines of their studio. They have more contacts with other American artists and with a variety of small galleries than most of the emigrés.

The emigré artists are ambivalent about their isolation. On the one hand, some expressed regret about the loss of close friendships

with other "Russian" artists as well as about the lack of contact with their American peers. Several mentioned that they did not understand Americans, "the American soul," American psychology, the American life-style. On the other hand, they identify themselves as professional artists in the American sense; that is, as they perceive Americans to be. They are able now to do the work they want to do, look at the art they want to see, read the books they want to read. Here, *talk* is not important; *work* is.

Yet their isolation, whether embraced or tolerated, takes its toll. Close contact with colleagues and friends who are grappling with similar problems could be a valuable support in the American art world, as it was in the Soviet Union; yet the competitive structure of artistic production in capitalist society makes such mutuality very difficult. Losing it can have profound consequences, for the rapport between artist and artist, and the relations between artist and critic, viewer, or buyer, seem to go to the very heart of artistic creation. If we see artistic work as a personal and social construction—building into the void, as it were—the artists' social world becomes more than the environment of their work and acquires artistic significance. A radical change in one's relation to other artists, then, means a change in the very foundations of one's art.

Thoughts on the Function of Art

Soviet and American society differ profoundly not only in the social organization of art, but also in their understandings of its function and role. Many of the Soviet emigrés I interviewed spoke of the importance of content, of the eternal truths revealed in art; they displayed a concern with social or spiritual purpose that is not typical of many American artists. Those who are at odds with official Soviet ideas of art, whether they emigrate or continue to work in the Soviet Union, are not united by a single, shared artistic outlook. On the contrary, their styles differ and so do their philosophies. What they have in common is a protest against the political control of art. As Igor Golomshtok notes, what the "unofficial artists" rejected in the mid-fifties was not so much "the dogmatism of socialist realism as . . . its bureaucratic optimism in the interpre-

tation of reality.''[36] Rather than accepting this as their task, artists turned to the creation of a new reality and to new creative concepts. Lev Kropivnitsky, who was released in the mid-fifties after nine years in a labor camp, writes of that time, "I underwent a transformation."

> The business of the artist is art—and only art. Teaching, propagandizing, laying down the law, is not his business. This I knew. And know. All activism is alien to me. Even inimical.[37]

Tupitsyn suggests that the "New Wave" artists in the Soviet Union today are cynical about those artists who believed art could change the world.

> "They don't believe art can change anything. They know what's going on. They have information from the West. In the '70s, when we left, we didn't have this."

Some of the artists I interviewed argued against any manipulation of culture, since this would only repeat in another form what they had fought against in Soviet official art. Yet most seemed to believe, nonetheless, that their art should be more than an end in itself; they tend to emphasize truth and purpose in their art, more than aesthetic pleasure.[38] And insofar as they set out to break the socialist realist mold, to change perceptions and to create a new reality, they and their art must function in opposition to Soviet political ideology. One art collector observes[39]:

> "Russian artists don't paint for themselves; they are always serving an ideology. Art for its own sake is a dear notion for Russian underground artists. They say they should be allowed to paint what they want, but the reasons for painting have another ideological context. There are major exceptions such as those who flirted with abstraction for a while; but inevitably, it led to a message."

In their art, Komar and Melamid make fun of Soviet bureau-
cratism, socialist realism, poster propaganda, and so on. Unlike
most of the emigrés, they also turn their irreverent attention on
American culture, satirizing pop art, for example, "to comment on
the commercialization of our notions of aesthetic value and our
whole social milieu."[40] John Bowlt suggests that Soviet artists' very
different view of the function of art helps explain the indifferent
responses they often encounter in the West. The emigrés, he says,
now live and work "in a sybaritic society that tends to regard artistic
creation as a form of recreation. They find it hard to stimulate
general interest in the urgent political tasks of Soviet art, the more
so since the art in question belongs to a specific political
structure."[41]

My respondents saw similar contrasts, but they tied them less
directly to politics. As one explained:

> "There is an historical tradition influencing our notion of art. Art
> was important in the church. Religion without art would have
> been empty. The function of the artist is to give people the feeling
> the artist has and they don't have. A real artist expresses what
> people feel deep in their souls."

This artist drew an interesting comparison:

> "I deeply respect Pollock and de Kooning. They are spiritual
> artists who express feelings close to religious ones . . . but
> Warhol and Rauschenberg reflect real American life. A mirror
> also shows what American life is. Without doubt it's art, but it's
> like socialist realism."

Other respondents echoed these sentiments.

> "Artists have intuitive power, a sense of the universal . . .
> American artists tend to think of art as a profession. For me, it
> involves something like a religious commitment."

> "Western art is really perfect with color and line, but Russian art
> expresses an emotional and spiritual inner being."

One of the artists I interviewed said he believed that art reflects society, not something greater or higher; but most of the others see their art in the service of higher values. As John Berger wrote:

The Russian cannot believe that the meaning of his life is self-sufficient . . . He is inclined to think that his destiny is larger than his interests . . . Russians expect their artists to be prophets because they think of themselves, they think of all men, as subjects of prophecy.[42]

The importance of the spiritual was particularly mentioned by several of the artists. In this view, art ultimately expresses something religious. Most of these artists put their belief not so much in a specific creed, but more generally in a universal God. One artist said that art has to involve God, another, that it is impossible to be a real artist without faith: "Art is guided by God and in the faith that some things are meant to happen." In their "Petersburg" group manifesto, *Metaphysical Synthetism*,[43] issued in 1974, Mikhail Chemiakin and Vladimir Ivanov wrote:

Art means the paths of Beauty leading to God. The artist must always aspire to God. The power and vitality of his style are determined by the extent of his faith. "As the branch cannot bear fruit of itself, except it abide in the vine, no more can ye, except ye abide in me!" (St. John, 15, 4)

Undoubtedly this religious or metaphysical dimension adds to the distance between Soviet emigré artists and the art world of the West. Some artists of both cultures, of course, use Christian symbols or Jewish themes in order to appeal to the nostalgia of certain groups; but this is not the sort of art of which we are speaking. In the contemporary American art world, one encounters few explicit invocations of religious themes. By contrast, the use of Christian and Jewish religious symbols has been very important for some of the leading unofficial artists. The symbols, as Igor Golomshtok explains, are used not to invoke some theological orthodoxy, but to mark a rejection of materialist values and to make contact with an ultimate—human or transcendent—reality.

> Since the permitted forms of religious life and access to them are
> so very exiguous, art is often the only way of making contact with
> the spiritual: it becomes a means of acquiring religious under-
> standing, thus transforming itself into a metaphysical act.[44]

One emigré who uses Jewish themes in his work spoke of clarify-
ing his own relationship to Judaism.

> "In the Soviet Union, I began to ask myself who I am. I'm not
> really Jewish, not a communist, not a capitalist. I began to think
> and go back to my Jewish roots. My mother was religious. I
> thought of familiar scenes from her house. I began creating some
> Jewish art. I am not religious, but I do believe in God."

Another remarked that his strong identification as a Jew distanced
him from the cultural heroes of other Soviet intellectuals, for exam-
ple Tolstoy and Dostoyevsky. He did not identify with the Russian
dissident movement and said he thought no Jew could depend on a
Russian in a difficult situation. Most of the artists, however, were
less particularistic in their beliefs and identifications. Very few of
the Jewish artists attended synagogue, even for the high holy days,
and almost no one of the small group of artists who identified
themselves as Christians went to church.

In general, the artists who ascribed such important functions to
their art were frustrated in Soviet society. They charged themselves,
as the "official" artists were charged, with "carrying a message."
But they had no way to reach the masses of people, to influence their
perceptions and beliefs. They were powerless to effect social change
through their art. Indeed, to support themselves, they often had to
accept official commissions—and be glad of them. Several of the
"unofficial" artists proudly saw themselves as alienated and truth-
searching intellectuals. They saw American artists as commercial-
ized and degraded, running after the galleries and standing with
society rather than against it (apparently they were unacquainted
with the complaints and feelings of isolation and alienation ex-
pressed by many American artists). The good artist, they thought,
should stand against society. But at the same time, even for the

nonconformist, being at odds with one's audience can be painful, and debilitating.

> Not being able to share the imposed values, beliefs and culture of the mass, the majority's misconception of reality and of the society . . . the artist comes to doubt his own ideology. There is a fear of not being able to represent and reflect the needs and the values of the majority in the artist's own work, which is derived from his or her own values and ideology.[45]

One emigré reflected that it was rare for people anywhere in the world to fully appreciate the eternal truths revealed in art—and rare for the artist to express spirituality in his or her life.

> "All countries are afraid of art. People don't like eternal truth; they don't want it . . . The serious artists in Europe care about the inner world. Artists are like Jews in Russia. They want survival. They carry on normally in their lives but express what they want to in their art. Here, nobody cares; there is no pressure."

The Intensity of Artistic Life

Most of my respondents in New York recalled the great respect the Soviet public has for the artist, the awe in which the artist is held, the hunger for art, the lively response of the public to genuine art and its support for it.

> "Some days in Russia, hundreds of people came to my studio; here maybe twenty show up at the most."

> "The artists feel the importance of their art more in the Soviet Union . . . In Russia, people would go anywhere to look at a work of art . . . Here, there is no hunger. There, people hunger for something new."

This recalls a passage from Alexander Zinoviev's novel, *The Yawning Heights*:

> I watch E.N. working, and my little affair begins to look insignificant and not worth bothering about. I have said that E.N. is my

artist. That was putting it too weakly. E.N.'s art is an inalienable part of my existence. I cannot think what would become of me without it. I enter E.N.'s studio like a temple, and cleanse myself of the filth of the world.[46]

Several of the emigrés remarked that in the Soviet Union, people responded with something like reverence when they discovered an artist, whereas in the United States only the famous artist, the celebrity, was regarded as special. One of the artists realized that the public's view of the artist intensely affected her self-conception as well.

"In the Soviet Union, it's rare to be an artist. You feel as if you're the only person doing it. Here you feel the same but in the general eye you're lost. You're not seen as anything special in the society, and in the end that affects how you feel as an artist."

Some of the emigrés thought that Americans did not take art very seriously, that they regarded art as an amusement.

"For Americans, art is fun and drink—on a higher level perhaps. For Russians, it's as if something comes out from the inside . . . Here, the artist is just a strange kind of businessman. Russians have a holy reaction. They will stand a few hours in line to see an hour of an exhibit. Americans won't do that."

Another respondent related the different attitude toward art to broader contrasts between the Soviet Union and the United States.

"I don't blame the Americans. I understand. Here in New York, there is so much going on, so many artists, so many films, so much theatre. There is a fantastic choice here. In Russia, there is much less to do."

These are only partial explanations, however. The intensity Soviet artists have experienced relates also to the function of "unofficial art" in the Soviet Union, discussed earlier, and to the shared concern for what it represents among members of the intelligentsia, not

only artists but scholars and scientists as well. Moreover, the commitment and support by members of the intelligentsia implies an understanding for the art form. Artists spoke of the greater verbal exchange in studios in the Soviet Union. One described exhibits as "intellectual fun" enjoyed by students as well as intellectuals and technocrats. "The money aspect wasn't at all important." Nearly all the artists I interviewed spoke of the divisions between artists and other intellectuals—writers, scholars, and scientists—in the United States.

> "In Russia, there is not such a division of artistic and intellectual life. It's the same. People educate themselves because there's not much else to do. In Russia, it's a small world which one can enter. There is an effort to find truth in life and in politics."

The intensity of cultural life in the Soviet Union, then, depends largely on shared understandings, a shared spirit, common goals, a way of life.

Of course, this shared intensity may be sacrificed if young Soviet artists, influenced by Western trends, move in radically new directions that will find little comprehension outside of the most innovative circles. Margarita Tupitsyn describes the diversification of the contemporary Soviet art world. Some of the younger, more experimental artists, she says, not only have not "earned the respect" of the authorities; their work is controversial even among some of the "unofficial" artists. "Their styles vary, but offer a new attitude toward artistic creation that is opposed to the previous generation's attitude of art as religious practice." Nonetheless, the performance artists, for example, "attract audiences hungry for new experiences, who are not yet saturated by innovative artistic developments."

The special intensity of the Soviet artist's life is irretrievably lost to the emigrés in New York. Yet they find another kind of intensity, springing not from the shared enthusiasm and the bond of people daring to create and appreciate new forms, but rather from a sense of new possibilities, the opportunity to experiment ("If you can't experiment, there's no art," said one), and from the variety of the art they are able to see in New York.

"Here, you can go from one gallery to the next. Technical work is brought to its peak. The examples here are better. New York is like a blacksmith that bangs out the best."

"Although some of the art is terrible, the serious and good people have the highest standards in the whole world. What is here now, will be in the Soviet Union in twenty years. Americans advance all the time."

Some of the emigrés hold on to a more traditionally romantic image of the artist: the "bohemian lifestyle" is desirable; "real" artists live dangerously, they do not need the same security as other people. In the Soviet Union, they say, "The artist is not like Van Gogh; he is just another worker." In America, "the artist is a businessman." One emigré observed:

"For American artists, art is business. They are other men, other human beings. They are not so spiritual; they're cool, professional in their art. Still, I admire their professionalism. Russians don't have the same technical skill but they are warmer, more familiar, friendly . . . Here, one must be selfish, be his own man."

Complaints about "art as business" can be heard from American artists as well, of course. The emigrés tend to overestimate their American counterparts' identification with the system of art that exists in the United States.

Emigration, and settlement in New York, has brought for the Soviet artists exposure to a tremendous variety of new art, the excitement of being able to experiment, and the chance to live and work as a "real artist," whether in the image of nineteenth-century bohemianism or twentieth-century professionalism. Yet their separation from a context of meaning, and the loss of mutual support and intense exchange in an artistic and intellectual community, has also meant for many a loss of inner security, self-esteem, and a vital stimulus for their creative work.

Coda: Dilemmas and Difficulties

Just as the artists shared with other Soviet emigrés many reasons for leaving the Soviet Union, they are challenged by some of the same problems upon arrival in the United States. They come to the American art world with a different history, a different education, a different political experience. "It's as if we were children. We have to start all over again," said one of my respondents. They find it difficult to understand Americans, to get to know them well.

"It's hard to understand the American soul. In Russia, with some people you can keep silent. But I can't do that here. I don't understand them, so a real connection isn't possible. My friend Y. in Russia, for example, can get the character of a plumber in a few moments by watching his movements. That is impossible here."

The emigrés complain about the "American life-style"—always rushing, meeting "contacts" at cocktail parties, not really learning to know people, forever making superficial acquaintances. Many, after an initial vain attempt to assimilate, begin to associate more exclusively with other emigrés, in a pattern that is a compromise between the society they had known before and the new one in which they must build a life. But none of this is unique to immigrants from the Soviet Union.

Soviet artists face some special difficulties in emigration. In hopes of inducing a response to their work, some are tempted to adopt the techniques of American contemporary art without having a real understanding or sympathy for it. It takes time to really integrate new forms. The artists worry about their development, and about the time it is taking them to adjust; they are anxious to exhibit and to assimilate into the American art world. As one said,

"I knew Western art through reproductions. I had a pass to Lenin library . . . Still, the Soviet artist here is like a tree planted in new soil. The artist has to see what he missed, reevaluate everything, even himself."

The emigré has also to learn to deal with the American art market, a complex world that is far more commercial and competitive than they had ever anticipated.

"In the Soviet Union, life is sheltered. You don't develop the initiative you need to make it in America . . . The only possibility of becoming well known here is by [spending] millions of dollars to create an image . . . But Russian artists aren't businessmen."

Finally, the artists are ambivalent about their goals. Some of their values are contradictory. They want a studio and prestige, but they think Americans emphasize such things too much and they criticize American artists for a lack of dedication to art. While they elected to become professional artists in the American sense—with no security, but no restrictions, and the possibility of enormous success—they were quite unprepared to have to "sell" themselves. The emigrés are attracted and also repelled by the image of the "artist as businessman."

"You have to persuade others and be a salesman. Most Americans have that training from childhood."

"They say their paintings are worth thousands of dollars, but there's no market for Soviet art. Still, although money and recognition are important, the artists don't want to prostitute themselves."

But some find it hard to hold fast to their high principles when they have no one but themselves to rely on.

"In Russia, you can be poor and a free man. Your friends, your parents help you. Here you are alone and no one helps you. You think about money all the time."

This particular artist had hesitated to sell his paintings in the Soviet Union because it interfered with the "spiritual" element in his work. In the United States he has had to change. "If a painting is less successful, I finish it anyway rather than just put it aside."

Poverty in the United States is not an artist's badge of pride, it is a sign of not "making it," of the impoverishment of one's dreams and hopes. There have been a few suicides among the emigré artists, here and in other Western countries. Many emigrés find it very difficult to come to terms with their lack of success. Others are more realistic.

"Some artists are stupid. Last week L. committed suicide. He threw himself under the train. Artists think all America waits for them. I know that's not true. I'm Jewish. No one waits for Jews to come. Some think they are great geniuses and people will give them everything . . . I know I'll reach my goals and make it but I have to take it easy. I work."

A few of the artists have made quite successful adjustments to their new life, but the majority expressed feelings of isolation and were anxious about the future. As one artist put it: "You should write how alone Soviet artists are in America."

Notes

1. Students from the Rhode Island School of Design visited one such experimental school in Moscow, met and talked extensively with the teachers and looked at the students' work. They were most impressed by the high technical quality of the art. In this particular school, 700 students attend classes twice a week for three hours; included in this program is a theory course for students fourteen and older.

2. Martiros Sarian, the Armenian painter, is an example cited in the review of Sjeklocha and Mead's book, *Unofficial Art in the Soviet Union*, in C., "Art and Apparat," *New York Review of Books*, May 9, 1968, p. 5.

3. Information provided by an official of the Union House for Artists, Leningrad.

4. Alexander Glezer, "The Struggle to Exhibit," in Igor Golomshtok and Alexander Glezer, *Soviet Art in Exile* (New York: Random House, 1977), p. 118.

5. Igor Golomshtok, "Unofficial Art in the Soviet Union," Golomshtok and Glezer, *Soviet Art in Exile*, p. 86.

6. C., "Art and Apparat," *New York Review of Books*, May 9, 1968.

7. Igor Golomshtok, "Contemporary Art: The Alternative Tradition," in Archie Brown, John Fennell, Michael Kaser, and H.T. Willetts, eds., *The Cambridge Encyclopedia of Russia and the Soviet Union* (Cambridge: Cambridge University Press, 1982), p. 182.

8. Betsy Gidwitz, "Problems of Adjustment of Soviet Emigrés," *Soviet Jewish Affairs*, Vol. 6, No. 1, pp. 27–42.

9. Paul Panish in his book *Exit Visa* (New York: Coward McCann and Geoghegan, 1981) describes in detail these experiences of the emigrants in Vienna and Rome.

10. Melvyn Nathanson gives a detailed account in *Komar/Melamid: Two Soviet Dissident Artists* (Carbondale: Southern Illinois University Press, 1978), p. xi.

11. "Of these twelve, perhaps 4 or 5 make incomes of $50,000 a year. Two artists living in Paris (one is now in New York) derive incomes of close to $100,000 in one case and more than $200,000 in the other from their American sales." Norton Dodge and Alison Hilton, *New Art from the Soviet Union* (Washington, D.C.: Acropolis Books), p.4.

12. Martin Greenberg, "Agency Concerns: The Special Problems Confronting Agencies in Providing Services to Immigrants from the USSR," in *The Soviet Jewish Emigré* (Proceedings of the National Symposium on the Integration of Soviet Jews into the American Jewish Community, Baltimore Hebrew College, 1977), p. 140.

13. *Ernst Neizvestny* (New York: Euramerica Translations Inc., 1978).

14. William M. Mandel, *Soviet Women* (New York: Anchor Press/Doubleday, 1975), p. 322.

15. For further discussion on the role of women in Soviet society, see Dorothy Atkinson, Alexander Dallin, and Gail Warshofsky Lapidus (eds.), *Women in Russia* (Stanford, Ca.: Stanford University Press, 1977); Feiga Blekher, *The Soviet Woman in the Family and in Society* (New York: John Wiley & Sons, 1980); Wesley A. Fisher, *The Soviet Marriage Market: Mate-Selection in Russia and the USSR* (New York: Praeger, 1980); Alena Heitlinger, *Women and State Socialism: Sex Inequality in the Soviet Union and Czechoslovakia* (London: Macmillan, 1979); Peter Juviler, "The Family in the Soviet System," paper prepared for the Annual Meeting of the AAASS, Washington, D.C., 1982; Gail Warshofsky Lapidus, *Women in Soviet Society: Equality, Development and Social Change* (Berkeley, Ca.: University of California Press, 1978); and Marilyn Rueschemeyer, *Professional Work and Marriage: An East-West Comparison* (London: Macmillan and New York: St. Martin's Press, 1981).

16. Heitlinger, *Women and State Socialism*, p. 100.

17. Blekher, *Soviet Woman in the Family and Society*, pp. 112–113.

18. Heitlinger, *Women and State Socialism*.

19. Conversation in Leningrad with a representative of the Union of Artists. One woman artist estimated that twenty to thirty percent of Soviet painters are women.

20. The women I spoke with included four artists, two art historians, and one curator. All the other respondents were male.

21. At the beginning of the Khrushchev "Thaw," Ely Beliutin was officially able to open a studio. It was used to give further training and introduce new approaches to professional artists.

22. Margarita Tupitsyn, "What Happened to the Art of the 'Russian Amazons,'" in Norton Dodge, ed., *Lydia Masterkova* Catalogue (Contemporary Russian Art Center of America, 1983).

23. *Ibid.*

24. *Ibid.*

25. The difficulty of not being able to work in an environment that is strange and even alien had also been expressed before her death by Anna Ticho, a well known Israeli artist who had come from Vienna. She was shocked by the new landscape and unable to paint for years. (Personal conversation.)

26. Margarita Tupitsyn writes of Katrina Arnold: "After her immigration to Israel . . . she worked out a series of performances, one of which, 'Diachronic Preservation of the Object of Art,' was to bury a variety of contemporary art works in sand, not to be dug out before July 15, 2080 . . . The ancient atmosphere of Jerusalem, where the items were buried, contributed to the impact of this performance."

27. Melvyn Nathanson recounts in *Komar/Melamid: Two Soviet Dissident Artists*: "I began four months of work with Feldman to prepare the exhibition. This required repeated lectures to convey a feeling for Soviet society, its repressive compulsions, the pretenses of its constitution, the monotony of its political propaganda, and also to make clear the meaning of the work of Komar/Melamid in its social setting. These lectures, repeated by Feldman to art writers who visited the gallery, appeared in many publications."

28. Bernard Rosenberg and Norris Fliegel, "Dealers and Museums," in Milton O. Albrecht, James H. Barnett, and Mason Griff, eds., *The Sociology of Art and Literature: A Reader* (New York: Praeger, 1979), p. 474 (originally published in Rosenberg and Fliegel, *The Vanguard Artist:Portrait and Self Portrait*, Chicago: Quadrangle Books, 1965). Studies that further illuminate the artist-dealer relationship, at different places and in different times, include: Howard Becker, *Art Worlds* (Berkeley and Los Angeles: University of California Press, 1984); Marcia Brystyn, "Art Galleries as Gatekeepers: The Case of the Abstract Expressionists," *Social Research* 45 (Summer 1978), pp. 390–408; Francis Haskell, *Patrons and Painters: A Study in the Relations between Italian Art and Society in the Age of the Baroque* (New York: Alfred A. Knopf, 1963); Harrison White and Cynthia White, *Canvasses and Careers* (New York: John Wiley, 1965).

29. Golomshtok gives this account in "Unofficial Art in the Soviet Union" (p. 90): ". . . during the changes after Stalin's death [Tsirlin] underwent a profound internal development as did many intellectuals of his generation. It would have been impossible to call the artists who gathered in his flat a creative organization or circle. Tsirlin simply told them about contemporary art, showed them reproductions, and gave material help to those who needed it, while in his flat they were able to show one another their work. In the late Fifties one of the central newspapers printed an article about him . . . denouncing Tsirlin as a secret apologist of abstractionism and an enemy of socialist culture. After this he was removed from all his posts and a year later he died of a heart attack."

30. Lisa Furman, after her trip with students from the Rhode Island School of Design to the Soviet Union, in personal conversation.

31. Vitaly Komar and Alexander Melamid, "The Barren Flowers of Evil," *Artforum*, March 1980, p. 46.

32. Margarita Tupitsyn, "Collective Action Group," in Norton Dodge, ed., *Russian New Wave* Catalogue (Contemporary Russian Art Center of America, 1981–82).

33. *Ibid.*

34. Robert J. Seidman, "The Politics of Art in Russia: An Interview with Ernst Neizvestny," *Partisan Review*, 1980, p. 257.

35. George Feifer wrote in his introduction to "Russian Disorders" (*Harper's*, February 1981) that it is chiefly friendships that compensate for the hardships of life in the Soviet Union, and that "There is more discourse about art, love, fantasy and freedom . . . ," p. 42. On friendship in the German Democratic Republic and in the Soviet Union, see Rueschemeyer, *Professional Work and Marriage*, pp.176–178 et passim.

36. Igor Golomshtok, "The Future of Soviet Art," in Dodge and Hilton, *New Art from the Soviet Union*, p. 50.

37. In Golomshtok and Glezer, *Soviet Art in Exile*, p. 148.

38. For a similar account see John Berger, *Art and Revolution: Ernst Neizvestny and the Role of the Artist in the USSR* (London: Weidenfeld and Nicholson, 1969), p. 21.

39. Alexander Levitsky, art collector and professor in the Slavic Studies department at Brown University, in personal conversation.

40. *International Herald Tribune*, February 20, 1976.

41. John Bowlt, "Moscow: The Contemporary Art Scene," in Dodge and Hilton, *New Art from the Soviet Union*, p. 21.

42. Berger, *Art and Revolution*, p. 21.

43. The statement is excerpted in Golomshtok and Glezer, *Soviet Art in Exile*, p. 155.

44. Golomshtok, "Unofficial Art in the Soviet Union," p. 98. See also the discussion in Roland Penrose's Introduction to the volume, Golomshtok and Glezer, *Soviet Art in Exile*, especially pp. xiv-xv.

45. Kunie Matsumoto, after her trip with students from the Rhode Island School of Design to the Soviet Union.

46. Alexander Zinoviev, *The Yawning Heights* (New York: Random House, 1978), p. 400.

The Artistic Development of Soviet Emigré Artists in New York

Janet Kennedy

Soviet emigré artists in the United States, although they differ greatly in their view of art and in the type of work they do, may be divided roughly into two groups. The first, consisting of the younger, more avant-garde painters and performance artists, has received a warmer welcome from the Western art world than the second group, whose art is more traditional. Recognition from Western colleagues does not necessarily mean that the first group enjoys greater success in worldly terms, but it does have psychological benefits. By contrast, the more "traditional" emigré artists, whose art was highly esteemed in the Soviet Union, now find themselves dismissed by Western critics as dated or conservative. In the end, the artists of neither group retain the moral authority they enjoyed as unofficial artists in the Soviet Union. As they themselves point out, this would be impossible in an American context, where artistic free-thinking is the rule rather than the exception. Nonetheless, neither group has adapted in any noticeable way to the American market or to American tastes. Virtually all of the emigré artists have continued to pursue, with little change, artistic goals that were formed in the Soviet Union. Some work in isolation; others have discovered an artistic advantage in their anomalous situation

between two cultures: they deliberately choose "to speak Russian in an English speaking society."[1]

The first unofficial artists who came to the attention of Western audiences worked in a refined and elegant style, expressing themselves in complex and introverted images. Their art, as it has continued to develop in the United States, has a strong surrealist flavor, and at times it explicitly pays homage to surrealism. Hard on the heels of this first group, however, came another group of emigré artists whose inspiration was drawn from "life," that is, from advertising, from social ritual, and from real objects. These artists—if they practice painting at all—do not consider painting a "fine" art but use it as a means of examining social conventions. Among the first group are Mikhail Chemiakin (illus. 1), Lev Meshberg (illus. 2), Oleg Tselkov (illus. 3), and Igor Tulipanov (illus. 4); among the second are Vitaly Komar and Alexander Melamid (illus. 5-6), Rimma and Valery Gerlovin (illus. 7-8), Vagrich Bakhchanyan (illus. 9), and Alexander Kosolapov (illus. 10).

It would be possible to describe the two groups as representing two generations within the Soviet art world, but the age differences are surprisingly small: Chemiakin and Tulipanov are no older than Kosolapov and Bakhchanyan. City of origin may be more important than chronological age. Chemiakin, Tulipanov, and Tselkov lived and worked in Leningrad; Komar and Melamid, the Gerlovins, Bakhchanyan, and Kosolapov in Moscow. Refinement of technique and nostalgia for the past have characterized the St. Petersburg-Leningrad school since the turn of the century, whereas Moscow has tended to be more "modern" and experimental.[2] Artists in both cities have been influenced to some extent by artistic events in the West, but each center developed in its own way, paralleling without exactly reproducing Western art movements such as surrealism, abstract expressionism, pop, and conceptual art.

The difference in outlook between the two groups of emigré artists is an acute one. In the first group a surrealist sensibility prevails, but the basic tone of their art is in many ways deeply conservative. They are dedicated to painting as craft; they believe in the enduring artistic values of beauty and harmony, even though

these coexist in their art—uneasily at times—with a taste for the grotesque and fantastic. When Chemiakin arrived in Paris, his art was received with admiration by critics there, not because of its surrealist qualities but because it seemed an embodiment of "culture" and refinement: "Russian by nationality, French by his place in art . . . [Chemiakin's] message is a message to cultured society and his mission, however hieratic he may become, is not unlike Cocteau's, to give pleasure and surprise."[3] Or as Wolfgang Fischer wrote in 1980: "The impulse is to paint new icons, instead of peppering canvases with dadaist blank cartridges." For artists of the "younger" generation, dadaist buckshot (not necessarily blank cartridges) has been an irresistible weapon. For this group "culture" is not a timeless realm of beauty, but something with a specific social context; their anarchic humor has been aimed equally at the official pieties embodied in Soviet art, at American commercialism, and at problems that afflict both societies.

Yet, certain common opinions are voiced by both the "younger" and the "older" groups. Condemnation of Western formalism is not a theme limited to the Soviet press, but one that can be heard again and again from Soviet emigrés. Mikhail Chemiakin speaks for a great many of his fellow countrymen when he says, "I prefer the art of my own country, because I find much more humanity and soul in it. What I see in France is much colder and seems dead to me despite the often extraordinary technical ability."[5] Chemiakin has since moved from France to the United States, but these sentiments still apply. He calls abstract and conceptual art just "the other side of the coin" from socialist realism, equally lacking in spiritual content.

Those emigré artists who practice some form of conceptual or pop art are less likely than their older compatriots to launch a frontal attack on contemporary Western art, but, like Chemiakin, they are aware of their Russianness as something that sets them apart from their Western colleagues. Rimma and Valery Gerlovin, organizers of the "Russian Samizdat" show at the Franklin Furnace, a nonprofit gallery in Manhattan's Tribeca area, stress that their art has ties with the Russian avant-garde of the 1920s. They believe that a desire to make art that interacts with life is characteristically Russian:

In our opinion, a characteristic trend of modern art, the emphasis
on the ideological aspect, was always a basic one in Russian art
and prevailed over all others, including the aesthetic dimension (it
suffices to compare the *peredvizhniki* [Russia's realist painters]
with the impressionists). . . . Most Russian art was founded on
the desire to solve moral, religious and social problems on the
basis of the artist's philosophical views, the latter frequently of an
intuitive nature. Typically, artists showed a certain indifference to
the formal quality of a work of art. The above considerations lead
us to believe that conceptual art finds its most favourable soil in
Russia and, despite the State's rejection of it, it is a very important
and vital phase in the Russian creative effort.[6]

Komar and Melamid, who make "Sots art" (an analog of Pop,
using socialist clichés instead of American advertising images),
express the same opinion in a different way. They argue that Ameri-
can art has "lost touch with subject matter," that it has lost touch
with reality, just as the American auto industry—their comparison—
has lost touch with real life. Their recent painting in a "socialist
realist" style restores to art, or so they say, both subject matter and
contact with real life.

To discuss a number of diverse personalities in a single essay on
Soviet emigré art tends to perpetuate an already uncomfortable
situation. The first publicity devoted to emigré artists lumped to-
gether the work of many artists of very different persuasions under
such broad titles as "unofficial art" or "dissident art." Indeed
press coverage of exhibitions, whether the works were by artists
still in the Soviet Union or by emigrés, tended to emphasize politics
to the exclusion of any serious discussion of artistic goals. This was
distressing to artists who had left the Soviet Union to escape a
situation in which any artistic statement was automatically subjected
to a simplistic political interpretation. Almost without exception the
emigré artists who now work in New York deny that their work is
"political," although this claim may seem perverse in view of the
political slogans, the images of Lenin and Stalin, and the allusions to
American advertising that appear in works by the younger genera-
tion of emigré artists. However, the word "politics," as

they generally employ it, carries connotations of compulsion and narrow-mindedness. The actual political content of their art, to the extent that it does exist, is subtle and satirical rather than prescriptive or dogmatic: it explores the function of images in public life, be it Soviet or American; it attempts to expose myths rather than to create them.

No Soviet emigrés have led lives that are free from conflict; however, the story of Mikhail Chemiakin's struggle to exhibit his art in the Soviet Union and then to leave the country is unusually dramatic and arresting. The son of a general in the Soviet army, Chemiakin took a job as a handyman at the Hermitage Museum after he had been expelled from the Repin School of Painting for "formalism." In 1964 he was one of the participants in an exhibition of paintings by the staff of the Hermitage. Instead of a harmless display of amateur painting this exhibition proved to be a spectacle at odds with the optimism and "civic-mindedness" of official Soviet art. The director of the museum lost his position, as did Chemiakin. For the latter this was the beginning of a career that included sojourns in psychiatric hospitals, an attempted escape from the country via the Black Sea, and numerous brief exhibitions, some of which were closed before they even opened. In 1971 he finally obtained permission to emigrate, and after a period of some years in Paris, he has now settled in New York.

Chemiakin's sympathy lies as much with past art as with the art of the present: his interests embrace, with almost obsessive completeness, the entire history of forms. One wall of his studio is covered with shelves that hold black-bound boxes of carefully arranged didactic material—each box is devoted to a specific motif, such as the circle, the abstract figure, or vertical and horizontal forms. Photographs of ancient ritual objects are mounted on large sheets of paper side by side with modern color field paintings in order to demonstrate not only the constant reappearance of basic forms but also their ceaseless transformation at the hands of the artist-creator. In Chemiakin's view the ancient example is almost always more vital than the modern. "Transformations," a series in which Chemiakin offered his own reworking of these materials, was shown at the Wolfgang Fischer Gallery in London in 1980; however, all of

Chemiakin's art is based on similar principles of metamorphosis and deliberate complication of form.

A first look at Chemiakin's painting (illus. 1) might lead the viewer to label it as surrealist. The forms are alternately playful and grotesque. Images form and then reform: a human head is also an animal, a saddle, a botanical drawing. From time to time one finds open acknowledgment of an established master like Max Ernst, Paul Klee, or the seventeenth-century fantasist Archimboldo, but Chemiakin's art has its own distinctive flavor expressed in its bright but refined color harmonies, its elegant curves, and its nostalgic delight in the dainty artifices of eighteenth and early nineteenth century art. Chemiakin himself would like to distinguish his own work from surrealism. Early in his career, in a manifesto entitled "Metaphysical Synthetism," he and another author accused the surrealists of intellectual laziness, of copying the images of their subconscious without attempting to reach a universal truth: "Freedom of the imagination turns into demonic tyranny. Idolization of the subconscious . . . the incestuous introduction of the naturalistic principle into imagination."

On an earlier page he had written: "The tension of Being in this world cannot be conveyed by simple mirror-like reflection. In reflection there is no tension. The job of the artist is to lift form and color to the highest degree of tension. In analytical art this is called the principle of wholeness."[7] With a characteristically Russian desire for universalism, Chemiakin proclaimed that the artist can achieve a kind of Godmanhood:

> In the twentieth century the birth of a new type of creative consciousness is taking place: those processes which earlier played in the subconscious and the superconscious regions of the soul are now—thanks to the power of the "I"—boldly introduced into the realm of the conscious. The artist is no longer a holy fool. He is a creator, a friend of God. The degree to which he is permeated by Christ's impulse determines the degree of consciousness in his work.[8]

This credo echoes the writings of the nineteenth-century religious philosopher Vladimir Solovev, who argued that human beings could

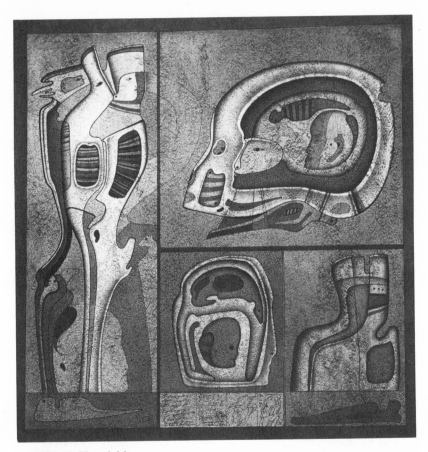

Mikhail Chemiakin

1 Philosophy of the Sea 1978
(Detail of triptych). Mixed media, 36 ″ x 12 ″. Photo by Jacqueline Hyde, Paris.
Collection of the artist.

become Godmen by participating in the divine creative power represented by Christ. While there are no specifically religious images in Chemiakin's art, the desire for a synthesis of ancient and modern, human and manufactured forms manifested in his "Transformations" expresses the artist's faith in a universal creative principle.

Despite the dogmatic tone of his pronouncements on art, Chemiakin's artistic sympathies are quite liberal. Among American artists of the recent past he admires Frank Stella, Jackson Pollock, Theodore Stamos, and Clyfford Still. However, when Russian art is in question he does not share the general enthusiasm for the avant-garde of the 1920s. Instead he stresses the importance of such artists as Tyshler, Falk, and Neizvestny, whose "individuality" seemed to the young Chemiakin like an "oasis" in a desert of socialist realism.

Among the emigré artists now living in New York, it is Lev Meshberg whom Chemiakin singles out as a "a genius." Meshberg's career shares few of its external circumstances with that of Chemiakin. Born in Odessa in 1933, Meshberg studied drawing and painting at the Odessa Art College. In 1960 he was accepted as a full member of the Union of Soviet Artists, and he participated in more than forty one-man and group exhibitions in the Soviet Union, winning prizes at two All-Union Art Exhibitions (in 1965 and 1967) for best painting of the show. Meshberg's works are represented in a number of prestigious Soviet collections, including the Tretyakov Gallery in Moscow and the Russian Museum in Leningrad. He emigrated to the United States in 1973 and he now lives in New York.

For Meshberg the contrast between the laurels he earned in the Soviet Union—even though his work did not fit the socialist realist mold—and the indifference that has greeted him in the United States is both extreme and disappointing. His art is not calculated to make a striking impression. It is intimate and reflective, small in scale, and personal in content. Many of his current works are still lifes in which certain objects—all possessing a patina of history—appear again and again: worn leather-bound books, candlesticks, a lantern, a model ship. Frequently the central motif is either a bird in a cage or an aquarium. These real objects (which are actually present in

Meshberg's studio) acquire an elusive symbolic quality: the half-seen caged bird (illus. 2) and the enclosed aquarium suggest not so much the pathos of captivity as a deliberately restricted world of poetic reflection. Meshberg's technique of thickly built-up, heavily worked layers of near monochromatic paint imparts a timeless quality to his paintings; the faded surfaces seem to have been created by a slow process of sedimentation rather than by a brisk application of the brush.

Certain of Meshberg's works use other images. A pair of canvases, which can be placed together like altarpiece and predella, shows the weathered facade of an arched building above and a vigorously primitive reptilian creature on the smaller canvas below. A small triptych with an arched central portion was inspired by an actual event, the death of the artist's fish. The dense white suface of the canvases is almost unmarked except for the ghostly presence of a small graceful fish in the upper part of each panel.

Themes having to do with the passage of time appeared in Meshberg's work at an early stage of his career: a townscape from the early 1960s, for example, contains architecture and costumed figures from three different epochs— ancient, medieval, and contemporary. In 1966 Meshberg visited the town of Bukhara in Soviet Uzbekistan. The town became the subject of a series of austere, dimly lit panoramas based on archaic architectural forms—simple blocklike buildings with occasional hemispherical domes. Curiously enough these works, given their severe geometry of form, are more "abstract" than Meshberg's later paintings. In fact he now claims that his painting is "post-abstract," that is that he uses abstraction as a tool rather than viewing it as an end in itself.

In short, Meshberg's emigration to the United States has not led him closer to modernism. His quiet and lyrical art is unlikely to find a place on the current New York art scene. The scale and color of his paintings do not catch the eye of an observer trained on color field painting, and their subject matter is "old-fashioned." Like many emigrés Meshberg does not hesitate to condemn American art as materialistic. He finds American artists poorly educated, obsessed with making money, and lacking in "heart." This does not mean, however, that he condemns all modern art; his admiration does

Lev Meshberg
2 STILL LIFE WITH BOOKS AND BIRD 1979
Oil and wax, 36″ x 40″. Collection of the artist.

extend to the work of Leon Golub, whom he once arranged to meet, to the early works of Mark Tobey and Willem de Kooning, and to Henry Moore's drawings. Without a doubt a prospective audience for Meshberg's art does exist in the United States, but it is not the audience that visits Manhattan art galleries. Meshberg's problem in finding an audience is in fact similar to that of many American artists, whose work is not in step with current trends; however, they are spared the irony of his transformation of status from a leader of the new art in the Soviet Union to a man with no artistic country in the United States.

A number of artists among the "older" generation of Soviet emigré artists are, or have been, represented by Eduard Nakhamkin Fine Arts. Nakhamkin has exhibited the work of Neizvestny, Chemiakin, Meshberg, Tulipanov, Tselkov, and many others (Elya Peker, Ilya Shenker, Mikhail Aleksandrov, Shimon Okshteyn), artists who differ considerably from each other in style. Neizvestny's vigorous semi-abstract bronze sculptures have little in common, for example, with the finely wrought Netherlandish technique of Tulipanov's paintings. However, the artists who have exhibited with Nakhamkin do tend to have certain things in common: a nostalgia for the technical perfection of past art, a tendency toward the grotesque in their imagery, and a distinct seriousness, or weightiness, of content.

Tselkov and Tulipanov both studied at the Theater Institute in Leningrad, and like other Leningrad artists they employ images that inhabit an uncertain territory between the beautiful and the grotesque. Although Tselkov was expelled from two art schools on the grounds of "formalism" (the Minsk Institute of Theater Art in 1945 and the Academy of Arts in Leningrad in 1955), he states his artistic purpose in terms of content: a desire to communicate "the most profound emotional idea" in a simple and intelligible form. In fact the masklike faces that appear in his paintings translate an abstract idea into nonabstract form. Tselkov writes:

[I]n 1960, for the first time, I painted a canvas with two strange, pinkish-white faces. Suddenly I had a feeling that there was something in those faces, that I had found a path I could continue to

travel. In 1958 I had seen a large number of Malevich's pictures in the storage cellars of the Russian Museum in Leningrad, and I was very much influenced by him. . . . One has the feeling that it is as if he subsumes all his emotions into an apparently very simple formula. . . . Malevich taught me simplicity. Later, when I was searching for my own path, I chose, or at least tried to choose, simplicity. I made every effort to discard what artists generally term painting, everything that was so noticeable in Cézanne and the Impressionists—complex, obscure use of color and a generally impressionistic, indeterminate attitude towards the subject of the picture. . . . But I never tried to make any specifically social comment, in the way Rabin does, for instance. I tried to make my social attitudes "universal." . . . The people in my pictures are indestructible. . . . They have small foreheads and heavy jowls. Those are signs not of feeble-mindedness but of brute force and firmness.[9]

The objects in Tselkov's paintings, familiar and domestic, have the same dumb firmness and ambiguously threatening quality as the faces (illus. 3).

In many ways Tulipanov's approach to painting would seem to be the opposite of Tselkov's. His compositions are complex rather than simple: constant shifts of viewpoint and spatial perception create an effect of calculated irrationality. One can hardly avoid noticing certain disturbing images, for example, a man crouching fully clothed in a glass bottle. The artist himself stresses that, despite this, he sees his paintings as "harmonious." His colors are bright and clear rather than heavy and dramatic. His detailed and illusionistic style of painting closely imitates Netherlandish painting of the fifteenth to seventeenth centuries. Indeed, love of the past has been characteristic of many Leningrad artists, who find more to please them in the Hermitage than in any contemporary art, whether it is produced in the East or the West. A similar "retrospective" attitude prevailed at the turn of the century among the artists of the "Mir iskusstva" (World of Art) group, who found in past art an alternative to the mundane realism of their immediate predecessors. Among unofficial artists in the Soviet Union, meticulous attention to detail has in the past been something of a rebuke to official art.

Oleg Tselkov
3 PACKAGED PERSON 1979
Oil, 64″ x 40″. Private collection.

However, since the end of the 1970s the younger generation of official painters has brought this aspect of unofficial art into official favor, replacing the broad, streamlined forms of the sixties socialist realism with minutely detailed and static forms.[10]

Tulipanov's painting lends itself to imaginative exploration rather than to precise explanation. His images derive from a variety of sources—from children's toys, art reproductions, artificial flowers, and, most of all, the artist's own peculiar fantasy. Contradictions abound: in the painting reproduced here (illus. 4) there are suggestions of change, motion, and metamorphosis (the disembodied face, the eroded stone ledge, the aggressive cyclone of flowers), but the style of painting is precise, even frigid. Aware of the difficulty of fathoming his paintings Tulipanov has written an essay about his art in which a number of speakers attempt to explicate one of the artist's paintings: each one contributes a partial view, none is entirely persuasive, but each strives earnestly for his own form of truth. One can, however, take advantage of a hint dropped by the artist in connection with an earlier painting, *The Mystery* (1976). He described the hidden theme of this painting as the weighing of good and evil.[11] In a subtle way this motif of weighing good against evil pervades all of Tulipanov's works; in them the beautiful outweighs the grotesque, but it just tips the balance. Reality—notwithstanding the artist's illusionistic style—remains elusive and all but impossible to discover.

One might assume that there is something inevitably Russian in the pre-occupation with questions of good and evil that pervades the paintings of Tulipanov, Tselkov, and Chemiakin. However, there is another side of Soviet unofficial art to consider as well: this is a lively and ironical art that takes the form of games, artists' books, performances, posters, and even re-creations of Stalin era painting. The artists who make art in this fashion recognize that the search for universal truth is a massive undertaking and quite likely to lead to negative results. Rimma Gerlovin, for example, comments that Russian "spiritualism" is often closer to sickness than to health. On the other hand art *can* reveal small truths instead of large ones—and it wields its own absurd and illogical authority.

Vitaly Komar and Alexander Melamid began their careers as

Igor Tulipanov

4 Being Flowers 1980–82
Oil, 36 ″ x 32 ″. Private collection.

"dissident" artists in 1972, when both were expelled from the Union of Artists for "distortion of Soviet reality and nonconformity with the principles of socialist realism." In the same year they met Melvyn Nathanson, an American mathematician in Moscow on a postdoctoral fellowship, and he began to make their work known to other Americans. Nathanson has given a vivid description of one of the works Komar and Melamid created in 1973:

> In spring of 1973, Komar and Melamid managed to find a room in an empty apartment in Moscow, a remarkable feat since the housing shortage is severe, and they turned the room into an environmental work called *Paradise*. The walls, floor, and ceiling were painted and covered with sculpted figures and bizarre electrical light effects. Soviet radio played in the background. A river of blue cloth flowed under a wooden bridge, while a hideous Stalin-like figure sculpted in a corner of the ceiling dripped blood, and a gold Buddha along the wall was covered with licelike miniature soldiers, planes and tanks. To experience the work, one was thrust into the room alone and locked inside.[12]

Other visitors to their studio encountered *Young Marx* (1976), a "portrait" of an awkward bespectacled lad painted on a dishtowel; *Color-Writing* (1974), a translation of the twenty-ninth article of the Soviet constitution into coded color squares (the article guarantees freedom of speech); and *Quotation* (1972), rows of small white squares on a red background, a reference to the political slogans that dot the Soviet cityscape. In another work, which was documented photographically, the two artists passed a copy of *Pravda* through a meat grinder to create a hamburger shaped patty—presumably an aid to easy digestion.

This picture of Komar and Melamid is incomplete, however. Not only politics but other contemporary phenomena as well were subjected to their perverse logic. A series of *Scenes from the Future* (1975) updated the genre of ruin painting by placing a crumbling and overgrown Guggenheim Museum in the midst of a romantic landscape. In another series of paintings, entitled *Post-Art* (1973), paintings by Andy Warhol, Roy Lichtenstein, and Robert Indiana appear as charred and pitted remains. Finally, *Factory for Produc-*

ing Blue Smoke (1975) offers a solution to the problem of industrial pollution: a factory that emits clear blue smoke into the gray atmosphere. With characteristic enthusiasm the two artists made their idea known in letters addressed to several world leaders including Prime Minister Karamanlis of Greece.

In 1976, while Komar and Melamid were still in Moscow, some of their work was shown at the Ronald Feldman Gallery in New York. The success of this exhibition is testimony to a rather surprising convergence of Soviet unofficial art and Western "postmodernism." Komar and Melamid's appropriation of an existing artistic language, whether it be realism or pop art, which alters its meaning when it appears in a new context, suited the ironical tone of the New York art world of the late 1970s. In the words of Jack Burnham, "the art of Komar and Melamid is eclectic in a special sense of the word. The very mixture of influences—Byzantine icons, Renaissance and Baroque painting, capitalist advertising, Soviet posters and documents, nonobjective art, plus the subtle confusion of bureaucratic prose with an undercurrent of Judeo-Christian mysticism—give it a special disjointed sense of ludicrous absurdity."[13] As Burnham points out, this "schizoid consistency" is, to some extent, characteristic of all contemporary Western culture.

Komar and Melamid themselves insist that they are "not political, but professional emigrés." They point to the large numbers of foreign artists working in New York as proof that their situation is to some extent a normal one. They are of course, well aware, of their position between two cultures. In Russia they did "American art"— art that was closer to pop art than to anything then being produced, officially or unofficially, in the Soviet Union—while in New York they feel acutely aware of their Russianness, and even express a nostalgia for socialist realism. Their response is deliberately to "speak Russian" in their new American setting.

A witty example of deliberate confusion between the Soviet and American cultures is their projection of Soviet political slogans into an American context. The *Poster Series* exhibited at the Ronald Feldman Gallery in 1980 consisted of a handpainted American flag and seven posters honoring the American family, the American worker, the American farmer, and so forth, by means of typical

Soviet slogans. One of the posters (illus. 5) shows a well groomed model in a dinner jacket holding an American flag and accompanied by the words "Onward to the Final Victory of Capitalism." Concerning their poster dedicated to the American family, Komar and Melamid explained that "just as we saw the process of Russian families trying to look like the 'ideal' Russian family portrayed in Soviet propaganda, so American people try to look like the families in advertisements."

Another way of "speaking Russian" to an American audience is to re-create the socialist realism of Stalin's day. For Komar (born in 1943) and Melamid (born in 1945) this is the art of their childhood, and they boldly proclaim socialist realism as one of the "best" art forms ever invented. Certainly they revel in its theatricality. *Stalin and the Muses* (illus. 6), in which the muse of painting presents the submissive Clio to a smiling Stalin, recaptures the academic surreality of Stalinist art. Prior to this Komar and Melamid used the same heroic style for a series of *Ancestral Portraits* (1980). Each canvas depicts a dinosaur (Protoceratops, Allosaurus, Plateosaurus) posed with dramatic lighting against a red drape. As Komar points out, the dinosaur without the drape, a standard prop in official portraiture since the Baroque, would be merely a dinosaur. With a change of background, the creatures change their identity. Lest the American observer feel that these dinosaurs walk only the halls of the Kremlin, one should note that a portrait of our current American leader as an aging centaur—an allusion, no doubt, to his fondness for being photographed on horseback—is included in the series.

At the end of his introduction to Komar and Melamid's work, Jack Burnham speculates on their possible fate in the West: "What is the artistic future of Komar and Melamid if they are deprived of the abrasion and suppression of Soviet dogma?" On the whole this worry seems to have been unfounded. Komar and Melamid feel that their art has changed little since their departure from the Soviet Union, except that they are now able to create projects on a grander scale. They have found the necessary abrasion even in the West. The New York art world, normally tolerant of extremes, was recently jolted by a colossal Hitler portrait that Komar and Melamid exhibited in the fall of 1981 at the Monumental Art show. A faithful replica

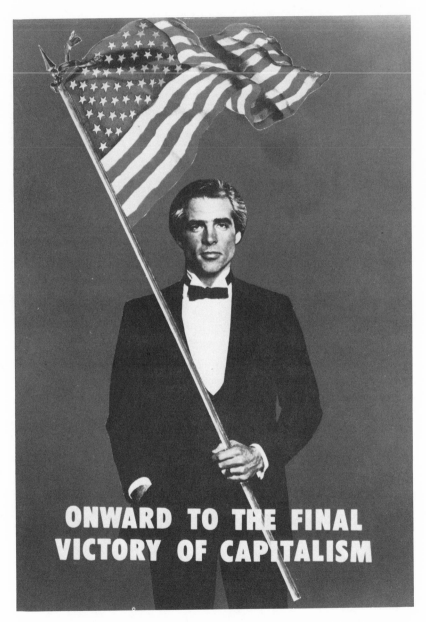

Vitaly Komar and Alexander Melamid

5 ONWARD TO THE FINAL VICTORY OF CAPITALISM 1980
Detail, poster series. Photo by Eeva-Inkeri, courtesy of Ronald Feldman Fine
Arts, New York.

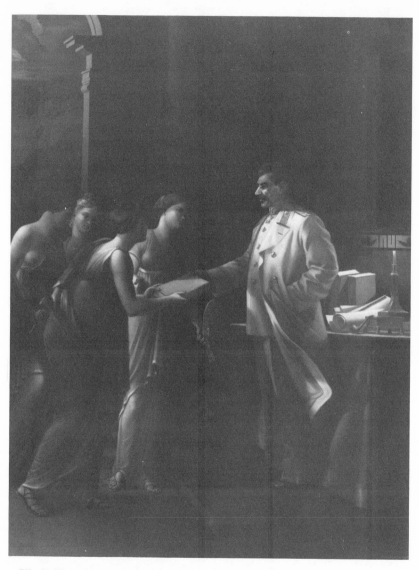

Vitaly Komar and Alexander Melamid

6 STALIN AND THE MUSES 1981–82
(The Muse of Painting Presents Clio, the Muse of History, to Stalin). Oil on canvas, 72″ x 55″. Photo by D. James Dee, courtesy of Ronald Feldman Fine Arts, New York.

of the standard Hitler portrait produced by Nazi artists, the painting was displayed on an easel, flanked by pots of flowers. Komar and Melamid argue that they have a right to show Hitler because they are Jewish. Also, the image has a more complex resonance for a Russian than it does for an American. Such reasoning, however, did not prevent the painting from being physically attacked: "People identifying themselves as members of the JDL threatened the artists, their gallery and the show's organizers." The painting was finally slashed through the heart by an individual presumed to be from the JDL, but who later identified himself as a member of a left-wing group and "tired of irony."[14] As will be seen below, other emigré artists have been equally quick to discover some of the spoken or unspoken taboos of American culture.

Komar and Melamid work together as a team, and their art has a social character; in fact, they call themselves not artists but "conversationalists." Viewer response to their provocative assertions is what gives their art its subtle shadings of meaning: "We want people to start talking after they see our paintings, just as we talk to produce them."[15] The desired response is an active, not a passive one; it is a teamwork that involves the viewer as well as the two artists.

Another example of artistic teamwork is that of Rimma and Valery Gerlovin, who have lived in New York since 1980. Valery began his career as a theater designer, Rimma as a concrete poet. Theirs, too, is a gregarious art and engages the spectator in active response. Their books, photographs, and constructions abound in exquisitely logical absurdities, but their work is not without its serious side. Rimma's first "games" involved verbal play of various kinds; for example, she inscribed lines of poetry on a set of cubes which could be manipulated to produce new poems. Another construction consisted of sixty cubes, each one bearing the name of a famous person, so that Plato, Picasso, Catherine II, and Stalin, for example, could be assigned, at the viewer's discretion, to their proper place within a framework that contained three zones: Heaven, Hell, and Purgatory.

Interchangeable Man (illus. 7) was conceived in 1976, and a new version was produced in New York in 1981. (These cubic

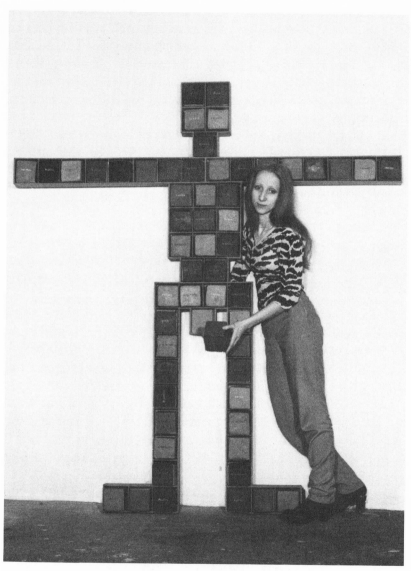

Rimma and Valery Gerlovin

7 INTERCHANGEABLE MAN 1981
Plywood and fabric, 72″ x 77″ x 4″. Photo by Valery Gerlovin. Collection of the artists.

constructions are based on Rimma's ideas, but since she and Valery work together on most projects they say they are all by "the Gerlovins."[16]) *Interchangeable Man* consists of fifty-seven cubes in a six-foot armature. Each cube bears six descriptive words, one per side, for example "intelligent, profound, brainless, normal, sensible, superficial." The colors of each side of the cubes vary, and the qualities named are numerous, although every cube has the word "normal" on one of its sides.

By turning cubes the viewer can create his or her own "ideal" personality, but an element of chance and surprise is always present, since one cannot control the final outcome with absolute certainty. It would be possible, if one wished, to turn all the cubes to "normal," producing, as the Gerlovins say, "nobody." A variation on this theme of participatory creation is the *Dog-Sphinx Calendar for the Next 100 Years* (1982), in which every cube has six different prophetic interpretations for a specific year—always with "chaos" as one of the possibilities. The spectator creates his or her own calendar by turning the cubes (soft foam covered in acrylic painted cloth) and replacing them in the dog-shaped frame.

Over the years Valery's projects have utilized a variety of materials such as mecchano sets, bread dough, and discarded hypodermic syringes. A series of photographs made in Moscow documented the adventures of a "spermatozoid," consisting of mecchano pieces, as it travels around the city. The *Bread Tree Insects*, molded from dough, make up an imaginary community, now said to be extinct. These tiny insects are enshrined in the Gerlovins' studio in a "mass grave" with a commemorative inscription that details their habits and suggests the necessity for biological control by means of warm-blooded animals and people who eat them.

At times the Gerlovins' projects take on—at least in imagination—a massive scale, for example, their 1977 proposal for a global birthday celebration:

> "Each day approximately ten million people celebrate their birthday with their friends, relatives, or alone. Many do not celebrate at all. We propose that all people born on a single day gather on this day on a single (endless) spot on the globe. Each day 365 (or 366) times a year men of all races, religions, and ages can gather

in a single designated spot, under a single symbol: Born under one and the same star.''

The Gerlovins propose the founding of an international organization to provide information and material help in realizing this scheme for global brotherhood.

Given the sociability of their art, it is not surprising to find that the Gerlovins engage in many collaborative projects involving other artists; they have organized several exhibitions of ''Russian Samizdat Art.''[17] With Vagrich Bakhchanyan they edit a handmade quarterly magazine, *Collective Farm*. Each issue consists of a series of envelopes bound loosely with string. Collaborating artists from all over the world (Italy, France, Belgium, Germany, Yugoslavia, Poland, Argentina, Mexico, and the United States) utilize these envelopes as miniature exhibition areas, and mail the results to the Gerlovins. Both the exhibitions and the magazine have been well received. The exhibitions, in particular, received considerable press coverage both in New York and in Washington, D.C., although some New York commentators objected to the use of the term ''Samizdat'' to refer to artists' books produced in the United States. They believed the term should be limited to the product of a specific political situation and should not simply apply to any self-published artists' books, even those by Soviet emigré artists.

The show at the Franklin Furnace consisted of books and similar materials by over thirty emigré artists. One striking feature of the show was its installation, with books dangling from the ceiling, strewn on the floor, and hung from ladders. At the opening the Gerlovins showered the audience with books, tickets, and other scraps of printed paper. The book, the Gerlovins say, is a satisfying form of expression because it does away with the usual hands-off relationship between the viewer and an art work: a book can be manipulated and provides verbal or visual surprises as each page is turned. ''A book,'' the Gerlovins write, ''is both a portable object and a mass-production item capable of an intimate relationship with the readers, and it is one of the best examples of collaboration between extroverted and introverted ideas of the history of Russian art.''[18]

Unlike Komar and Melamid, who advertise their ties with social-
ist realist art, the Gerlovins see precedents for their art in the
Russian avant-garde of the 1920s. (They also consider themselves
more "international" than Komar and Melamid.) The Gerlovins
are particularly drawn to Alexander Rodchenko, not only because
he worked in various media (sculpture, photography, poster design,
and furniture design) but also because of his "acceptance of the
world as an environmental space." However, constructivism had
little place for humor, and humor plays a major role in the
Gerlovins' art. Their wit, which has a dada character, might be
linked, Rimma suggests, to the work of the *oberiuty*, absurdist
writers of the 1920s.[19]

All this notwithstanding, the Gerlovins point out that there is a
visible tension in their work. Their most recent work, for example,
is a series of syringe "mosaics" (illus. 8). These are paintings
studded with syringes filled with oil paint (one of the couple has
diabetes, so used disposable syringes are readily available). The
subjects of the syringe mosaics include *Soldier*, *Dove*, *Man with
Dog*, and *Face on the Ladder*. *Face on the Ladder* was made for a
show at the abandoned Pier 34 on the Hudson River and was to be
left behind in the abandoned space. *Soldier*, which can be alternately
read as Soviet or American, was shown at the Monumental Show
already mentioned above. The Gerlovins' claim that the syringes
"give a flexible imitation of specific structures like hair, fur, and
grass," while simultaneously having something of the heaviness and
overbearing quality of large mosaic tesserae.

The syringe paintings project a threatening monumentality. Their
overbearing quality has been noted by the artists, who ascribe this to
"the human similarity with animals subjected to
experiments . . . when behavior is controlled by external events—
reinforcement and punishment." They note, too, that in New York
the use of syringes has an element of actual illegality because of the
association of syringes with narcotics use. According to Valery the
syringes signify an attempt at "self-affirmation outside society as
well as a means of self-destruction." Rimma tells of one confronta-
tion with the police at a show of syringe paintings in a storefront
gallery. Apprehensive neighbors called the police, who checked

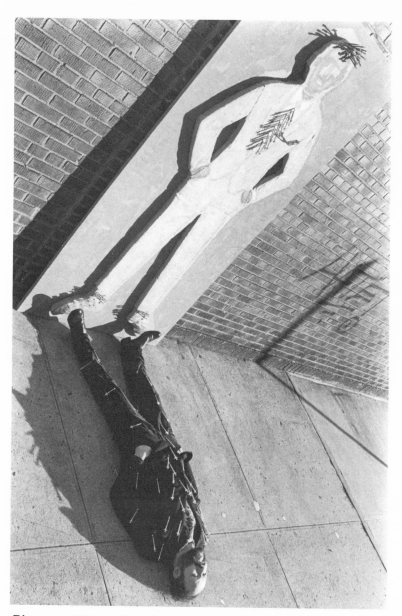

Rimma and Valery Gerlovin

8 SHADOWS 1983
Acrylic, syringes, canvas, and artist's body, 96 ″ x 48 ″ x 12 ″. Photo by Francis
Hauert. Collection of the artists.

Rimma's arms for needle marks before dismissing her with a warning. Although it is true of course that this incident has not prevented the Gerlovins from continuing to work, Rimma believes that, differences between the American and Soviet systems notwithstanding, there is always some form of expression that is subject to censorship.

While some of their themes and materials have changed, the Gerlovins, like most other emigré Soviet artists, continue to practice their art along more or less the same lines as they did in the Soviet Union. This is true also of their friend Vagrich Bakhchanyan, although Bakhchanyan is an artist who delights in creating a hybrid world where images from East and West meet in incongruous ways. The familiar image of Stalin makes various unexpected appearances in new, American contexts, for example in advertising or as the subject of a half-time show at a football stadium (illus. 9). Almost any printed matter provides grist for Bakhchanyan's mill. He produces, for example, a magazine entitled *Arm News* (cf. *Art News*), each page of which shows an arm in some different position or situation.

Bakhchanyan was born in 1938 and came to the United States in 1974. In the Soviet Union he was active for more than a dozen years as an artist and graphic designer, working for a variety of publications (*Iunost'*, *Znanie i sila*, *Literaturnaia gazeta*) since design and illustration allowed him greater freedom than painting. Bakhchanyan acknowledges without hesitation his debt to dada and offers such cheerful inventions as the newspaper masthead "PRAVDADA" and the slogan "Bozhe Tzara khrani" ("God save Tzara"—a slogan in which the dada poet's name neatly takes the place of the word *tsar* in the more traditional "Bozhe Tsaria khrani"). Bakhchanyan has no New York gallery, but he claims this is not a matter for great regret. His public consists largely of other artists, whom he reaches through the medium of mail art, including the publication *Collective Farm* which he edits with the Gerlovins.

Famous personalities attract his attention, in part because of their immediate recognizability. In "One Hundred Namesakes of Alexander Solzhenitsyn" he presents an array of photographs with bilingual captions. These are gathered from various sources, some

Vagrich Bakhchanyan
9 STALIN TEST 1982
Photomontage.

of them antique. Each one, whether it is a nineteenth-century lady in fancy dress or a modern couple on a beach, is said to bear the name Solzhenitsyn, although some have changed their names since their famous namesake emigrated (these photographs are surrounded by a black border). The bilingual captions lead to further confusion: the couple on the beach are Elizaveta and Leonid Solzhenitsyn in the Russian caption and Liz and Richard in the French (the photograph, not of the famous Liz and Richard, vaguely resembles them).[20]

Bakhchanyan's appropriation of Solzhenitsyn's name aroused the ire of more conservative members of the emigré community, but Bakhchanyan explains that he chooses names not for any political statement but simply because they are familiar to both Russian and American audiences. He might use Tolstoy's name, for example, but not that of an author unknown in the West. Like the Gerlovins and Komar and Melamid, he plays on social taboos and expectations: this is more vital than any specific point about the personality whose name or image is used. It would be difficult to assign a specific "political" significance to Bakhchanyan's *Home Delivery of Stalin* (superimposed on a *Time* magazine subscription coupon) or to his portrait of Lenin in thirty-six small stapled booklets. When arranged in proper sequence, the covers of these booklets form a posterlike image of Lenin, but on the interior they contain small rectangular pieces randomly clipped from the pages of *Playboy*. In a similar portrait of Stalin, the booklets contain newsprint from *Pravda*.

One more group of artists who work together will serve to round out this discussion of Soviet emigré art. The group, which includes Alexander Drewchin, Alexander Kosolapov, Victor Tupitsyn, and Vladimir Urban (the last an American of Russian descent), calls itself the "Kazimir Passion" and specializes in performance art. Kazimir Passion has staged such events as a mock funeral for Malevich (in front of the Guggenheim Museum at the time of the Costakis exhibition and a "Twenty-Seventh Party Congress" at SoHo's Kitchen Gallery (produced with the aid of a small grant from the gallery). The Party Congress included a showing of the film *Lenin in New York*, made by the group, ideological speeches, and "two dances—the first a pas de deux featuring Lenin and a ballerina

and the second a shamanistic flutter of Brezhnev [a heavy-set actor in bathing trunks] holding a hammer and sickle."[21] In retrospect the artists found it fateful that Brezhnev's death was announced a few days after the performance took place.

The Kazimir Passion artists practice their own form of "Sots Art." Like Komar and Melamid they combine Soviet political slogans with American images, and in their new context the slogans often appear two-edged; for example, in the film *Lenin in New York* the words "Workers of the world unite" appear against the background of lower Manhattan skyscrapers. To whom is the message being addressed? When the film was shown at a theater at St. Marks Place in Greenwich Village, some of the audience accused the makers of procommunist sympathies, an accusation the makers found somewhat bizarre. According to Victor Tupitsyn, the film has been given opposite political interpretations, depending on the perceptions of the viewer, but he says that he and his fellow artists are in fact "cynical about politics." Indeed, he distinguishes himself and his colleagues in the Kazimir Passion group from other emigré artists, such as the Gerlovins, saying that they are "too serious" about their art.

Kazimir Passion draws its material both from socialist realism and from the art of the 1920s. In the film *Lenin in New York*, the example of Dziga Vertov is clearly reflected in the dynamic camera angles and assertive "documentary" flavor of the action.[22] Tupitsyn, a poet and an articulate spokesman for the group, defines the performances of the Kazimir Passion group as "Sots Art." He explains this as a combination of two impulses: (1) nostalgia for the post World War II period of Russian culture (the time of their childhood) and (2) irony toward Soviet culture, but an irony of the affectionate kind that a child might feel for its parents.

Alexander Kosolapov, another member of Kazimir Passion, makes liberal use in his paintings of past monumental traditions (Egyptian, Early Christian, Renaissance), but injects these with a formal and hieratic socialist imagery. An "Egyptian" mural, for example, finds pharaoh's head replaced with Lenin's, and the hieroglyphs transformed into small Soviet tanks, hammers, and sickles. In Kosolapov's *The Final Step of History* (illus. 10) human progress

Alexander Kosolapov
10 THE FINAL STEP OF HISTORY 1983
Detail of triptych. Oil on canvas, 62 ″ x 240. Collection of the artist.

from caveman to Soviet astronaut and ballerina unfolds with lurid academic pomp. Kosolapov says he feels a stronger kinship with European artists like the German Anselm Kiefer than with American artists, since Americans—he claims—lack the experience to deal with "ideology." On the other hand it is American advertising that provided Kosolapov with the same type of exploitable archetypes he finds in socialist realism. In his poster *Symbols of the Century*, the Coca Cola emblem (in white on red ground) enters into harmonious union with a portrait of Lenin. In fact, in the Soviet Union, the latter image, stenciled in white on red, enjoys public visibility on approximately the same scale as Coca Cola in other parts of the world. Not only do the two symbols, Lenin's face and the Coca Cola trademark, combine in one seemingly unified image, but the accompanying slogan—"It's the real thing"—acquires a teasingly ambiguous meaning from its new context.

The Lenin–Coca Cola image has been produced as a postcard and in poster form. News of its distribution was not long in reaching the Coca Cola company, which has vigorously objected to Kosolapov's use of its trademark. However, Kosolapov can cite previous cases— Andy Warhol's paintings and Robert Rauschenberg's *Coca Cola Plan*—in which the company's emblem has been used. Like the Gerlovins, he has managed to discover some of the forbidden fruits of capitalist society, but so far he has not been persuaded to abandon his five-year program for distribution of the Lenin–Coca Cola image via postcards, silkscreens, posters, billboards, buttons, T-shirts, and so forth.

About this work Kosolapov writes that it is above all, an artistic conception, and it is a mistake to consider it outside this plane.

> "It poses no commercial or political questions, although it is based on methods of ideological influencing.
> This design, "Lenin–Coca Cola," is structured on the juxtaposition of Lenin, the symbol of communism, and the trademark of the Coca Cola company, which I conditionally use as the symbol of capitalism. Use of the color red for the two structures is not a major issue. In a broader sense, this is an exposure of a certain

common character of methods in the propaganda of ideas and goods by means of mass information, which has the goal of influencing people.

As an artist I believe that artistic irony frees a person from the power of ideology and propaganda, and that this is the main premise of any work. In the process of work it is possible to discover other similarities and differences in the two systems.''

Artists like Kosolapov, Komar and Melamid, the Gerlovins, Bakhchanyan, and Tupitsyn have found an audience among their professional colleagues and the art public of New York. The avant-garde audience to whom their work appeals is concentrated in New York, and this makes rapid communication and feedback possible. Their art thrives on the high-pressure world of contemporary urban life; this was the case before they emigrated from the Soviet Union and it has facilitated their transition into a new setting. In fact, they enjoy the chaotic matching and mismatching of phenomena belonging to different cultures and different artistic languages. Humor is another protective device. As a response to political repression it is a well developed reflex in Eastern Europe; in the hands of Soviet emigrés it has proved to be a medium readily translatable to the tension-filled West.

Ironically, those artists of the ''older'' generation who aspire to transcend time and place in their art have faced greater difficulty in finding a sympathetic audience after emigration. The aspiration to universality presents a difficult goal in itself, and it is certainly a handicap in appealing to a young and urban audience. However, it should be noted that moral seriousness, even a didactic bent, is not absent from the work of conceptual and performance atists. The convenient division of Soviet emigré artists into two different camps—one dealing with weighty and serious themes, the other favoring the absurd—is, in the end, not fair to either group. Chemiakin, Tulipanov, and Tselkov are fully aware of the absurdities of modern life—and this is part of their strength; while the Gerlovins, Komar and Melamid, Kosolapov, and the others—disclaimers aside—take their games seriously.

Notes

1. Interview with Vitaly Komar and Alexander Melamid, May 22, 1983. Unless otherwise noted, direct quotations derive either from interviews or from written materials provided by the various artists discussed in this chapter.

2. Janet Kennedy, "From the Real to the Surreal" and Norton Dodge, "Conceptual and Pop Art" in *New Art from the Soviet Union*, edited by Norton Dodge and Alison Hilton. (Washington, D.C.: Acropolis Press, 1977). The artists involved support this observation. Igor Tulipanov, for example, says that Neizvestny's powerful abstract sculpture could not have been created by a Leningrad artist.

3. Alexis Rannit, cited in *The Stanford Daily* (August 10, 1982).

4. Wolfgang Fischer, *Mikhail Chemiakin: Transformations* (Exhibition catalogue: Fischer Fine Art, London, 1980), p. 6.

5. Mikhail Chemiakin: Interview with *Playboy Magazine* (typescript in the possession of artist).

6. Statement by Rimma and Valery Gerlovin in *A-Ya*, No. 1 (1979), p. 17. *A-Ya* is a review of unofficial Russian art, covering work by emigré artists and by artists living in the Soviet Union. Its editors are Alexei Alekseev and Igor Chelkovskii; the American representative is Alexander Kosolapov.

7. Mikhail Chemiakin and Vladimir Ivanov, "Metaphysical Synthetism: Programme of the Petersburg Group, 1974" in Igor Golomshtok and Alexander Glezer, *Soviet Art in Exile*, edited by Michael Scammel (London: Secker and Warburg, 1977), p. 156.

8. *Ibid.*, p. 157.

9. *Ibid.*, p. 159.

10. This phenomenon is well documented in recent volumes of *Iskusstvo*, the art journal published by the Union of Artists, and also in recent books on the younger generation of Soviet painters. See Anna Dekhtiar's, *Molodye zhivopistsy 70-kh godov* [Young Painters of the 70s] (Moscow: Sovetskii khudozhnik, 1979).

11. *New Art from the Soviet Union*, pp. 17, 39.

12. *Komar/Melamid: Two Soviet Dissident Artists*, edited by Melvyn B. Nathanson. (Carbondale and Edwardsville: Southern Illinois University Press, 1979), p. x.

13. *Ibid.*, pp. xvii-xviii.

14. Jamey Gambrell, "'Monumental Show' des Refusés, Gowanis Memorial Artyard," *Artforum* 20 (October 1981), pp. 80–82.

15. David K. Shipler, "Impish Artists Twit the State," *The New York Times* (February 6, 1977).

16. The syringe project, which originated with Valery, is also exhibited jointly.

17. Variants of the Russian Samizdat show have been exhibited at the Visual Studies Workshop, Rochester, N.Y.; Chappaqua Library Gallery, Chappaqua, N.Y.; Washington Project for the Arts; Anderson Gallery, Richmond, Va.; Western Front Gallery, Vancouver; 911 East Pine Street Gallery, Seattle; and the Hewlett Gallery, Pittsburgh. The show continues to travel.

18. Rimma and Valery Gerlovin, "Russian Samizdat Books," *Flue* (Spring 1982), p. 10. *Flue* is published periodically by Franklin Furnace, a non-profit gallery specializing in artists' books.

19. See George Gibian, *Russia's Lost Literature of the Absurd* (Ithaca, N.Y/: Cornell University Press, 1971).

20. Vagrich Bakhchanyan, "Sto odnofamil'tsev Solzhenitsyna," *Kovcheg: Literaturnyi zhurnal*, No. 5 (1980), pp. 46–56.

21. Margarita Tupitsyn, "Painting History and Myth," *American Arts* (July 1983), p. 30.

22. A. Kosolapov, "Lenin in New York," *A-Ya*, No. 5 (1983), pp. 58–59.

Afterword

Marilyn Rueschemeyer

Artistic creation is one of the most individualistic pursuits a human being can engage in. Yet it is tied—by delicate webs and deft knots— to personal relations, cultural traditions, economic organization, and political rule. Like our very sanity, it depends in great measure on the understandings, standards, and supports that come from the social world we live in. Creativity in the arts does, of course, flow from deeply personal sources; but even the most private, aesthetic standards and goals are influenced and molded by the world in which artists develop and come into their own. It is not only that academic art is shaped by schooling and tradition; one's very access to artistic traditions and movements is mediated, and can be controlled, by the institutions of art—museums, academies, and schools, critics and publications. Artists are concerned about reactions to their work, especially the response of those institutions and people who define the standards by which art is recognized, judged, and acquired. Even the boldest innovators are affected by others' reactions. Indeed, for them the response of a few trusted viewers, fellow artists, and critics is perhaps especially important: it sustains the reality of their work.

The creation of a work of art, then, is grounded in a social setting. Art acquires its meaning from a web of social relations, even if it defines itself as much by negation as by affirmation of what is conventionally accepted. It is this social character of art that

makes the emigration of artists from a highly controlled environment to a very different, open-ended social environment a fascinating subject. For the individual artist it is a venture that inevitably entails uncertainty and change. It may mean disorientation and despair, but it might also bring new opportunities and release a surge of creativity. Observing how Soviet emigré artists cope with such a transition and respond to its opportunities and difficulties can reveal a good deal about the character of the artistic environment they left as well as the new one they enter.

The Soviet artists we interviewed developed their style and their identity within a very well-defined art system. In Soviet art schools and specialized institutes of applied arts, they acquired particular standards for judging "good" art and for evaluating their own work and themselves. Although the alternatives they learned about were limited, they did gain access to some Western art and they participated in discussions of new creative possibilities. Some began to move away from the conventions of socialist realism, experimenting with new ideas they encountered, or perhaps returning to older Russian and other traditions for inspiration. Igor Golomshtok describes how in the 1960s different groups of artists moved in a short period of time from Russian Cézannism to pop art, from constructivism to Western-style happenings.

The preceding essays reveal important differences among Soviet artists and the art they produce. It is evident that the Soviet art system is experienced in a variety of hues, even if, in official art, the basic components are in most cases the same and are arranged in a distinctive order of limited variety. Some experience the official system as an authoritarian imposition of rules alien to true art. Others take a more differentiated view. They may, for instance, feel pride in the artistic workmanship that is cultivated in the system, even if they deplore its limitations. The artists' evaluation of their situation also depends on the risks they are prepared to take.

The Soviet system of art is restrictive. The artists, therefore, either adapt themselves to its official standards and norms or look for available alternatives. These alternatives are not very extensive, but artists who find them may be able in some ways to work around the official expectations and conventions—sometimes within the

system, more often out of it. The very courage it takes to set one's work apart from official orthodoxy infuses the art with a peculiar weight and meaning. The Soviet official reaction to stylistic nonconformity, although unpleasant and frightening, is not typically violent. Through the years, some of the innovative artists have made attempts to exert more influence in the Union of Artists, and during certain periods they have been able to move it in a more ''liberal'' direction. In these attempts, artists aligned themselves with values that transcended the narrow doctrine of socialist realism, yet were not only officially acceptable, but sometimes even cherished by some among the elite. One such vehicle for free artistic expression could be found in the cultural heritage of the nation; another in the early socialist ideas about art and revolution.[1] These traditions could serve also to provide a system of symbols for implicit criticism of the regime.

Most of the truly innovative artists remained barely visible to the public except for a very limited audience, primarily among the intelligentsia. From members of the intelligentsia they received respect and support, and sometimes even opportunities—commissions or small exhibits, perhaps, for institutions and publications not directly subordinate to the official cultural apparatus. Also supportive were the relations they developed with trusted colleagues. They shared newly discovered artistic developments and ideas among themselves, and turned to each other for help and support during difficult periods.

Still, these artists could not fully develop in their work, and they could not live the way they thought artists should live. They were either blocked within the system, or they lived in poverty or just ''made do'' outside of it. If they managed to sell their work to foreigners, they gained financially, but their position as artists in Soviet society was generally not improved. There were a few exceptions. Some of the artists who exhibited in Western galleries were so celebrated in the international art world that an effort was made to reintegrate them somehow into the Soviet establishment. Their success paved the way for a few of the younger artists.

The Soviet system of art is repressive because it is so closed. It is ideologically defined and closely linked to the political order. It

locks out many traditions and movements that, outside the Soviet Union, define the heritage of modern art. The official system of art is well understood. Not even the most heterodox artistic experiments are immune to its influence. One develops from it, out of it, perhaps decidedly against it. Yet the official standards often remain a weighty point of reference, and the insulation from major parts of world art and art history is not easily overcome.

Those artists who considered the alternative of emigration to the United States hoped that this would permit them to fulfill their goals and develop their artistic potential, which they imagined would expand enormously through close contact with American artists and exposure to new art forms. They would learn from the movements they had studied from afar with such intensity. Moreover, they expected to be welcomed and supported in the United States. Compassion, they thought, would be inspired because they had suffered in a system that was antagonistic to full artistic expression and because they had dared to defy its norms, risking comfort and security. They would be respected, they hoped, for what they had tried to accomplish. They anticipated that knowledgeable and important people in the American art world would come to look at their art and show interest in their development, in the creative work they were now able to do and exhibit.

They hoped to become part of the American art scene and the ongoing "discussion," and they believed that they had something distinctive to say. They wanted to share their particular artistic contribution, their theories and perspectives. Their work, as well as not conforming to conventional Soviet standards, was also quite different from what was being done and talked about in America. It had developed in dialogue with traditions and impositions quite alien to American artists.

The Soviet artists who do emigrate find it enormously difficult to enter the American art world. It is a world that since the late 1940s has thought of itself as the international center of artistic development. It is characterized by dramatic change and drastic contrasts. Most emigré artists cannot fully comprehend its organization, its standards, its ideology, its audiences, its judges. They cannot take part in the ongoing "discussion" because they can neither fully

internalize its dimensions nor make their own perspectives and backgrounds truly understandable to the Americans. As Igor Golomshtok suggests, instead of finding an environment receptive to their notions of themselves as creative educators, teachers of life, the emigré artists encounter indifference and even cutting criticism.

Many have no choice but to turn to galleries and collectors with a special interest in "Russian" art. A few sell their work to other Soviet emigrés and even earn money teaching art to their children. Those artists who live in middle- and lower-middle-class communities in the outer boroughs or in New Jersey are not only far from the commercial and social centers of the New York art world, but are separated as well from their compatriots. They become increasingly distant from each other while not integrating into new groups. Their lack of community, loneliness, and loss of self-esteem are vividly described by the artists themselves. Those who moved into the inner city, especially to SoHo, have been able to make contact with interesting and accomplished people in the arts. Once they manage to get their work exhibited in small galleries, or become involved in performance art or "mail" art, they begin to feel more a part of the New York art scene and more familiar with its inner structure than do their colleagues outside the city.

The development of the emigré artists' work is discussed by Janet Kennedy, who gives an overview of what a number of artists have been doing since their arrival in the United States. Although influenced and challenged by what they have seen in America, most are working out creative ideas that evolved while they were still living in the Soviet Union. Almost without exception the emigrés continue to reject Western formalism, which they see as devoid of content. In so doing, they take different paths, some aspiring to spiritual content, others to a satiric social content. A few of the younger artists have attempted to come to grips with American society, perceptively and on occasion aggressively challenging its assumptions in their art. They have found a small but responsive audience among like-minded American artists and an art world that has become highly critical of "formalism."

Occasionally one of the older artists who for years had been virtually ignored will find attentive viewers. Marc Klionsky, for

example, who came to the United States ten years ago, recently had a show of his work reviewed by John Russell in the *New York Times* (28 March 1984). Russell saw "an unreconstructed Russian painter" who had turned his attention to portraying American life; yet he concluded that Klionsky "is likely to become one of the best portrait painters around."

The favorable reception of some of the younger artists and the new attention to a few of the older ones give some relief to a generally bleak scene. Some of the emigrés find themselves yearning in certain ways for the security of the system they rejected and for the intimacy of their niche in it. They are distant from what they appreciate and even admire in the American art world. They are aware of its complexities and remain perplexed by its contradictions. Still, most of the emigré artists, impatient and insecure about their futures, show great determination and ingenuity in pursuing their work. And they arrived in the United States during a relatively favorable period. A large number of galleries and nonprofit institutions sprang up during the 1970s, encouraging a diversity of artistic activities and audience responses. The dominant role of the avant-garde has been modulated by a slightly greater tolerance of more traditional forms, and even some nostalgia.

Artistic and intellectual life in the United States has been enriched by many streams of immigration. The new arrivals from the Soviet Union have had to traverse a greater gulf than many others. They will need time to become established as artists in America, and it seems unlikely that in the process they will fully assimilate. Yet, whether they will add a lasting new dimension to American art is still an open question.

Note

1. Jeffrey Goldfarb discusses these bases of artistic diversity in "Social Bases of Independent Public Expression in Communist Societies," *American Journal of Sociology*, 83, January 1978, pp. 920–39.

Selected Bibliography

A-Ya (1979–) A multilingual journal published in Paris, devoted to contemporary unofficial Russian art.

Becker, Howard (1984) *Art Worlds* (University of California).

Berger, John (1969) *Art and Revolution: Ernst Neizvestny and the Role of the Artist in the USSR* (London: Weidenfeld and Nicolson).

Betz, Margaret (1983) "Lydia Masterkova Striving Upward to the Real," in Dodge (ed.).

Birman, Igor (1979) "Jewish Emigration from the USSR: Some Observations: *Soviet Jewish Affairs*, Vol. 9, No. 2, pp. 46–63.

Bowlt, John (1977) "Moscow: The Contemporary Art Scene," in Dodge and Hilton (eds.).

Brown, Archie, Fennell, John, Kaser, Michael and Willetts, H. T., eds. (1982) *The Cambridge Encyclopedia of Russia and the Soviet Union* (Cambridge University Press).

Bystryn, Marcia (1978) "Art Galleries as Gatekeepers: The Case of the Abstract Expressionists," *Social Research* 45, Summer, pp. 390–408.

C. (1968) "Art and Apparat," *New York Review of Books*, May 9, pp. 4–6.

Chagall, Marc (1965) *My Life* (London).

Chemiakin, Mikhail (1980) *Mikhail Chemiakin: Obras 1965/1980* (Rio di Janiero: Museu de Arte Moderna).

Dodge, Norton (ed.) (1983) *Lydia Masterkova* Catalogue (New York: Contemporary Russian Art Center).

———— (1981–82) *Russian New Wave* (New York: Contemporary Russian Art Center).

Dodge, Norton, and Hilton, Alison (1980) "Emigré Artists in the West (USA)," Second World Congress on Soviet and East European Studies, Garmisch.

———— (eds.) (1977) *New Art from the Soviet Union* (Washington, D.C.: Acropolis Books).

Feifer, George (1981) "Russian Disorders," *Harper's*, February, pp. 41–55.

Fischer, Wolfgang (1980) *Mikahil Chemiakin: Transformations* (London: Fischer Fine Art).

Fitzpatrick, Sheila (1974) *The Commissariat of Enlightenment: Soviet Organization of Education and the Arts under Lunacharskii* (Cambridge: Cambridge University Press).

Florsheim, Yoel (1980) "Demographic Significance of Jewish Emigration from the USSR," *Soviet Jewish Affairs*, February, Vol. 10, No. 1, pp. 5–17.

Gambrell, Jamey (1982) "Komar and Melamid: from behind the ironical curtain," *Artforum*, Vol. 20, pt. 8, pp. 58–63.

Gerlovin, Rimma and Valery (1982) "Russian Samizdat Books," *Flue*, Vol. 2, No. 2, pp. 10–15.

Gidwitz, Betsy (1976) "Problems of Adjustment of Soviet Emigrés," *Soviet Jewish Affairs*, Vol. 6, No. 1, pp. 27–42.

Gitelman, Zvi (1977) "Demographic, Cultural, and Attitudinal Characteristics of Soviet Jews: Implications for the Integration of Soviet Immigrants," *The Soviet Jewish Emigré* (Proceedings of National Symposium on the Integration of Soviet Jews into the American Jewish Community: Baltimore Hebrew College), pp. 59–85.

———— (1977) "Recent Emigres and the Soviet Political System: A Pilot Study in Detroit," *Slavic and Soviet Series*, Vol. 2, No. 2, Fall, pp. 40–60.

———— (1982) "Soviet Emigrant Resettlement in the United States," *Soviet Jewish Affairs*, Vol. 12, No. 2, pp. 3–18.

Goldfarb, Jeffrey (1978) "Social Bases of Independent Public Expression in Communist Societies," *American Journal of Sociology*, 83 (January), pp. 920–39.

Golomshtok, Igor and Glezer, Alexander (1977) *Soviet Art in Exile* (New York: Random House).

Greenberg, Martin (1977) "Agency Concerns: The Special Problems Confronting Agencies in Providing Services to Immigrants from the USSR" (Baltimore Hebrew College: Proceedings of National Symposium on the Integration of Soviet Jews into the American Jewish Community), pp. 136–142.

Harris, David (1976) "A Note on the Problems of the 'Noshrim,'" *Soviet Jewish Affairs* Vol. 6, No. 2, pp. 104–113.

Horowitz, Tamar R. (1982) "Integration without Acculturation: The Absorption of Soviet Immigrants in Israel," *Soviet Jewish Affairs*, Vol. 12, No. 3, pp. 19–33.

Kennedy, Janet (1977) "From the Real to the Surreal," in Dodge and Hilton (eds.).

Komar, Vitaly and Melamid, Alexander (1980) "The Barren Flowers of Evil," *Artforum*, March, pp. 46–53.

———— (1980) "In Search of Religion," *Artforum*, May, pp. 36–46.

Markish, Simon (1978) "Passers-by—The Soviet Jew as Intellectual," *Commentary*, December, pp. 30–40.

Nathanson, Melvyn (1978) *Komar/Melamid: Two Soviet Dissident Artists* (Carbondale: Southern Illinois University Press).

Panish, Paul (1981) *Exit Visa* (New York: Coward McCann and Geoghegan).

Rosenberg, Bernard and Fliegel, Norris (1965) *The Vanguard Artist: Portrait and Self-Portrait* (Chicago: Quadrangle Books).

Rueschemeyer, Marilyn (1981) *Professional Work and Marriage: An East-West Comparison* (London: Macmillan and New York: St. Martin's).

Seidman, Robert J. (1980) "The Politics of Art in Russia: An Interview with Ernst Neizvestny," *Partisan Review*, pp. 249–263.

Sjeklocha, Paul, and Mead, Igor (1967) *Unofficial Art in the Soviet Union* (Berkeley and Los Angeles: University of California Press).

Trotsky, Leon (1957) *Literature and Revolution* (New York: Russell and Russell).

Tupitsyn, Margarita (1981–82) "Collective Action Group," in Norton Dodge, ed., *Russian New Wave* Catalogue (New York: Contemporary Russian Art Center of America).

———— (1983) "Painting History and Myth," *American Arts*, July, pp. 30–31.

———— (1981–82) "Some Russian Performances," *High Performance*, Winter, pp. 11–18.

———— (1983) "What Happened to the Art of the 'Russian Amazons,'" in Dodge (ed.).

White, Harrison and White, Cynthia (1965) *Canvasses and Careers* (New York: John Wiley).

Zimmer, W. and Nadelman, C. (1981) "I got what I wanted in New York," *Art News*, November, Vol. 80, pt. 9, pp. 101–5.

Index

About the Authors

MARILYN SCHATTNER RUESCHEMEYER, educated at the University of Toronto and at Brandeis University, where she completed her doctorate, is assistant professor of sociology at the Rhode Island School of Design and adjunct assistant professor of sociology at Brown University. She is also affiliated with the Russian Research Center at Harvard University and in 1979 and 1982 was a senior associate member of St Antony's College, Oxford. Rueschemeyer has conducted field research in Israel, the German Democratic Republic, and the USSR as well as in the United States. She is the author of *Professional Work and Marriage: An East–West Comparison*.

IGOR GOLOMSHTOK is an art historian and critic who specializes in the art of the Renaissance and of the twentieth century. Before his emigration from the Soviet Union he was a senior research fellow at the Museum of Fine Arts in Moscow and lectured on the history of Western art at Moscow University. He was a member of the Union of Soviet Artists. Since moving to England in 1972 Golomshtok has taught at Oxford University and worked for the BBC. He is also an editor of *A-Ya*, a multilingual periodical devoted to contemporary Russian "unofficial" art, published in Paris. In addition to a number of monographs, he is the author, with Alexander Glezer, of *Soviet Art in Exile* and with Andrei Sinyavsky of a book on Picasso.

Janet Kennedy, who received her doctorate from Columbia University, is an associate professor in the School of Fine Arts at Indiana University. She has been a visiting fellow at the Kennan Institute and spent 1979–80 in the Soviet Union as a Fulbright-Hays scholar. Kennedy is the author of The *"Mir iskusstva" Group and Russian Art 1898–1912* and many articles on modern art and sculpture, and is completing *Mikhail Vrubel: An Art Historical Perspective on Russian Symbolism.*